THE ADVANCED PHOTOGRAPHY GUIDE

THE ADVANCED PHOTOGRAPHY GUIDE

David Taylor

Senior Editor Angela Wilkes
Project Art Editor Katie Cavanagh
Editors Francesco Piscitelli
David Tombesi-Walton, David Summers
Designers Steve Bere, Phil Gamble, Mark Cavanagh,
Katie Knutton, Simon Murrell
Photography Production XAB Design Nigel Wright
Photographers Gerard Brown, Janice Browne, Ruth
Jenkinson, Dave King, Rob Streeter, Nigel Wright
Producer, Pre-production Jacqueline Street-Elkayam
Production Controller Mandy Inness
Managing Editor Gareth Jones
Senior Managing Art Editor Lee Griffiths
Jacket Designers Mark Cavanagh
Stephanie Cheng Hui Tan
Jacket Editor Claire Gell
Jacket Design Development Manager Sophia MTT
Associate Publishing Director Liz Wheeler
Art Director Karen Self
Publishing Director Jonathan Metcalf

First published in Great Britain in 2018 by
Dorling Kindersley Limited
80 Strand, London WC2R 0RL

Copyright © 2018 Dorling Kindersley Limited
A Penguin Random House Company
10 9 8 7 6 5 4 3 2 1
001–305933–July/18

A CIP catalogue record for this book
is available from the British Library.
ISBN: 978–0–2413–0192–0

Printed and bound in China

All images © Dorling Kindersley Limited
For further information see: www.dkimages.com

A WORLD OF IDEAS:
SEE ALL THERE IS TO KNOW

www.dk.com

CONTENTS

INTRODUCTION

Photography has never been more popular, and yet cameras have never been more complicated. Over the next 176 pages, this book will gently guide you through the important concepts necessary to build on your experience and technical grounding to take your photography to a more advanced level. To help you digest this new knowledge, you will also be reminded of the basics along the way. This guide covers a range of comprehensive topics, from experimenting with exposure, depth of field, lenses, and flash, to how to enhance your images using digital editing software. It will also teach you new skills to practise, such as how to freeze or blur movement, use a variety of filters effectively, and create brilliant images using multiple and long exposures. However, reading this book is only half the story; you will also need to put your new-found knowledge to practical use. The simplest way to embrace new skills is to shoot regularly, so that using your camera becomes second nature to you. The key is not to get stuck in a creative rut. Experiment, and don't be afraid to make mistakes: it's important to. Have fun, and enjoy your photographic journey.

ABOUT THIS BOOK

Full of practical information and tutorials, this book will help you to learn new skills and take your photography a step further. Canon and Nikon dSLRs are used throughout, but even if the make or model of your camera is different, you will find that most dSLRs and many CSCs have very similar functions and controls.

CAMERA SETTINGS KEY

The following icons are used in the book to show you precisely what settings were used for the final images in the step-by-step tutorials.

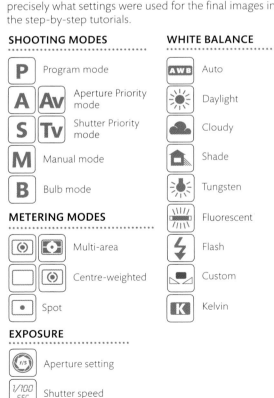

SHOOTING MODES

P — Program mode

A / Av — Aperture Priority mode

S / Tv — Shutter Priority mode

M — Manual mode

B — Bulb mode

METERING MODES

Multi-area

Centre-weighted

Spot

EXPOSURE

Aperture setting

Shutter speed

ISO setting

WHITE BALANCE

AWB — Auto

Daylight

Cloudy

Shade

Tungsten

Fluorescent

Flash

Custom

K — Kelvin

WHAT'S ON THE PAGES?

INTRODUCING

At the start of every chapter "Introducing" pages provide an overview of the topics that are covered in the chapter. They introduce the basic principles behind each topic, such as what composition is or what filters do, show which equipment you need to use, and explain in simple terms how it works.

THINGS YOU'LL SEE

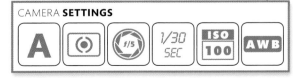

Camera settings Wherever you are shown how how to apply a technique, you will also see the final result, and the settings used to create it (see Key, left). Throughout the steps, you may find that different settings have been used to take test shots.

EXPLAINING |

The "Explaining" pages in the book take an in-depth look at a particular aspect of photography. It could be an explanation of autofocus modes, how different types of flash work, or the ways in which you can adjust your photo in post-production. The technical know-how is presented clearly throughout.

APPLYING |

The "Applying" pages provide inspiring photographic tutorials that show you step-by-step exactly how to put the theory into practice on particular projects. There are feature boxes about specific points of technique, and plenty of helpful tips on how to apply them to different subjects and situations.

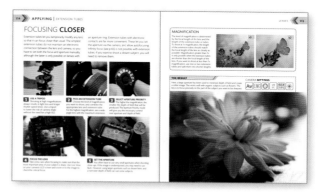

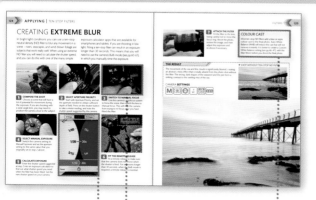

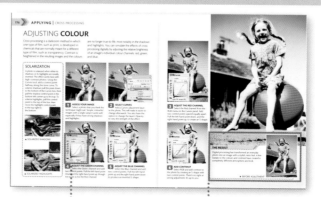

Apps Screenshots of apps are included in cases when you may need help in calculating the best camera settings to use.

Close-up camera details These photos in the tutorials show you exactly which buttons and dials on your camera to use.

Boxes These provide additional information or tips on technique.

The result A brief overview of the final image sums up how it was created and what makes it successful.

Screenshots These show you what the window or panel will look like when using a particular editing software on a PC or Mac.

EQUIPMENT

EQUIPMENT

Cameras can be grouped into two broad categories: all-in-one designs and system cameras. All-in-ones can be used straight out of the box without any other gear. System cameras are just one element of a large, varied family of photographic equipment that includes lenses and flashes. Being able to increase the capabilities of a system camera makes them ideal for creative photographers.

Cameras

A camera is a tool for producing photographs. Like all tools, a particular camera is not necessarily right for every task, so many photographers use more than one type, according to their exact shooting needs at the time. Understanding and appreciating the strengths and weaknesses of your camera equipment will help you make informed decisions on how best to use it.

CAMERAPHONE	COMPACT	ADVANCED COMPACT
Cameraphones are simple devices with a fixed lens, but accessory lenses can be fitted to some models.	This is a relatively simple point-and-shoot camera that has a built-in zoom lens and flash.	The higher specification includes greater control over exposure, and the facility to shoot JPEG and Raw.
POSITIVES	**POSITIVES**	**POSITIVES**
■ You always have it with you ■ Apps expand creative possibilities ■ Images can be shared	■ Easily carried in a pocket or bag ■ Modest to good zoom range ■ Discreet	■ Small size and lightweight body ■ Often allows for added accessories ■ Good zoom range
NEGATIVES	**NEGATIVES**	**NEGATIVES**
■ A tiny sensor that requires good light ■ Fixed-focal-length lens ■ Limited control over exposure	■ Creative controls tend to be limited ■ No viewfinder ■ Autofocus (AF) often slow	■ Limited apertures and shutter speeds ■ May not have a viewfinder ■ Filters cannot be fitted

WI-FI CONTROL

Most modern cameras have built-in Wi-Fi to connect with an app on a smartphone or tablet. The app usually mirrors the camera's controls, as well as displaying a live image streamed from the camera. This lets you shoot remotely without having to be near your camera. Once a photo has been shot, the app will automatically transfer a copy to your device for review. This is usually a resized JPEG, but some apps can also transfer Raw files.

Common uses for a Wi-Fi connection include shooting with a drone and photographing skittish wildlife subjects. The big drawback is power consumption: camera batteries deplete more rapidly when Wi-Fi is enabled.

When to upgrade

The desire for the latest camera is understandable, but it is a mistake to change cameras without first getting the most out of your existing model. Attend photography workshops or visit new places to get inspiration and improve your photography. Then, when you feel that your camera's specifications no longer meet your needs as a photographer, upgrade to a new model.

BRIDGE	MIRRORLESS/CSC	DSLR
This all-in-one camera has a built-in lens. It accepts accessories such as flash and remote releases.	The compact system camera relies solely on the LCD or electronic viewfinder to display a Live View image (see p.19).	Similar in style to film-based SLRs, this type of camera is popular with both amateurs and professionals.

BRIDGE

POSITIVES
- Can be used without extra gear
- Automatic and manual modes
- Excellent zoom range

NEGATIVES
- The lens cannot be changed
- Small sensor, so the image quality may be compromised in low light

MIRRORLESS/CSC

POSITIVES
- Interchangeable lens
- Shoots both JPEG and Raw
- Automatic and Manual modes

NEGATIVES
- The battery life is often limited
- Autofocus usually slower than that in dSLR cameras

DSLR

POSITIVES
- Interchangeable lens
- Shoots both JPEG and Raw
- Allows total creative control

NEGATIVES
- Can be heavy and bulky
- Fewer manufacturers are now making dSLRs

FROM **CAPTURE** TO **STORAGE**

When you press the camera shutter button, you start a sequence of events that leads to a photo. First, the shutter inside the camera opens, exposing the digital sensor behind it to light. (Some cameras use an electronic shutter, but the basic principle is the same.) The light, which is reflected from your subject towards the camera, is focused by the lens on to the sensor, and then the shutter closes to complete the exposure. The light that reached the sensor is then measured and converted into Raw image data. If you are shooting JPEG, this data is processed and discarded, and the finished JPEG is saved to the memory card; if you shoot Raw, the image data is processed more lightly before being saved.

DIGITAL SENSORS

An image sensor is an electronic chip that converts light into digital data. The surface of the sensor is covered in photodetectors, the number of which determines the camera's pixel resolution. Image sensors are made in a variety of sizes. The smallest are found in smartphones and compact cameras, while the largest are used in CSC, dSLR and digital medium-format cameras. The size of the image sensor influences the final image in a number of ways, including its ISO performance (sensitivity to light), dynamic range (see top right), and the crop factor (see p.98) of the lens fitted to the camera.

BAYER FILTER

Individual photodetectors can only detect light levels, not colour. To produce colour information, light passes through a colour filter – red, green, or blue – before it reaches the photodetector. The filters are arranged in a mosaic of four; the most common arrangement – one red, one blue, and two green filters – is known as the Bayer pattern, after its inventor.

IMAGE SENSOR

The size of the sensor in a camera is directly related to the size of its photodetectors. A small sensor with the same pixel resolution as a larger sensor will need to include smaller photodetectors. However, the smaller the photodetectors on an image sensor, the more it will suffer from graininess at high ISO settings, and the lower its dynamic range.

KEY TO ANNOTATIONS

1	Camera lens
2	Bayer filter
3	Image sensor
4	Photodetectors
5	Analogue electronics
6	Analogue/digital (A/D) converter
7	Digital image processor
8	Buffer memory
9	Memory card

DYNAMIC RANGE

A sensor's dynamic range is the ratio of the minimum amount of light that is needed to record the details in shadows to the maximum amount of light possible before details in the highlights are lost due to overexposure. Usually, the larger a sensor's photodetectors are, the greater their dynamic range, so larger sensors, such as those in full-frame cameras, have a greater dynamic range than the sensors in compact cameras. This results in fewer problems such as image noise or loss of detail in the shadows or highlights of an image.

READ/WRITE SPEED

The storage capacity of a memory card is just one aspect of its specification. Almost as important is its read/write speed, which is the rate at which data – photos or video – can be recorded to and then read back from the card, either by your camera or by a PC. The faster that data can be written to the card, the less likely it is that the camera buffer memory will fill when you are shooting continuously, or when shooting with Raw+JPEG selected.

PHOTODETECTORS

Photodetectors are cavities on an image sensor that capture photons (elements) of light. The number of photons captured determines the brightness of the image pixel associated with the photodetector. A photodetector completely filled with photons produces a white, fully exposed pixel; a photodetector that receives no photons will produce a black pixel.

DIGITAL IMAGE PROCESSOR

Once an image is exposed, the analogue data captured by the sensor is converted to a digital signal and sent to the digital image processor. This decodes the colour information from the photodetectors to create the full range of colours of a digital picture. It also reduces image noise, sharpens the image, and creates a finished JPEG, if required (unless shooting in Raw).

BUFFER MEMORY

A camera's buffer memory is a temporary store for image data until it can be saved to the memory card (determined by the card's read/write speed). If the buffer memory fills, the camera won't let you continue shooting until it clears sufficiently. The "burst rate" of a camera is how many images, and of what type, you can shoot before the buffer memory fills.

MEMORY CARD

The most commonly used memory card is currently the Secure Digital (SD) type, available in different capacities and a variety of read/write speeds (see above left). The latest type of SD card at the time of writing is the SDXC, which is available in sizes up to 512GB. Another type of memory card, called the XQD, may offer higher capacities and read/write speeds than the SDXC.

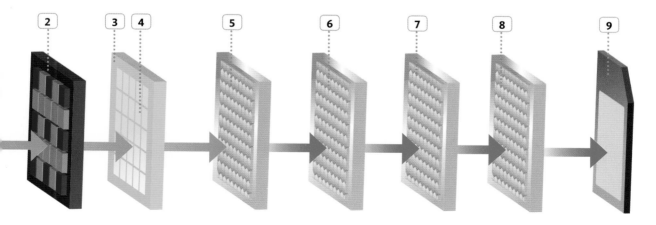

SINGLE LENS REFLEX CAMERAS

Inside a single lens reflex (SLR) camera there is a mirror that directs light from the lens through a pentaprism (a five-sided prism) to an optical viewfinder. The image in the viewfinder is displayed in the correct orientation and allows the photographer to compose shots accurately. This system has been used in 35mm film cameras since the 1940s, but the concept itself dates from the late 19th century. Modern digital SLR cameras (or dSLRs) can trace their lineage directly back to 35mm camera designs. This means that some equipment, such as lenses, may be compatible on both types of SLR.

CONSUMER VS PROFESSIONAL

There are two broad categories of dSLR: consumer and professional. Consumer dSLRs are usually smaller, lighter, and cheaper than professional models and are generally designed to make photography as easy and foolproof as possible. Professional dSLRs, though less intuitive to use, offer a wider range of options and are more rugged in build.

CONSUMER

Consumer cameras tend to have all the key features that a serious photographer needs without the cost or bulk of a professional model.

WHAT TO EXPECT

- Pop-up flash
- Low flash-sync speed (see pp.138–39)
- 95–98% optical viewfinder
- Automated scene modes for simplified shooting
- Few physical controls and buttons
- Low frame rate
- Lightweight polycarbonate body with little or no weather-sealing
- APS-C (cropped) sensor
- Available with a kit lens
- Around 9 to 19 AF points

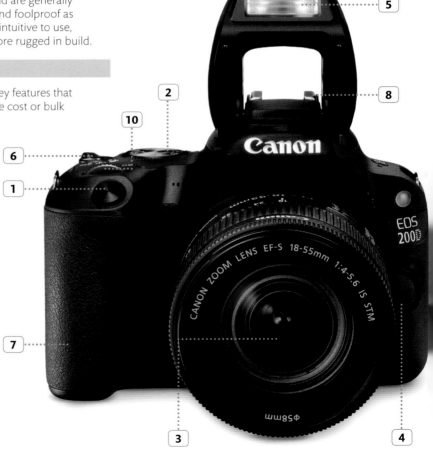

LIVE VIEW

Modern dSLRs can stream a live image directly from the sensor to the camera's rear LCD. To do this, the mirror is raised, blocking the optical viewfinder, and the shutter opened. Using Live View means that you can easily check the exposure and options such as white balance before shooting. You can also zoom into the image to fine-tune focusing (particularly useful when shooting macro). The downside is that the camera battery will be depleted more quickly. Autofocusing will also be slower.

PROFESSIONAL

Anyone who owns a professional camera and lenses is usually eligible to join the manufacturer's professional programme. This offers useful benefits such as faster camera-servicing and repair times. However, lenses designed for APS-C cameras may not fit or work correctly on professional full-frame cameras. Cameras with an optional vertical hand grip also have space for extra batteries, which extends the time that you can shoot for.

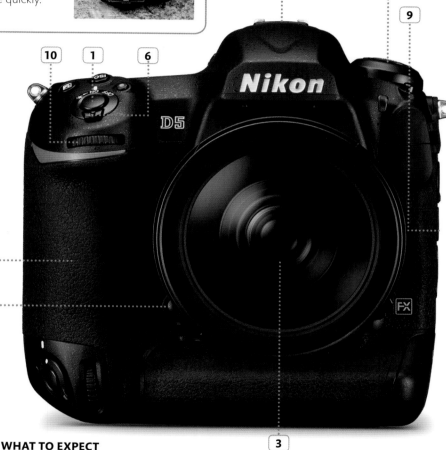

KEY TO ANNOTATIONS

1	Shutter-release button
2	Mode dial
3	Lens
4	Lens release button
5	Pop-up flash
6	On/off switch
7	Hand grip
8	Hotshoe (for mounting a flash)
9	Connection port covers
10	Control wheel

WHAT TO EXPECT

- No built-in flash
- High flash-sync speed (see pp.142–43)
- 100% optical viewfinder
- More physical controls and less automation
- High frame rate

- Greater connectivity
- Magnesium-alloy body
- 35mm (full-frame) sensor
- Increased number of AF points
- Integrated/optional vertical grip

COMPACT SYSTEM CAMERAS

Compact system cameras (CSCs) are often referred to as mirrorless cameras because they do not use a reflex mirror as dSLRs do. Instead, a live image is fed directly from the camera's digital sensor to either an LCD screen or an electronic viewfinder (EVF). This makes CSC bodies smaller and lighter than an equivalent dSLR, without losing important features or final image quality. An advantage of a CSC's EVF is that you can see the effect of changing exposure or white balance before shooting. The CSC is a fairly new category of camera and is not derived from older designs. This means that fewer accessories are available for CSCs than for dSLRs, but this is changing as they become more popular.

CONSUMER VS PROFESSIONAL

Like dSLRs, CSCs can be broadly subdivided into the two categories of consumer and professional. Professional CSCs tend to be larger than consumer CSCs, though the size difference between the two types of CSC is less marked than with dSLRs. One important difference between dSLRs and CSCs is that a wider range of sensor sizes is used in CSCs, from 2.5cm (1in) to full-frame.

CONSUMER

Consumer CSCs are designed to be user-friendly, with a wide range of exposure modes to suit almost any shooting situation. Their compact size makes them ideal travel cameras.

KEY TO ANNOTATIONS

1	Pop-up flash	**7**	Handgrip
2	Mode dial	**8**	Lens
3	Shutter button	**9**	Lens release button
4	Exposure compensation dial	**10**	Vertical handgrip
5	Function button	**11**	Flash sync port
6	Autofocus illuminator	**12**	Hotshoe

WHAT TO EXPECT

- Pop-up flash
- No flash hotshoe
- No electronic viewfinder
- Few physical controls and buttons
- Single memory-card slot
- Wide range of shooting modes
- Built-in Wi-Fi
- HD video modes
- Available with a kit lens

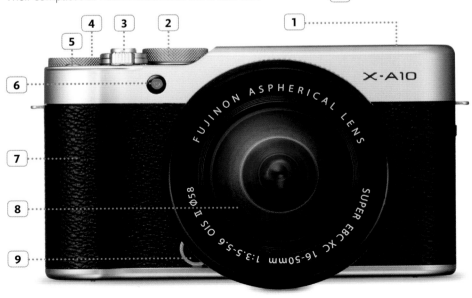

X-A10

FUJINON ASPHERICAL LENS

SUPER EBC XC 16-50mm 1:3.5-5.6 OIS II Ø58

LENS ADAPTERS

You can fit virtually any SLR or dSLR lens to a CSC by using an adapter. Simple versions don't transmit an electronic signal between the lens and the camera, so the lens has to be focused manually and the aperture set by hand. More sophisticated adapters allow full control of the lens, but AF tends to be slower than with a CSC lens.

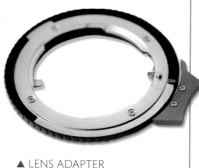

▲ LENS ADAPTER

BATTERY LIFE

The most appealing aspect of CSCs is that they are smaller and lighter than dSLRs, but this also means that their batteries are smaller, resulting in faster depletion. DSLRs are also more battery-efficient because they have optical viewfinders. Get into the habit of starting each photography session with a full battery, and always keep several spare batteries handy.

PROFESSIONAL

Other than a mirror, there is generally very little difference between professional versions of CSCs and dSLRs. Both types of camera are designed to help photographers achieve the results that they want in their photos reliably and consistently.

WHAT TO EXPECT

- Flash hotshoe
- No pop-up flash
- Electronic viewfinder
- More physical controls and less automation
- Higher frame rate
- Greater connectivity
- Weather-sealing
- Dual memory-card slots
- 4K video modes
- Depth-of-field preview
- Increased AF options
- Optional vertical grip

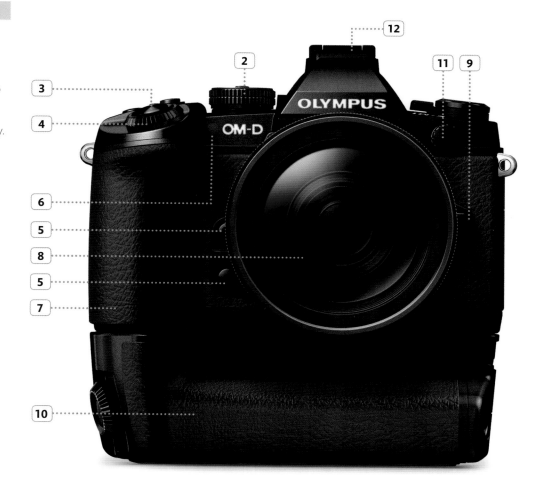

WHICH **LENSES?**

One of the benefits of shooting with a CSC or dSLR camera is being able to change lenses to suit your creative requirements. Using different types of lens will expand the possibilities of what you can achieve with your camera. However, lenses are a significant financial investment. The key to choosing a lens is to consider carefully how useful it will be to your needs as a photographer, both immediately and in the foreseeable future.

▲ Ultraviolet (UV) filters (see p.128) don't have any impact on the exposure of your photo, but they can be used to protect your lens.

KIT LENS	PRIME LENS	SUPERZOOM LENS
The first lens a photographer owns is often the kit lens sold with the camera. Kit lenses are usually zoom lenses that add little to a camera's price.	Prime lenses are fixed-focal-length lenses that are available in a wide range of lengths – from fisheye to telephoto lenses (see pp.104–05).	A superzoom is an all-in-one lens that covers a very large range of focal lengths. These lenses usually vary from wide-angle to telephoto.
POSITIVES	**POSITIVES**	**POSITIVES**
■ Inexpensive ■ Lightweight ■ Unobtrusive	■ Excellent optical quality ■ Large maximum aperture ■ Relatively inexpensive	■ No need to change lenses ■ Very versatile ■ Compact design
NEGATIVES	**NEGATIVES**	**NEGATIVES**
■ Optical quality is often compromised ■ Small range of focal lengths ■ Variable maximum aperture ■ No weather-sealing	■ You will probably need to change lenses more often ■ Less versatile than a zoom lens	■ Optical quality is often compromised, particularly at the most extreme ends of the zoom range ■ Variable maximum aperture ■ Slower autofocusing

CLEANING LENSES

Dirt and dust on the glass surfaces of a lens can affect image quality. It is therefore important to keep the lens as clean as possible. One easy way to do this is to fit the front and rear lens caps whenever a lens isn't in use. Lenses should be cleaned only when it is necessary; too much cleaning increases the risk of scratching or damaging the lens coatings.

1 USE A BLOWER BRUSH
Start by holding the lens upside down and using the blower brush to remove any loose dust and grit.

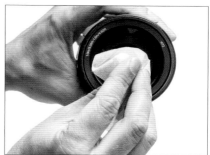

2 WIPE WITH A CLOTH
Use a moistened cloth to gently wipe in a circular motion from the centre of the lens out towards the edge.

PRO-SPEC LENSES	MACRO LENS	SPECIALITY LENSES

Many lens manufacturers offer higher-spec lenses, with features such as weather-sealing and low-dispersion glass to reduce chromatic aberration.

A macro lens enables you to shoot close-up images life-size or larger. See pp.112–13 for more information on shooting with macro lenses.

This category of lenses (see pp.106–7) includes fisheye and tilt-shift lenses. It may be more financially viable to hire these as needed instead of buying them.

POSITIVES

- Excellent optical and build quality
- Zooms feature a fixed maximum aperture

NEGATIVES

- Expensive
- Larger and heavier than a consumer lens

POSITIVES

- Can also be used as a normal lens
- Excellent optical quality
- Large maximum aperture

NEGATIVES

- Expensive
- Limited focal-length options
- True macro lenses are usually only available as fixed-focal-length lenses

POSITIVES

- Unique features not found with standard lenses

NEGATIVES

- Expensive
- For specific uses only

LIGHTING

Consumer DSLRs and CSCs usually have a built-in flash, which can be used as a fill light when you are shooting a backlit scene, or for extra illumination when the ambient light levels are low. However, a built-in flash may not be ideal (see pp.136–37). Options such as an external flash or continuous studio lighting are far better. An external flash can be fitted either directly to the camera's hotshoe or triggered wirelessly via an optical or radio connection.

EXTERNAL FLASH

There are several things to bear in mind when choosing a flash. A key specification is the guide number of the flash, which indicates its illuminating power. Other useful features include a bounce head that enables you to direct the light from the flash very precisely, and wireless capability, so that you can use the flash off-camera.

FRONT

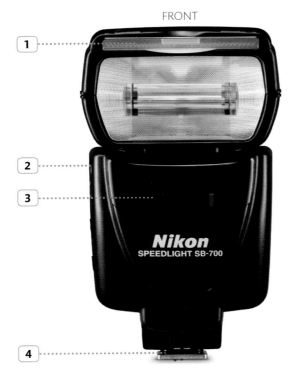

BEHIND

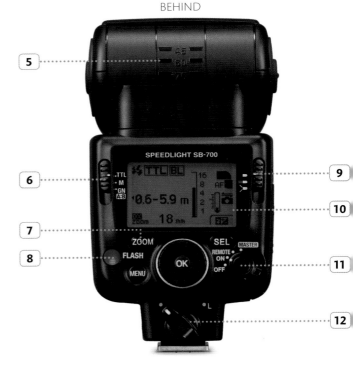

FLASH KEY

1	Slide-out reflector/wide-angle diffuser	**5**	Bounce head	**9**	Illumination-pattern selector		
2	Wireless flash sensor	**6**	Mode selector	**10**	LCD panel		
3	Autofocus (AF) illuminator	**7**	Zoom control	**11**	On/off–remote/master control		
4	Foot (to attach to the camera hotshoe)	**8**	"Ready" light	**12**	Locking switch		

Other types of flash

There are two basic types of external flash: manual and proprietary. A manual flash only has one pin on the foot of the flash, the firing pin, which can be used on most cameras with a hotshoe but offers little or no exposure automation. As well as the firing pin, a proprietary flash has communication pins, the positions of which may vary between manufacturers. The advantages of a proprietary flash are that the exposure can be automated, and modes such as High Speed Sync are available.

CONTINUOUS LIGHTING

The one big advantage that continuous lighting has over flash is that the effect of any change you make in the position or intensity of a light will be immediately apparent. The downside to this kind of lighting is that it is usually far less powerful than flash, and is also less portable. Each type of continuous lighting has its own unique characteristics.

STUDIO LIGHTS

Studio lights use either incandescent tungsten or fluorescent bulbs. Incandescent lighting has a colour temperature of approximately 2,900 Kelvin (K). Light from fluorescent bulbs is more neutral, typically 3,000–4,200K. Incandescent lights generate heat, making them less easy to handle than fluorescent lighting, which runs at a lower temperature. Tungsten bulbs also don't last for as long as fluorescent ones.

LED LIGHTING

LED is a type of continuous photographic lighting that is available either as an array across a rectangular panel or as a ring light (see below). It is very power-efficient and does not get hot, so it is safe to use for long periods, and can be placed close to a subject without causing damage. LED lighting is available in a number of different colour temperatures (measured in Kelvin) and can often be dimmed to reduce the light intensity.

LED LAMP ▲

RING LIGHT

Circular in shape, ring lights are available in different sizes, and as both flash and continuous lighting. Small ones can be fitted to the filter thread on the front of a lens and are mostly used for macro photography. Large ring lights tend to be used in studios, especially when shooting portraits. Both types produce a soft, even light and create distinctive circular highlights on reflective surfaces.

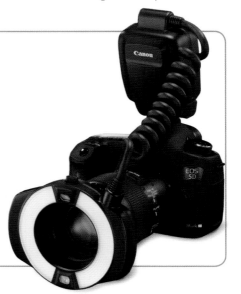

▲ STUDIO LIGHT

▶ MACRO RING LIGHT

LIGHT **MODIFIERS**

The light from a flash or studio light can be modified by using one or more different lighting accessories. These light modifiers affect the quality of the light that falls on your subject and can be used to reduce contrast, enabling the camera to record detail across the full tonal range of a scene. Light modifiers can also be used to direct where light falls, so that you can illuminate part of your subject or scene to create a focal point in the photo.

DIFFUSER

A diffuser is an accessory that effectively places a sheet of translucent cloth or plastic between the light source and the subject. This helps to reduce glare and eliminate hot spots on the subject. It also makes shadows softer and less dense. Diffusers are usually small and portable, making them ideal for use outdoors. Some diffusers are easy to make yourself.

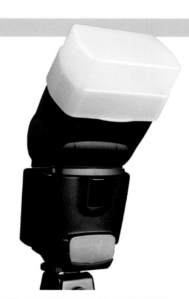

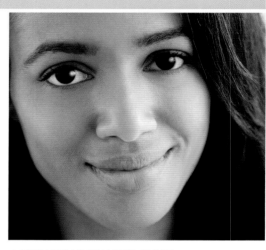

▲ REDUCES UNWANTED GLARE

SOFTBOX

A square, rectangular, or octagonal cloth unit with a reflective inner surface and a diffusing screen fitted at the front, a softbox houses a flash or studio light. The combination of the reflective inner surface and the diffusing screen softens the light that is emitted from within. Softboxes are generally used on a lighting stand, making them better suited to indoor photography.

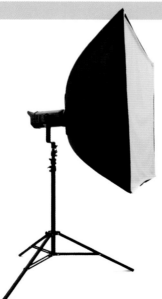

▲ SOFTENS THE LIGHT SOURCE

REFLECTOR

Available in several sizes and shapes, reflectors are used to bounce light on to a subject. White reflectors create a soft fill light that is particularly good for portraits; metallic reflectors create a more intense fill light, which is useful when contrast levels are high.

▲ BALANCES A BACKLIT EXPOSURE

SNOOT

These simple conical or rectangular tubes fit over the head of a flash or studio light. Snoots are used to direct the light more specifically, and to restrict the amount of light falling across a scene, focusing it more on the subject.

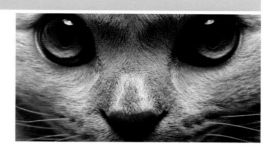

▲ DIRECTS LIGHT ON TO THE SUBJECT

GRID

A grid creates directional light in a similar way to a snoot, channelling light through a mesh of cells. Small grids that can be fitted directly to a flash or studio light are known as honeycomb grids because of the hexagonal shape of the individual cells.

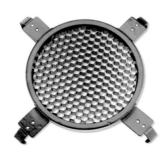

▲ CONTROLS THE SPREAD OF LIGHT

BEAUTY DISH

Using a combination of a small reflector and parabolic dish, a beauty dish produces a slighter harder, more focused light than a softbox. Beauty dishes are often used for head-and-shoulder portraits and create pleasing circular catchlights in the eyes.

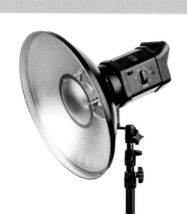

▲ CREATES CIRCULAR CATCHLIGHTS

CAMERA **SUPPORT**

A fault caused by inadvertently moving the camera during an exposure, camera shake usually occurs when you are shooting in low light with shutter speeds below 1/30 sec. Unfortunately, camera shake is one image problem that is impossible to correct in post-production. Lens or sensor-based image-stabilization systems can help to minimize camera shake, but ultimately it is best to use a tripod when shooting at low shutter speeds, and every photographer should buy the best that they can afford.

TRIPODS

The price you pay for a tripod will depend on two main factors: its size and what it is made of. Ideally, a tripod should reach your eye level without using its centre column. However, large tripods are invariably more expensive and harder to carry around. The two main materials used to construct tripods are aluminium and carbon fibre. Aluminium tripods are stable but heavy: carbon-fibre tripods are stable and light but often cost around twice as much as comparable aluminium tripods.

USING A TRIPOD

A tripod that has been set up incorrectly is almost as bad as not using a tripod at all. There are a number of do's and don'ts that, once you're aware of them, will help you to get the best out of your tripod.

TRIPOD TIPS

1. Open the tripod legs fully
2. Tighten the leg locks fully
3. Extend the legs fully before using the centre column
4. Ensure that the centre column is vertical
5. Tighten the tripod head fully
6. Don't move around your tripod during an exposure
7. Use a remote shutter release for your camera
8. Use your lens's tripod collar, if it has one

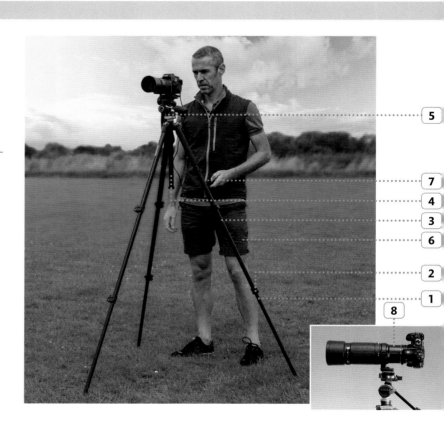

TRIPOD HEADS

There are two main types of tripod head that are either built into or can be fitted to your tripod: ball-and-socket and pan-and-tilt (also known as a three-way head). Both variants have their advantages and disadvantages, and there is no right or wrong choice, but you should take into account the combined weight of your camera and largest lens.

BALL-AND-SOCKET

ADVANTAGES
- Quick to position
- Lightweight
- Compact size
- Simple to use

DISADVANTAGES
- Hard to adjust in one axis only
- Less fine control
- Often less stable in the vertical orientation
- Camera needs to be supported when you adjust the position of the head

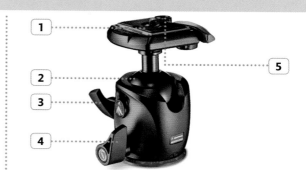

PAN-AND-TILT

ADVANTAGES
- Fine control over each axis
- Very stable in every axis once tightened
- Good for larger camera systems
- Usually less expensive than an equivalent ball-and-socket head

DISADVANTAGES
- Heavy and bulky
- Takes time to position each axis correctly

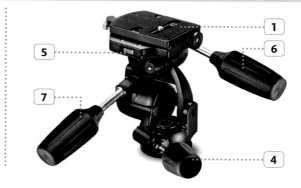

KEY TO ANNOTATIONS

1	Quick-release plate	**3**	Ball-and-socket adjuster	**5**	Spirit level	**7**	Tilt lever
2	Ball-and-socket joint	**4**	Pan direction lever	**6**	Vertical/horizontal lever		

SHOOTING STRAIGHT

A spirit level is really useful when shooting landscapes or architectural subjects. It will help you to align your camera so that it's level in at least one axis. Spirit levels are built in to quality tripod heads. They can also be bought separately and fitted to a hotshoe. Some cameras also have a spirit level in either the viewfinder or the rear LCD.

▲ TRIPOD SPIRIT LEVEL

▲ IN-CAMERA SPIRIT LEVEL

JPEG vs RAW

Both dSLR and CSC cameras – as well as bridge and advanced compact cameras – allow you to shoot with two different image-file formats: JPEG and Raw. JPEG is usually regarded as being for amateur photographers, while Raw is the choice of professionals, but each has advantages and disadvantages, and it is useful to switch between the two according to the needs of a particular shoot. JPEG is convenient, but Raw soffers more post-production options.

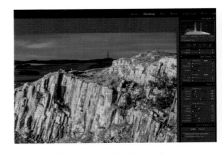

▲ In good post-production software, such as here in Adobe Lightroom, there are more options for crafting the look of an image than on your camera.

JPEG FILES

A JPEG is created and processed by a camera directly after exposure. The selected image options, such as white balance, are embedded in the JPEG and cannot easily be undone later. JPEGs are also compressed, to save space on the memory card. This compression works by discarding fine details – the higher that the compression is, the lower the quality of the final image. JPEGs can also often be shot at a different pixel resolutions. The appeal of JPEG is that immediately after shooting you have a final file that can be used for a variety of purposes, such as posting on social media.

RAW FILES

Raw files are huge and are almost the opposite of JPEGs: they are not processed by the camera, other than being compressed using non-destructive methods. Raw files can only be viewed and edited in specialized Raw conversion software. The image options that you select when shooting are applied to a Raw file but are not permanent. You can unpick those settings – without losing any quality – when you import the Raw file into Raw conversion software. For general use and sharing, a Raw image has to be adjusted first and then exported as a more convenient format, such as JPEG.

JPEG COMPRESSION

Cameras usually offer two or more levels of compression. Which is most useful will depend on how you intend to use the photos. The lowest level of compression will retain the most image detail and is the best option for making large prints. Unless you really need to save memory-card space, higher levels of compression are best left for photos that will only be viewed on-screen or used online.

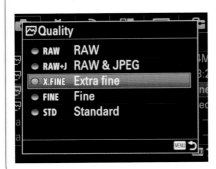

◄ The naming convention for compression is brand-specific. Fine tends to be less compressed than Standard.

COLOUR SETTINGS

All digital cameras let you control the colour, sharpness, and contrast of your photos. Different manufacturers use various names for these options. You can usually choose from presets created for specific genres, such as landscapes or portraits, or create a custom setting. The effects of these presets are essentially permanent when shooting JPEG but can be changed in post-production when Raw is selected.

◄ Colour settings are very much down to personal taste. Neutral (or similar) produces natural-looking photographs.

WHICH FILE FORMAT TO USE?

Since JPEGs are processed by the camera, you have to choose your image options before you shoot, considering what the end effect will be. If you choose Raw, however, you can make those decisions later. JPEG is ideal when you are shooting tens or hundreds of photos, while Raw is a better option if you want to control the look of a few key images.

SUBJECT		FORMAT	REASONS
SOCIAL EVENTS Photos from family gatherings or school events are prime candidates for quick and easy sharing.	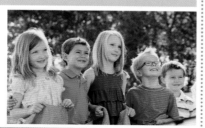	JPEG	■ Photos can be shared immediately ■ No post-production time necessary ■ You can fit more photos on a memory card ■ Photos are print-ready after shooting
TRAVEL You'll need plenty of storage if you're away for a long time. Multiple memory cards and a cloud account are useful.		Either	■ JPEGs take up less room on your memory card ■ JPEGs can be backed up to cloud storage more easily ■ Raw offers more scope for post-production fine-tuning
LANDSCAPE From the natural world to city scenes, the biggest challenge when shooting landscapes is high-contrast subjects.		Raw	■ Photos can be refined at the post-production stage ■ Higher-quality images ■ Greater dynamic range ■ You retain more control over the print qualities of the photos
PORTRAITS A good portrait should flatter your subject. If you shoot with Raw, you will have more flexibility to refine the photo.	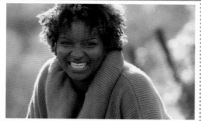	Raw	■ Sharpness can be applied more sympathetically ■ More control over white balance ■ Finer control of colour settings for natural skin tones ■ No fine detail lost through compression
SPORT You should use JPEG for sports events, because you will be shooting lots of photos quickly to capture key moments.	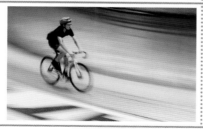	JPEG	■ Photos can be shared immediately ■ Potentially faster rate of continuous shooting ■ Lens corrections applied in-camera ■ The camera buffer won't fill up as quickly

COMPOSITION

COMPOSITION

Successful photos rarely happen by accident. It goes without saying that you need to have mastered your camera so that you are on top of technical issues such as exposure and focusing. There is one thing that your camera cannot do, however: it cannot compose a picture. Composition essentially means how you line up a shot to make it look as interesting and striking as possible, choosing your viewpoint image format, and framing to make the very best of your subject.

What makes a great photograph?

Great photos may have impact because of their split-second timing, pleasing balance of form and line, or brilliant colour. They are often the result of several factors: being in the perfect place, catching the right moment and the best lighting conditions, and having the right lens to hand. All of these things take planning. Ultimately, however, the best photos are created when you have a clear idea of what you want the photo to achieve. This means focusing on your subject and thinking about exactly what to include in the image and, just as importantly, what to leave out.

FRAMING

To try out different viewpoints, hold a small card frame up to your scene and vary its position. Ideally, the hole in the frame should be the same shape as the camera's sensor (this can be found in its manual). Try mimicking a specific lens by holding the frame the same distance from your eye as the lens's focal length.

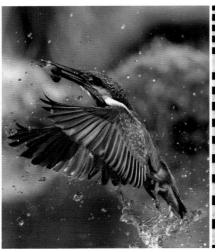

▲ FROZEN MOVEMENT

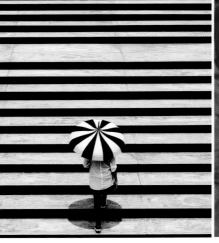

▲ CONTRASTING PATTERNS

▲ BRILLIANT COLOUR

Choosing a viewpoint

The most natural way to compose a shot is to hold your camera at eye level. There's nothing wrong with shooting this way, but it will not necessarily produce the most interesting images. Start by walking around your subject to find the best point of view and angle, then experiment with different shots (see below). Do you want a background, or does your subject stand out best filling the frame on its own? Try getting down low and looking up at it, or shoot it from above, either from a higher viewpoint or by holding the camera above your head, perhaps at the end of a tripod. You could vary the angle of your shots to see how that works, then zoom in on details. Be creative in your approach and review your shots as you go, to see what creates the most impact.

IMAGE FORMAT

Most photographers default to shooting in landscape format (horizontally), because this is the most comfortable way to hold a camera, but it does not suit every subject. To help you to decide between landscape and portrait, think about your subject and how it sits in the image space.

▲ LANDSCAPE FORMAT

◀ PORTRAIT FORMAT

COMPOSITION GUIDELINES

There are rules for composition that artists have been using for hundreds of years. These "rules", however, are really nothing more than guidelines that have helped artists to create more pleasing and interesting paintings. The guidelines work just as well for photographs as they do for paintings (or designs). There are several things that you can do to draw the eye into an image and make it work better. Try following the guidelines below and on the next two pages to help you to improve your shots. After you've shot a photo, look at it upside down. This change in orientation is a simple way to check if the composition looks right. Don't hesitate to reshoot if you think a new composition would be more effective.

GUIDELINES	EXAMPLES

FOLLOW THE RULE OF THIRDS

The Rule of Thirds directs you to set the subjects of your images off-centre. To follow it, you mentally divide the scene with two equally spaced horizontal and vertical lines to create a grid of nine boxes, then position important elements of the image where the boxes intersect, or align them with one of the lines. There are times, however, when a centrally placed subject creates a perfectly balanced composition.

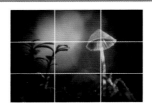
▲ Use your camera's grid view to aid composition.

USE LINES TO DRAW VIEWERS IN

Lines in a photo are an effective way to draw the eye through a composition towards the main subject. The lines don't need to be a permanent part of the scene: they may be fleeting, such as the trailing edge of water washing up on a beach. They can also be implied by aligning some of the elements within the picture. Diagonal lines are particularly effective, because they give a photo energy. Lines may be straight or curved; a straight line is more direct, while a curved line leads the eye along a meandering path. An image can, on the other hand, be strikingly simple when the subject stands alone without the need for any leading lines.

EXPLOIT NATURAL FRAMES

Framing your subject with another element in the scene helps to emphasize it, particularly if the frame conceals distracting details. Windows, trees, and archways all make good frames, but be careful that they do not detract from the subject. One way to reduce this risk is to use a dark or silhouetted frame. An out-of-focus frame can also work well and will be less distracting. Make sure that you focus on your subject rather than on the frame, and use a telephoto lens combined with a large aperture to restrict depth of field. Photographs without a compositional frame are, however, best for capturing the impact of wide open spaces.

Breaking the rules

Guidelines are there as a starting point, but that doesn't mean you have to stick to them all the time. Ultimately, how you want your photo to look is just as important as the rules of composition and to be creative, you sometimes have to break the rules. The Rule of Thirds, for example, discourages you from placing your subjects centrally. However, if a photo would be stronger with a central subject, you should ignore the rule. The same applies to all the other guidelines covered here and overleaf.

FINDING INSPIRATION

To see great examples of good composition, visit art galleries and study the paintings that you think really stand out. Why do you think they work so well? Look at how the key elements are positioned within the picture, which colours have been used, and how the light and shade fall. It is also a good idea to study photographs that you admire, to work out how the photographer has achieved the effects that you like. You can then adopt the same techniques yourself, or try recreating the images in your own way to see how close you can get to the effects created in the original photographs.

BREAKING THE RULES

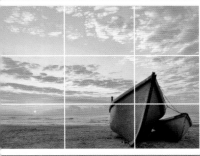

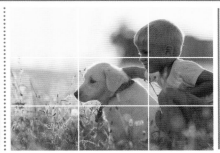

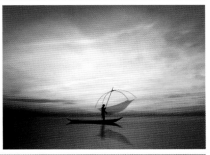
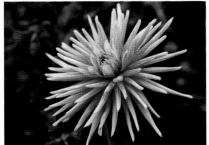

GUIDELINES	EXAMPLES

FILL THE FRAME

If you include too many competing elements in a photo, it can be hard to "read", or understand what is going on. To create visual impact, fill the frame with your subject, excluding most or all of the background. Don't be afraid to lose the outer edges of your subject; the important details, such as facial features in the case of a portrait, are all that you need. To fill the frame, you either need to get close to your subject or shoot with a long-focal-length lens. Alternatively, there are times when shooting your subject as a small part of a much larger scene creates a statement.

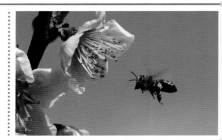

SIMPLIFY THE BACKGROUND

A simple background creates negative space, which helps to define the shape of your subject. Try to find a naturally plain background, or if that is not possible, shoot so that the background is out of focus. A neutral- or cool-coloured background is less obtrusive than one with a warm colour. A long-focal-length lens is ideal as it helps you to exclude distracting details. Restrict depth of field by using a large aperture and focusing on the subject. In complete contrast, you may sometimes want to incorporate a complex background to create a sense of atmosphere.

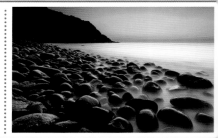

LOOK FOR PATTERN AND TEXTURE

Patterns are created when a shape is repeated across the image space, and they can be particularly interesting when they stretch to the edge of the photo, as that implies the pattern continues beyond it. Texture describes the qualities of an object's surface, such as whether it is hard, smooth, soft, or rough. Soft lighting tends to flatten texture, whereas harder lighting, particularly side lighting, helps to reveal it by creating shadows and highlights. You can also create interesting images by looking out for forms or colours that break a regular pattern or texture.

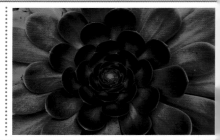

EXPLORE SYMMETRY

Simple bilateral symmetry occurs when half of a composition is mirrored in the other half, as when there is a reflection in a lake. The "fold line" for the symmetry can be either horizontal or vertical. Radial symmetry is when the symmetry radiates around a point, as is often the case with flowerheads. Symmetrical compositions are inherently calming, although they can look contrived. As with pattern above, you can also create visual impact by disrupting symmetry. One way to achieve this effect is to shoot just part of something that is symmetrical, or to set it off-centre.

ENJOY COLOUR

Having an eye for colours and how they work together is an important part of creating a good composition (see pp.40–41). Colour creates an emotional response and affects how viewers respond to your photo. Hues are influenced by the type of light illuminating a scene, by the direction of the light, and by camera functions such as White Balance and the colour settings that you select. Bright colours may create immediate impact, but muted colours can be equally pleasing, so make the most of a minimalist, monochrome palette if you chance upon the right scene.

BREAKING THE RULES

COLOUR **HARMONIES**

Colour is one of the most powerful elements of any photograph. When two colours are placed next to another, they create an effect, depending on how alike they are. Combinations of colours that are similar to each other are visually restful and convey serenity, whereas colours that are very different zing out and create a sense of energy. Understanding how colours work together will help you to make your photos more vibrant.

RGB AND CMYK

The colours of pixels on a monitor and in a digital photo are created by mixing varying amounts of red, green, and blue (RGB). But photo printers use cyan, magenta, yellow, and black inks – a colour system known as CMYK. When an image is printed, the printer's software converts it from RGB to CMYK.

The colour wheel

The simplest way to see how colours work together is to use a colour wheel, like the one on the right. This shows the full spectrum of colours, including the primary colours – red, blue, and yellow – and the secondary colours – violet (purple), green, and orange, each of which is made by mixing two primary colours together. (There are various types of colour wheel, which differ subtly from the one on this page and refer to other primary and secondary colours.) Colour wheels also help you to choose the right filter when you are shooting in black and white. A coloured filter will lighten the tone of objects that are a similar colour to the filter and darken those that are a complementary colour to the filter. This helps to widen the tonal range of a black-and-white photo and increase contrast.

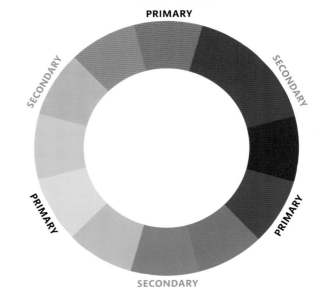

PRIMARY
SECONDARY
SECONDARY
PRIMARY
PRIMARY
SECONDARY

▲ Colours are divided into warm and cool colours. Red, orange, and yellow are warm colours, whereas blue, green, and violet are cool. Warm colours tend to jump out in an image and be more dominant than cool colours, which are recessive.

WARM COLOURS

COOL COLOURS

COLOUR PARTNERSHIPS	THE COLOUR WHEEL	IN PRACTICE

COMPLEMENTARY

Two colours – one primary and the other secondary – that are opposite each other on the colour wheel are said to be complementary. When they are placed next to one another, these colours make each other stand out. Blue and orange are complementary, as are red and green, and yellow and purple, so look out for them.

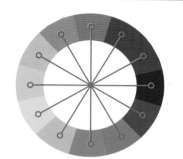

ANALOGOUS

Three or four colours that are next to each other on the colour wheel, including at least one primary colour, are called analogous, or harmonious, because there is little contrast between them. Red, orange, and yellow are analogous, as are green, cyan, and blue. Analogous colours tend to be either cool or warm, rather than mixed.

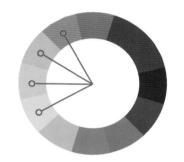

MONOCHROMATIC

A slice of one colour from the colour wheel, made up of variations in the brightness or saturation of the colour, is said to be monochromatic. A range of monochromatic colours is restful on the eye, particularly when one of the cooler colours is used, yet there can be high contrasts in tone. It is more subtle than the other colour partnerships.

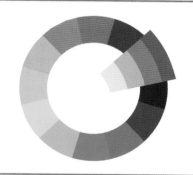

TRIADIC

Using three colours that are evenly spaced around the colour wheel creates what is known as a triadic harmony. The relationship between the three colours – red, blue, and yellow for example – is vibrant, but as warm colours can overpower cool colours, it is important to try and keep the colours in an image balanced.

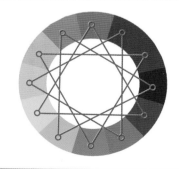

USING **COMPLEMENTARY** COLOURS

An image that is dominated by two complementary colours has immediate visual impact, and artists explored the possibilities of this in painting long before the advent of colour photography. A pair of complementary colours always contains one warm and one cool colour, such as red and green. When complementary colours are seen next to each other, they both look more intense – an effect known as simultaneous contrast. The three most effective and most common pairings are blue/orange, red/green, and yellow/violet (purple). Urban environments and gardens are good places to find suitable subjects.

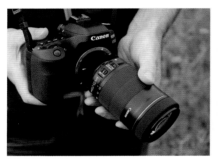

1 SELECT YOUR LENS
Fit a moderate telephoto lens to your camera. This will make it easier to simplify the shot and exclude other potentially distracting colours.

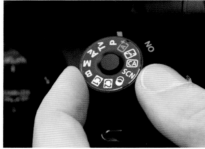

2 SELECT PROGRAM
In Program mode, the camera will select the exposure setting, freeing you to concentrate on the composition of your image.

3 CONSULT THE COLOUR WHEEL
Check the colours of what you want to shoot against a colour wheel (see pp.40–41) to make sure that they are complementary.

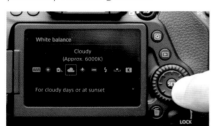

4 SET THE WHITE BALANCE
By using the right White Balance setting, you will ensure the colours in your photo are correct. The easiest way to achieve this is to select a White Balance preset (see p.45).

5 FRAME YOUR SHOT
Carefully compose your photo so that your two subjects fill the image space. Cooler colours tend to recede visually, so blue or green subjects benefit from being prominent in the frame.

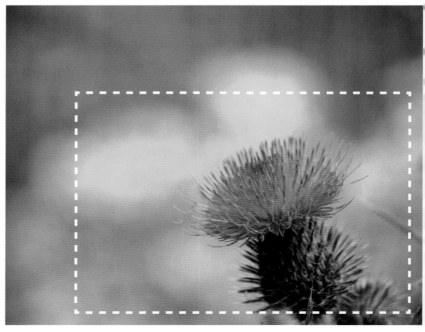

COMPLEMENTARY COLOURS

Highly saturated complementary colours create a strong visual impact. Very vibrant colour is relatively rare in nature, but you can increase saturation in post-production software. Warm colours tend to be visually dominant, so try to balance the colours equally, or use more cool colours than warm ones.

THE RESULT

The vivid purple of the thistle pops out against the soft-focus complementary yellow background. The photo would have had less impact if the backdrop had been green or blue.

CAMERA **SETTINGS**

P | f/5.6 | 1/250 SEC | ISO 160

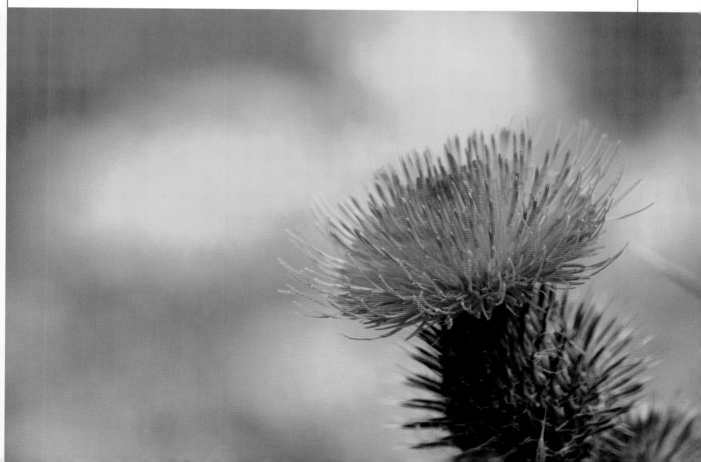

COLOUR TEMPERATURE

Light is rarely neutral in colour and often has a colour bias that can affect your photos – a sunset, for example, casts a reddish light, whereas a clear blue sky creates light with a blueish tinge. The amount of bias between red and blue is measured on the Kelvin (K) scale, which indicates the colour temperature of light: the bluer the light, the higher its Kelvin value. You can correct the colour bias of light by using your camera's White Balance function.

▼ The colour temperature of light varies throughout the day, depending on the height of the sun in the sky and the weather conditions.

TONE		TEMPERATURE	TYPE OF LIGHT	EXAMPLE
COOL LIGHT		12,000K	CLEAR SKY IN SNOW OR OPEN SHADE IN AMBIENT LIGHT	
		10,000K	HAZY SKY LIGHT OR OPEN SHADE	
		7,000K	A HEAVILY OVERCAST SKY	
		6,000K	A CLOUDY DAY	
		5,500–6,000K	ELECTRONIC FLASH	
		5,500K	DAYLIGHT AT MIDDAY	
		5,000K	SUNLIGHT	
		4,200K	COOL FLUORESCENT LIGHT	
WARM LIGHT		3,750K	A PHOTO LAMP	
		3,500K	SUNSET/SUNRISE	
		3,000K	WARM FLUORESCENT LIGHT	
		2,900K	A 100-WATT TUNGSTEN LIGHT BULB	
		1,900K	CANDLELIGHT/FIRELIGHT	

White Balance (WB)

Your camera's White Balance settings compensate for any colour cast in the light by adding blue or red. The easiest setting is Auto, but it only works well with temperatures from 3,000 to 7,000K and does not adjust well if there is one predominant colour in the shot. The other presets are more precise, and you choose the one that best matches the light in which you are working. The Custom White Balance is the most precise, but you need accurate light readings.

WHITE BALANCE SETTINGS

 AUTO: The camera automatically assesses the colour bias of the lighting and calculates the white balance for you.

 CLOUDY: The Cloudy setting corrects the slightly blue bias of the ambient light on a heavily overcast day.

 FLASH: This setting is balanced for use with an electronic flash, which, at around 6,000K, is a very white light.

 DAYLIGHT: The Daylight setting does not make any colour adjustment, because the sunlight at midday on a cloudless day is neutral.

 FLUORESCENT: Most cameras have a range of fluorescent settings to compensate for the colour casts of different types of artificial light.

 TUNGSTEN: This setting should be used when shooting under incandescent bulbs. It adds blue to correct the red bias of the lighting.

 SHADE: This setting adds orange-red to compensate for the blue shadows that are created outdoors on a sunny day.

 CUSTOM: The Custom setting enables you to set an accurate white balance yourself, by using a grey card (see p.68).

 KELVIN: This setting allows you to set the colour temperature manually in Kelvin (see top right), which gives you great flexibility.

USING KELVIN VALUES

Although the White Balance presets are accurate for most images, using a Kelvin value gives you greater accuracy, since you can set the White Balance at anything from 2,500 to 9,900K, usually in increments of 100K. Use the chart on the page opposite to assess the colour temperature of the light. (You can check the temperature of internal lights by consulting the manufacturer's website.) The most useful Kelvin values to remember are those for daylight, cloudy days, and tungsten light bulbs. Set the Kelvin value to the temperature of the light, then shoot and review your shot. Assess whether the white balance looks accurate. If not, adjust the Kelvin value by 500K, re-shoot, and assess the white balance again, repeating as often as necessary.

PLAYING WITH COLOUR

If you try out a range of Kelvin values in normal daylight, you can see how they make the camera add blue or red to compensate for the type of light it expects when using each value. These images were shot with values from 2,500 to 10,000K, instead of the 5,500K used for daylight.

2,500K

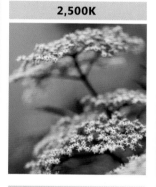

5,000K

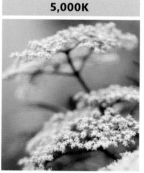

7,500K

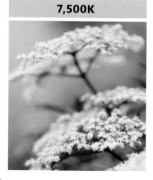

10,000K

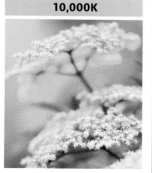

SETTING **WHITE BALANCE** FOR CREATIVE EFFECT

White balance can be set one of two ways. You can either select a preset or create a custom setting to neutralize the colour temperature of a light source, or you can set a technically incorrect white balance for artistic effect. The second option makes it possible for you to craft the mood of a photo, using colour to convey a particular emotion. This can be achieved by using one of your camera's White Balance presets. However, you have far greater control if you select a specific Kelvin value (see p.45). The more neutral your light source, the more latitude you will have for making creative adjustments.

1 SELECT PROGRAM
A camera's fully automatic and scene modes usually prevent you from setting direct Kelvin values. However, Program gives you this level of control, despite being an automatic mode.

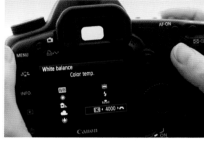

2 SET A KELVIN VALUE
First decide on the kind of emotion you want to convey in your final image. To help to achieve it, select a low Kelvin value to create a cool, blue effect or a high value to add warmth.

3 DIRECT YOUR SUBJECT
The emotion shown by your subject should be consistent with the Kelvin value you choose, so direct your subject to capture the mood. A mismatch will produce a visually ambiguous effect.

4 SHOOT AND REVIEW
Check the photo to see if the Kelvin value you've selected expresses the required emotion. If not, adjust the value up or down, and re-shoot. There's no right or wrong Kelvin value; it is very much a personal preference based on your own taste and creative goals.

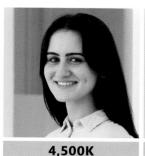

4,500K

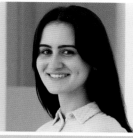

5,500K

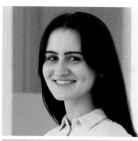

6,500K

5 **TRY OTHER KELVIN VALUES**
Take a few shots using a range of different Kelvin values.
This will give you the chance to decide which setting works best.

EMOTION AND COLOUR

Colour can have a strong emotional effect, both positive and negative. Warm colours, such as reds and yellows, help to evoke feelings such as happiness and friendliness. Less positively, red also conveys danger and aggression. Cooler colours, particularly blue, are associated with emotions such as sadness and depression but also with serenity, calmness, and trustworthiness.

THE RESULT

The soft, slightly peachy tones of the photo suit the cheerful expression of the subject. The White Balance setting ties in perfectly with the emotional warmth of the subject.

CAMERA **SETTINGS**

 1/125 SEC ISO 250 K

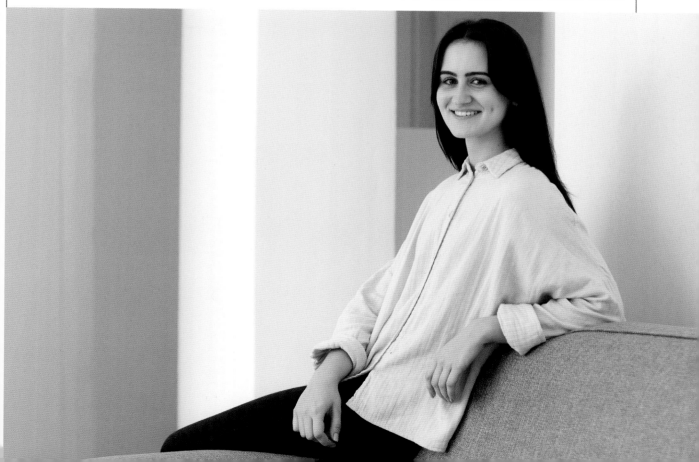

EXPOSURE

EXPOSURE

Exposure is the art of letting just the right amount of light reach the sensor in order to create a good photograph. Three variables need to be juggled for a successful exposure: shutter speed, aperture, and ISO (sensitivity to light). How you balance these three elements will have an effect on the visual quality of your images, and understanding this is a significant step on your path to creative photography.

Exposure basics

A "correct" exposure is one that creates a pleasing tonal range across an image. While personal preference and the artistic intention of the photographer determine what is "a pleasing tonal range", it's also true that when too little or too much light reaches the sensor, a photo will be under- or overexposed respectively. An underexposed photo has dark shadows that have little or no detail, and no highlights. An overexposed image has bright shadows, and the highlights will be burned-out to pure white.

CONTROLLING EXPOSURE

By using the shutter-speed settings, you will have the greatest scope for altering exposure; the range of available ISO and aperture adjustment is usually smaller in comparison. However, you may encounter situations in which it's impossible to set a particular shutter speed without over- or underexposing the shot. Use filtration to solve the first problem, and flash and other lighting for the second.

ALTERING THE APERTURE

UNDEREXPOSED		**CORRECT EXPOSURE**	OVEREXPOSED	
f/11	f/8	f/5.6	f/4	f/2.8

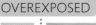
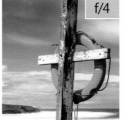
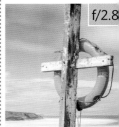

■ Muddy highlights ■ Dense shadows with little detail ■ Extensive depth of field	■ Underexposed highlights ■ Areas in deepest shadow lose detail ■ Excellent quality	■ Ideal exposure ■ Detail in both highlights and shadows ■ Good quality	■ Overexposed but with details in the shadows ■ Decreased depth of field	■ White highlights ■ Bright shadows ■ Shallow depth of field and reduced image quality

Exposure circle

The three main exposure variables have a reciprocal relationship – that is, if one is altered, at least one of the others must also be adjusted to maintain the same degree of exposure. For example, you have two choices if you want to increase the shutter speed but maintain the same level of exposure: you can either make the aperture larger, reducing the depth of field, or increase the ISO, adding image noise. Exposure often involves making compromises, particularly in low light, when you have fewer options. Once you understand the consequences of altering each setting, you will be able to judge what you have to change to achieve – or avoid – certain results before pressing the shutter button.

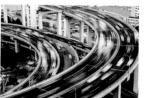

▲ Fast shutter speed ▲ Slow shutter speed

SHUTTER SPEED

The shutter is a mechanical curtain that controls for how long the camera's sensor is exposed to light. When you increase the shutter speed by one stop, you halve the length of time that the shutter is open; when you reduce the speed by one stop, the length of time doubles. The shutter speed you select also affects how much blur you will get in a photo of a moving subject. Each unit is a fraction of a second.

ISO

This setting determines how much the signal from the sensor is amplified to create an acceptable image based on the light available. You should use high ISO values (800 and above) in low light, but they will increase image noise, or graininess, in the photo. In bright daylight, you can set an ISO of 80 or 100. For the best image quality, use the lowest setting possible (known as the "base ISO").

APERTURE

The aperture is a variable opening in the lens that controls how much light passes through it to make an exposure. The amount of light that it lets through halves each time that the aperture is made smaller by one stop, and doubles each time that it's made larger by one stop. The higher the f-stop, the smaller the aperture. The aperture also controls depth of field, the zone of sharpness in the photo.

▲ High ISO ▲ Low ISO

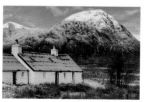

▲ Large aperture ▲ Small aperture

EXPOSURE MODES

Modern cameras include a wide range of exposure modes that are designed for specific purposes. Consumer cameras usually include a number of highly automated scene modes. These are ideal when you just want to pick up your camera and shoot, but they prevent you from making any decisions about exposure, which limits how creative you can be.

MODE		WHAT IT DOES
PROGRAM	P	Program **(P)** is an automatic exposure mode. The camera sets both the aperture and shutter speed, usually favouring shutter speed to minimize camera shake. However, you can still control exposure. You can alter the balance between aperture and shutter speed using Program Shift; you can also use functions such as Exposure Compensation to adjust the exposure. Program also gives you full control of ISO and image-adjustment options such as White Balance. Program is good for social and holiday photography, when you have less time to fine-tune exposure.
APERTURE PRIORITY	A Av	Aperture and Shutter Priority are semi-automatic exposure modes. In Aperture Priority **(A or Av)**, you select the required aperture, letting the camera set the appropriate shutter speed to make a "correct" exposure. As with Program and Shutter Priority, you have full control over all the other camera functions, including Exposure Compensation and ISO. You should select Aperture Priority when you want control over the depth of field. Small apertures increase the depth of field and are often used for landscapes; large apertures are ideal for portraits.
SHUTTER PRIORITY	S Tv	When you select Shutter Priority **(S or Tv)**, you set the required shutter speed, leaving the camera to choose the aperture. Use Shutter Priority when you want to control how movement is captured in the final image. The faster the shutter speed, the more movement is frozen, which is ideal for sports and wildlife. Fast shutter speeds also help to reduce the effects of camera shake when using telephoto lenses. Slower shutter speeds blur movement, but increase the signs of camera shake.
MANUAL	M	There is no automation when using the Manual **(M)** mode because you have to set both the shutter speed and aperture. Check the exposure before every photo. If the light levels change or you fit a filter, you must adjust the settings as necessary. If you do not do this, the exposure will be incorrect. Manual mode is ideal when you want to shoot a series of consistently exposed images, for techniques such as the Brenizer method (see pp.104–05), for example, as well as when using flash.
BULB	B	When setting the shutter speed in Manual mode and your exposure is longer than 30 seconds, Bulb **(B)** is a good option. When Bulb is selected, you can lock the shutter open by holding down the shutter button or using the shutter lock on a remote release. Bulb is useful when you need shutter speeds that are longer than 30 seconds, such as at night, or if using very dense neutral-density (ND) filters. Movement, such as stars moving across the sky, will leave noticeable trails. To use Bulb successfully, you need a stopwatch, or a camera with a counter, and a tripod.

AUTOMATED MODES

The range of automated modes varies between cameras, and professional-specification dSLRs and CSCs generally don't feature them at all. The most common automated mode is Fully Automatic (Auto), in which all the shooting functions except the drive mode (see p.89) are controlled by the camera. Scene modes for specific situations, such as for portraits, offer more control, but functions such as exposure control and white balance are set by the camera and cannot be adjusted.

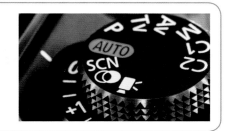

TYPICAL SUBJECTS	KEY FEATURES

- Automated exposure
- You can apply exposure adjustments
- You can change the ISO
- All other functions available

- Semi-automatic exposure
- You select the required aperture
- Camera sets the shutter speed
- All other functions available

 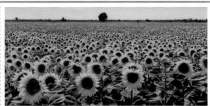

- Semi-automatic exposure
- You select the required shutter speed
- Camera sets the aperture
- All other functions available

- No automation
- You set both the aperture and shutter speed
- All other functions available

 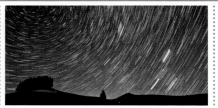

- No automation
- You set the aperture
- You lock the shutter open using the shutter button
- All other functions available

FINE-TUNING **EXPOSURE**

Photographing groups of people, whether on the street or at a social event, can be challenging. You will be moving about and will need to shoot fast. It is a good idea to check out the location or venue first, to identify the best places to shoot from, find out whether there may be any issues with the lighting or exposure, and to decide which White Balance (WB)

setting to use. Program is the best mode to begin with, as it provides all the benefits of automated exposure but allows you to alter the shutter speed and aperture if you want to. It also usually maintains a shutter speed that is fast enough to avoid camera shake. Make sure to shoot in Raw, as you will be able to correct exposure in post-production more easily than in JPEG.

1 PLAN YOUR SHOTS
Social events can be chaotic, but you can plan shots to some extent by watching people's behaviour. Look for areas where they tend to gather, such as around food and drink areas.

2 SELECT PROGRAM AND THE ISO
The light levels are bound to change as you move around. Select Program mode and set your camera to Auto ISO, so that the ISO automatically changes depending on the ambient light levels.

3 SET THE WHITE BALANCE
The best preset depends on where you are (see pp.44-45). Indoors, go with either Tungsten or Fluorescent, or Auto WB if under mixed lighting. If you are outdoors, it depends on the weather.

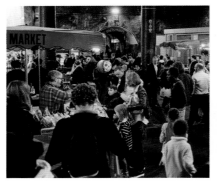

4 CHECK THE EXPOSURE
Review your images as you shoot to check the exposure. If they are too dark or too bright, use Exposure Compensation to modify the exposure. Raise it if you want to make your photos brighter, and lower it to make them darker.

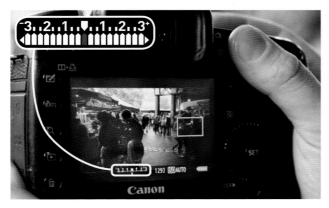

5 USE PROGRAM SHIFT
If you want to use a wider aperture, to blur a background for example, you can use Program Shift to temporarily override the shutter speed and aperture settings selected by Program. You usually do this with the camera's control wheel.

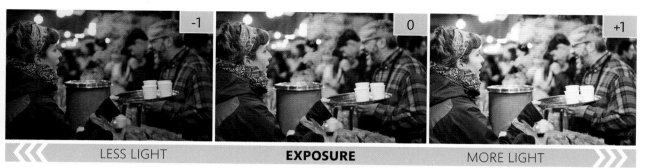

LESS LIGHT | EXPOSURE | MORE LIGHT

6 USE AUTOMATIC EXPOSURE BRACKETING (AEB)

If you've used Exposure Compensation and are still not sure which light levels work best, you can try bracketing: shooting several shots at the same time, each with a different exposure. Activate AEB to set the number of frames and an exposure gap, then set your camera's Continuous Drive mode (see p.89) and hold down the shutter-release button to take your bracketed sequence. For this image, we set AEB to make three exposures at 1-stop increments, giving us three options to choose from.

THE RESULT

Here, the exposure chosen was 1 stop brighter than the suggested reading as it captured the vibrancy of the scene. Program Shift was used to blur the background and focus attention on the woman serving drinks.

CAMERA **SETTINGS**

P | ⊙ | f/2.8 | 1/100 SEC | ISO 640 | AWB

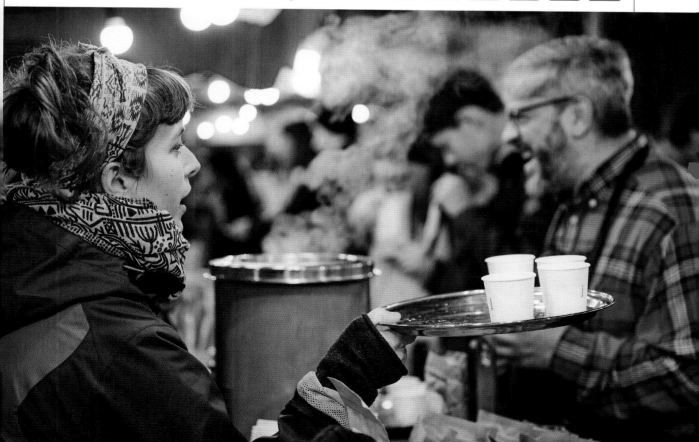

ACHIEVING **DEPTH OF FIELD** IN **LANDSCAPES**

A common aim of landscape photography is to capture a natural scene in such a clear and realistic way that the viewer feels as if they could step right into the shot. This is achieved by maximizing the depth of field, so that the image is completely sharp, from the foreground to the background. To make this possible, landscape photos are generally shot using a small aperture, but avoid minimum aperture due to the effects of diffraction (see p.91). Landscape photographers often shoot at the beginning or the end of the day, when the sun is close to the horizon and the light is warm and soft.

1 **USE A TRIPOD**
A small aperture means that the shutter speed will be quite slow. Using a tripod helps you to avoid camera shake and also gives you the chance to plan how to compose your shot.

2 **SELECT APERTURE PRIORITY**
Select a relatively small aperture such as f/11 to increase the photo's depth of field. Hyperfocal distance focusing (see p.90) is a precise way to determine the best aperture setting.

3 **CHECK THE SHUTTER SPEED**
It important to check shutter speed when shooting landscapes, particularly if there is anything moving in the scene. Increase the ISO to freeze movement, or fit an ND filter to blur it (see p.122).

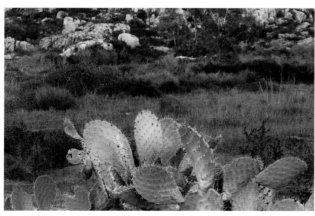

4 **SELECT YOUR FOCUS POINT**
A rough-and-ready rule when shooting landscapes is to focus one-third of the way into the scene. Either focus manually, use Single Point selection and move the active AF point to the required place (see p.83), or stack your shots later (see pp.116–17).

5 **USE THE DEPTH OF FIELD PREVIEW BUTTON**
The aperture usually stays open at maximum to keep the viewfinder bright, and only closes when the exposure is made. Holding the depth of field button down closes the aperture to the selected value and lets you see the depth of field.

6 SHOOT AND REVIEW

Take the shot, then zoom into the photo on the LCD screen to check that it is sharp from the foreground right through to the background. The nearest and furthest points in the scene are the areas most likely to be soft. If the image is not sharp, shoot it again, using a smaller aperture to increase the depth of field.

THE GOLDEN HOUR

Just after sunrise and just before sunset, during a period known as the "golden hour", sunlight is at its warmest in colour. Despite its name, the length of this "hour" varies depending on the season and latitude position. During summer, and in the tropics, the golden hour is relatively short. In winter, and at more temperate latitudes, the light from the sun will be warmer for longer at either end of the day.

THE RESULT

The photo is pin-sharp from the foreground to the background. The cactus – the dominant feature closest to the camera – is crystal clear, as are the sunlit rocks in the middle distance and background.

CAMERA **SETTINGS**

A | 1/250 SEC | ISO 400 | AWB

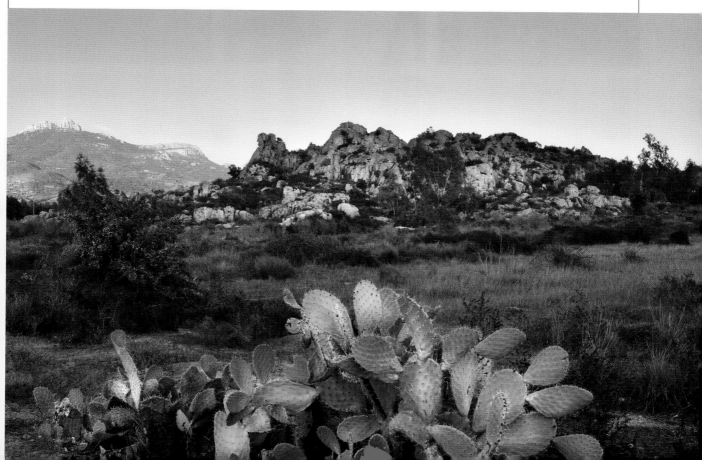

SIMPLIFYING **COMPOSITION** WITH **SELECTIVE FOCUS**

The Aperture Priority mode is useful for more than simply ensuring front-to-back sharpness (depth of field) in a landscape shot. It can also be used for a technique known as selective focus, which requires a minimal amount of depth of field. When people look at a photo, their gaze naturally gravitates to the sharpest parts, and they tend to ignore areas that are out of focus. Using selective focus is an effective way to direct the viewer's eye to the most important part of the image. The challenge for the photographer is deciding what should be sharp and what should be soft and out of focus.

1 FIT A LENS
The longer the focal length of a lens, the easier it is to minimize depth of field. Long-focal-length primes are ideal because they tend to have larger maximum apertures than zoom lenses.

2 SELECT APERTURE PRIORITY
The selective-focus technique relies on restricting depth of field to a minimum. Aperture Priority mode gives you full control over both the aperture and depth of field.

3 SET THE APERTURE
Select a large aperture – either maximum or close to it. Maximum aperture will limit depth of field the most, but lenses do not produce their best results at this setting.

PORTRAITS

Eyes, whether they are of a human or an animal, have a greater "visual weight" – that is, they attract more attention – than any other facial feature. When people see a face, they tend to look at the eyes first, even when they're closed. The same thing applies to portraits. You can emphasize the impact of eyes by using selective focus for portraits. It is important, however, to make sure that the eyes are pin-sharp. Eyes that are even slightly out of focus lose impact and create an unsettling effect.

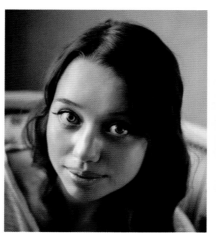

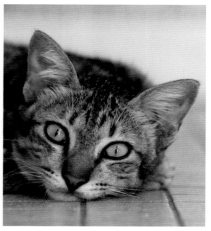

4 CHOOSE A FOCUS POINT

Select Single point AF. Use the camera's control pad to move the AF point to the area of the scene that you want to focus on.

5 FOCUS PRECISELY

Because depth of field is limited, you need to focus precisely on the spot you want to be sharpest (see p.82). Press the button fully to take the shot.

6 SHOOT AND REVIEW

Zoom into the photo in playback mode to double check that your focusing was accurate. If it was not, re-shoot and check the photo again. If the focusing is consistently inaccurate, you may need to calibrate your lens (see p.81).

THE RESULT

Using selective focus here has minimized the distracting clutter of the woodworker's bench, helping to draw the eye towards the graceful curves of the violin's scroll.

CAMERA **SETTINGS**

 1/160 SEC ISO 200 AWB

ACTION **SHOTS**

Sporting activities are a great opportunity to shoot moving subjects using different shutter settings. It can be very tempting just to shoot continuously, in the hope that one or two photos will be successful, but that will leave you with masses of similar-looking photos to sort out later, and the camera's buffer may become full at a critical moment. It is worth taking the time to watch the action for a while first so that you can anticipate what will happen, plan your shots, and shoot more precisely and sparingly. Shutter Priority mode is ideal for shooting sports as it gives you the control that you need over shutter speed.

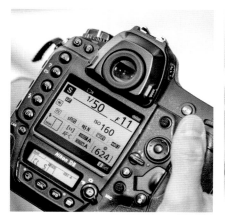

1 FIND A VIEWPOINT
Try to get as close to your subject as is safely possible. This will reduce the risk of spectators getting in the way as you shoot. Use a telephoto zoom lens to home in on the action.

2 SELECT SHUTTER PRIORITY
Set your camera to Shutter Priority (on this particular camera, you press the Mode button) so that you have full control over the shutter speed. Set Auto ISO to maintain the shutter speed that you want.

3 SET THE SHUTTER SPEED
There are two approaches to shooting sports: you select a fast shutter speed, such as 1/1000, to freeze the action, or use a slower speed and pan with the subject to blur the background.

4 CHECK THE APERTURE
Even with Auto ISO selected, the required aperture may be outside the range that is available on your lens, so adjust the shutter speed if necessary.

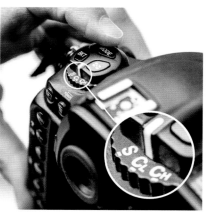

5 ACTIVATE CONTINUOUS DRIVE
Select Continuous drive, but be aware of the buffer limit of your camera. Shooting JPEG will allow you to shoot more photos than Raw.

6 SHOOT AND REVIEW
Watch your subject to anticipate the best time to shoot, then press the shutter a split second in advance. Check your images quickly, then carry on.

MOTION BLUR

Panning while shooting with a slow shutter speed adds motion blur, and creates a sense of movement and speed. Move the camera in an arc to follow your subject as it crosses in front of you, and fire the shutter at the mid-point of the arc. Try experimenting with shutter speeds ranging from 1/8 to 1/125 second.

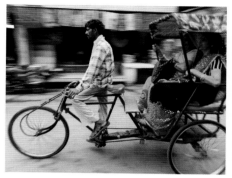

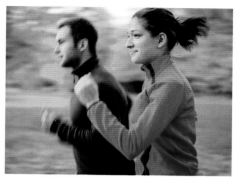

THE RESULT

Panning with the subject, a slow shutter speed, and precise focusing have ensured that the skater's face is pin-sharp. Careful planning has also eliminated any distracting details that might have cluttered the composition.

Tv | 1/50 SEC | ISO 160 | AWB

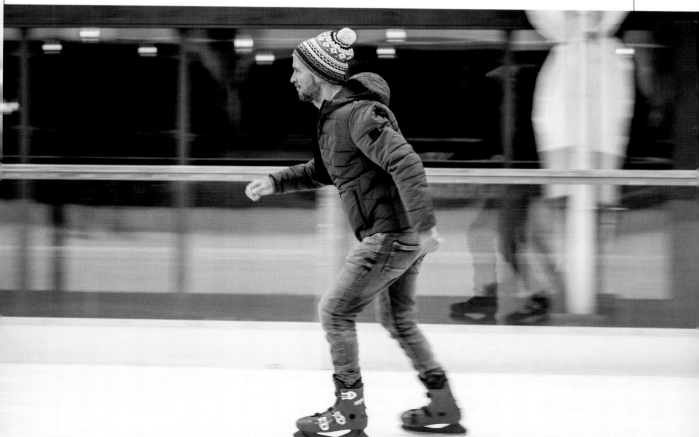

INTENTIONAL
CAMERA MOVEMENT

If you deliberately move your camera during a long exposure it blurs everything in the image, transforming your subject into semi-abstract shapes and colours. This technique is called intentional camera movement (ICM), and is easy and fun to do. It works very well with brightly coloured subjects, especially points of light, but is also good for landscapes and seascapes. Panning the camera horizontally or vertically stretches shapes out and creates a streaked effect, but you can move the camera in other ways too. There are no rules, so experiment with the shutter speeds, take a lot of photos, and see what happens.

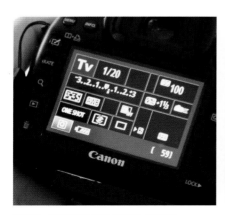

1 **CHOOSE YOUR LENS**
ICM works best with lenses that are 50mm or greater. Long-focal-length lenses will help to isolate particular areas of interest in the scene.

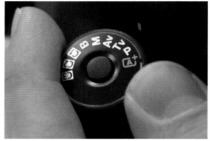

2 **SELECT SHUTTER PRIORITY**
Shutter Priority gives you control over the low shutter speed that you need for ICM. Select Tv (Shutter Priority) if you have a Canon camera. Program, with Program Shift applied, will also work.

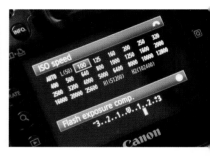

3 **SET THE ISO**
Select the lowest ISO on your camera, so that any motion is captured as blur. Avoid using Auto ISO, as this will alter the ISO setting and maintain a relatively fast shutter speed.

4 **SET THE SHUTTER SPEED**
Select 1/20 as your initial shutter speed, as it is a good starting point for experimentation. Different shutter speeds will produce different effects.

5 **FIT AN ND FILTER**
The ambient lighting of the scene will determine whether you can shoot at 1/20. If your photos are overexposed, fit a standard ND filter (see p.122).

6 **SHOOT AND REVIEW**
Look through your photos as you shoot. Try different shutter speeds to see how this changes the look of your shots and add more filters if necessary.

CREATIVE EFFECTS

You can create painterly washes of colour by moving the camera, as ICM reveals vibrant colours even in the most natural subjects, such as grasses. Try rotating the camera 360° to produce a more abstract effect. You could also zoom through the entire focal range of your lens as you shoot, to see what effects that produces.

LONG EXPOSURE NOISE

Photos that have been shot with a shutter speed of one second or longer are prone to an effect known as long exposure noise. This looks like multi-coloured pixels randomly scattered across the photo: the longer the exposure, the greater the number of these pixels. To combat this, cameras have a noise reduction option, but it doubles the exposure time.

THE RESULT

The final image of a train leaving a station is semi-abstract but still recognizable. The camera was panned fast horizontally, creating dynamic streaks of colour and light.

CAMERA **SETTINGS**

| Tv | (◉) | f/3.5 | 1/33 SEC | ISO 100 | AWB |

CREATING A **STITCHED-TOGETHER PANORAMIC IMAGE**

With many cameras, you can create panoramic photos by slowly sweeping or panning the camera from side-to-side or up and down. These photos are easy to shoot, although the downside is that the final image can only be saved as a JPEG. A more time-consuming method, but one that provides a more impressive result, is to shoot a sequence of overlapping photos that you stitch together later (see pp.170–71). This enables you to control the image's resolution and shape, and also means that you can shoot in Raw, giving you more scope to alter aspects such as white balance to perfect the shot later. Set your camera to Manual mode so that the exposure stays constant every time you shoot.

PANORAMIC KIT

You can shoot panoramic sequences with standard tripod heads, but having additional equipment, such as a panning base, will make it easier. A panning base fits beneath your camera and makes it possible to rotate it smoothly on the tripod.

1 CHOOSE YOUR LENS
A panoramic sequence can be shot with any lens, but lenses that are 50mm or longer will reduce perspective distortion.

2 SET THE EXPOSURE
Select Manual, an aperture that will give you a suitable depth of field, and set an appropriate shutter speed.

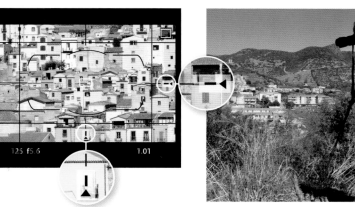

3 USE YOUR SPIRIT LEVEL

Use a hotshoe-mounted spirit or built-in electronic level (if available) to make sure that your camera and the tripod are level. Some cameras have a viewfinder level accessible via a customized button, usually set on the camera's Settings menu.

4 SHOOT THE SEQUENCE

Using a tripod, start from one side of the scene you are photographing and shoot the panoramic sequence, overlapping each successive photo in turn horizontally by about a third.

5 REVIEW YOUR IMAGES

Pay close attention to how sharp each image is and whether there is enough overlap between them. If one photo is not up to the same standard as the others, it is best to re-shoot the entire sequence.

THE RESULT

In the final image, the photos merge seamlessly into a striking panorama of geometric shapes and bold colours. Once it had been stitched-together, the image was tightly cropped, to remove potentially distracting details such as the sky and thus create greater impact.

CAMERA SETTINGS

M | 1/7.1 | 1/800 SEC | ISO 200 | AWB

SHOOTING **STAR TRAILS**

The Earth's rotation makes stars rise and set in the night sky just like the Sun and Moon. By using a long exposure, you can record this movement so that the continuous arcs made by the moving stars are visible in the final photo. In the Northern Hemisphere, stars appear to rotate around Polaris, the North Star, found in the constellation Ursa Minor. The further north you are, the higher Polaris will appear in the sky. There is no similar star in the Southern Hemisphere; the nearest equivalent is Sigma Octantis, which is much fainter than Polaris. The further south you are, the higher Sigma Octantis will appear.

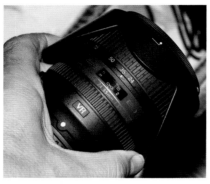

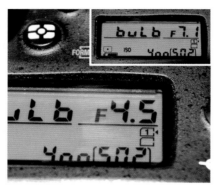

1 **CHOOSE YOUR LENS**
The focal length of the lens will affect the size of the star trail arc – the wider the lens, the broader the arc will be. A prime lens, with a large maximum aperture, is more useful than a zoom lens.

2 **SELECT BULB MODE**
Set the aperture and the ISO. By using a large aperture and a moderately high ISO setting you will record faint stars as well as those more visible to the eye. Set your camera to Bulb mode.

3 **FOCUS ON INFINITY (∞)**
Using a large aperture means that the depth of field will be limited, so it is important to focus precisely on ∞. Switch to MF to do this, as there is not enough light at night for AF to work properly.

INFINITY FOCUS

On a lens distance scale, infinity (∞) is the furthest point from the camera at which the lens can focus. Older or manual lenses have a hard stop at infinity, preventing the focus ring turning further. Modern lenses have a soft stop, so you can focus slightly beyond infinity. This aids the autofocus system and helps to counter the effects of temperature variations. With Canon lenses, use the vertical stroke of the L on the distance scale; Nikon lenses should be focused in the middle of the ∞ symbol. For lenses without a distance scale, you will need to experiment.

4 **USE A REMOTE RELEASE**
In Bulb mode, you need to use a remote release that can hold the shutter open. You can either use a mechanical switch or an app connected via Wi-Fi.

5 **EXPOSE FOR 10 MINUTES**
Experiment with exposure times, starting with 10 minutes. If you are using long exposure noise reduction (see p.63), the total exposure will take 20 minutes.

SHOOTING THE MOON

The distance that the Moon moves across the sky in around two minutes is equal to its diameter. This may not sound fast, but it does mean that you need to use a fast shutter speed to avoid blur, particularly when using telephoto lenses. There is no one correct shutter speed to shoot the Moon as its brightness changes depending on its current phase; a Full Moon is far brighter than when it is half full (in its Quarter-Moon phase) for instance. Using 400 ISO, experiment with exposures of 1/500 at f/8 for a Full Moon, 1/250 at f/8 for a Quarter Moon, and 1/60 at f/8 when the Moon is a crescent. Atmospheric conditions can affect exposure so it pays to bracket, using either a higher ISO or a larger aperture to avoid reducing the shutter speed.

THE RESULT

Because the shot was taken pointing roughly north, the stars appear to be circling around Polaris, near the top right corner of the image. A reasonably high ISO has produced a photo full of stars.

CAMERA **SETTINGS**

B | | f/5 | 10 MIN | ISO 400 | AWB

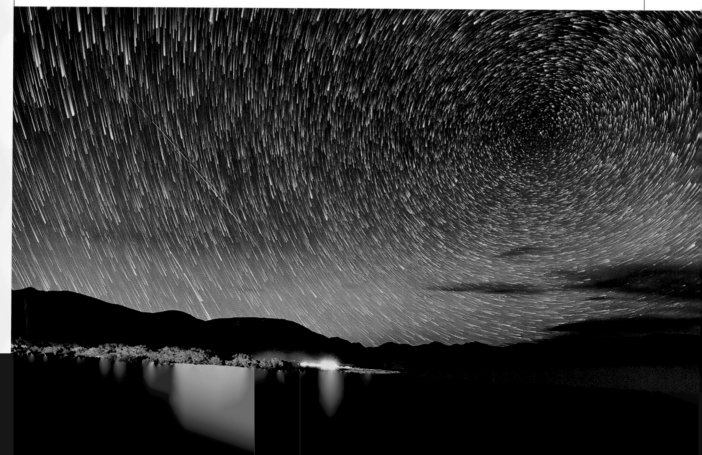

EXPOSURE **METERING**

To know what aperture, shutter, and ISO values to set, you need to use an exposure meter, which measures the brightness levels of light. After this simple step, you interpret the reading in order to produce accurate, consistent exposures. First, though, it is important to know how an exposure meter works and what its limitations are, since this will give you full control over exposure, and you will be better informed about how to fix any problems that might arise.

AVERAGE REFLECTIVITY

The term "average reflectivity" is used for a scene that reflects 18% of the light that falls on it. Averagely reflective colours are known as mid-tones and include mid-greys and other colours of a similar level of brightness. **18% GREY**

Incident versus reflective metering

There are two ways to meter a scene. You can measure the amount of light falling on it or the amount of light that is reflected from it. A handheld light meter takes an incident reading, and camera meters take a reflective reading. Incident metering is generally more accurate, because reflected metering assumes that a scene has average reflectivity. Darker or lighter scenes will be over- or underexposed respectively.

▲ Handheld meter readings are taken close to the subject. This makes them less convenient than a camera meter, if your subject is far away.

▲ The meter built into a camera takes a reflective reading. It is a useful tool, but it can be fooled by subjects that are not 18% reflective.

GREY CARD

A grey card (or 18% grey card) is calibrated to reflect 18% of the light that falls on it, making it averagely reflective (see top right). Use it to help choose the correct camera settings for your shot, especially if your scene has a higher- or lower-than-average reflectivity that could cause an error in exposure. Take a meter reading from the card, and use this to determine your exposure, rather than a reading from the scene you are shooting.

1 **POSITION THE GREY CARD**
Set the exposure mode to Manual and the metering mode to Spot. Place the 18% grey card close to your subject, and point your camera at it.

2 **TAKE THE READING**
Take a meter reading, ensuring that the grey card fills the spot-metering area. Set the required shutter speed and aperture, then remove the card.

METERING MODES

MULTI-AREA METERING

Also known as evaluative, multi-segment or matrix metering, this mode is the default on all modern cameras. It divides the entire frame into cells, or zones, each of which is metered independently. The camera then compares the distribution of light and shade across the scene against an internal database of common situations and deduces what type of scene you're shooting. This information, as well as factors such as where the camera is focused, is then used to calculate the final exposure. Multi-area metering is generally very accurate for most types of photography.

◀ Multi-area metering gives entire control to the camera, allowing it to make the exposure based on the light across the whole scene.

SPOT METERING

In this mode, the camera will meter from one specific zone only, usually the zone at the middle of the frame, which is shown in the viewfinder or on the LCD as a small central circle or square. However, some cameras link the spot-metering zone to the active AF point instead. This mode lets you take an accurate reading from your subject without other areas of the scene affecting the exposure. This is useful when the rest of the scene is predominantly dark or light; as this would cause inaccurate exposure if using multi-area or centre-weighted metering.

◀ In spot metering, you should always take a reading from a mid-toned section of your scene.

CENTRE-WEIGHTED METERING

An older mode that has now largely been replaced by multi-area metering, this option is still available and can be more accurate and consistent than multi-area. It bases the exposure reading on a fuzzy region at the centre of the frame and places less emphasis on the edges. This bias makes centre-weighted metering ideal for portraits, especially when the subject is in the centre of the shot. Centre-weighted metering is very straightforward to use.

◀ The light background of this portrait was ignored by centre-weighted metering, and the exposure was taken from the subject's face.

SHOOTING AT A CONCERT

A concert is a great place to shoot striking photos, if the venue permits photography. The lighting is often dramatic and colourful, and the performers are spotlit as they play. Exposure using multi-area metering can, however, be frustratingly hit-and-miss, because the high level of contrast in the lighting can fool the metering into making incorrect exposures. Spot metering directly on a performer ensures that he or she is exposed correctly, while the rest of the scene is ignored. Spot metering works best when you use it in conjunction with your camera's exposure lock function.

1 CHOOSE YOUR LENS
Your lens choice will be determined by how close you are to the stage. Longer focal-length lenses are generally more useful than wide-angle lenses, unless you are on, or directly below, the stage.

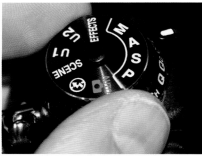

2 SELECT APERTURE PRIORITY
As camera shake is a risk when shooting indoors with a long lens, select a large aperture to maximize shutter speed. This will produce a limited depth of field, so accurate focusing is crucial.

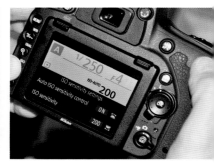

3 SET AUTO ISO
Light levels can vary dramatically during a concert, so select Auto ISO to maintain a high shutter speed. This will also help you to freeze the movement of the performers.

4 SELECT SPOT METERING
Switch the metering to Spot (or Partial, if spot metering is not available). Meter from a mid-tone (see p.72) on your subject, then lock the exposure and reframe the shot if necessary.

5 SHOOT AND REVIEW
Check your images quickly as you shoot, to see if there are any problems with exposure. If there are, use Exposure Compensation (see p.55) to fine-tune it.

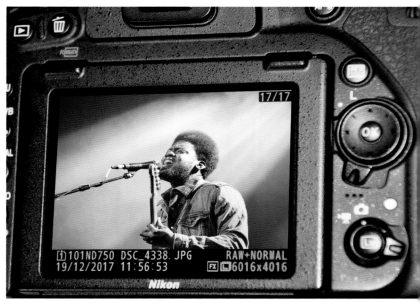

EXPOSURE LOCK

Pressing a camera's exposure lock button holds the current exposure settings temporarily. This means that once the exposure is locked, you can reframe a shot and the exposure will remain the same (Holding the shutter button half-way down locks exposure, but it also locks focus, which you may not want.) Exposure lock is usually cancelled once you have taken a shot, or if the camera powers down. The symbol for the exposure lock button on most cameras is a star. You can often set it to toggle on and off, or so that you hold it down to lock exposure.

THE RESULT

Despite the challenging lighting conditions, the musician is perfectly exposed. Exposure lock made it possible to frame and shoot several different photos when the light levels remained constant.

CAMERA **SETTINGS**

A | • | f/4 | 1/250 SEC | ISO 200 | AWB

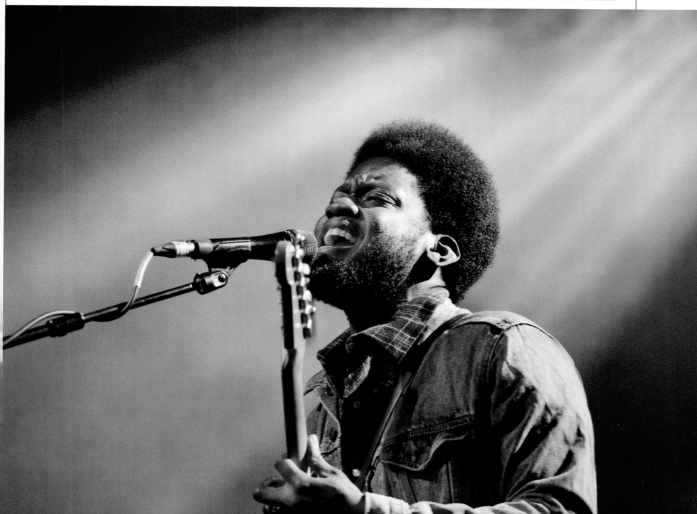

CREATIVE EXPOSURE

To achieve the best results, a photographer has to be able to visualize what the finished photo will look like. To do this, you need to have a clear understanding of precisely how a camera records the tonal range of a scene. Cameras differ in the amount of detail that they capture in the shadows and highlights. A camera that can retain the maximum detail in both is said to have a high dynamic range, while a low-dynamic-range camera will struggle to show detail in anything but the flattest low-contrast light.

TONAL RANGE

A photograph is essentially a patchwork of dots (pixels) of different levels of brightness that, when seen from a distance, creates a recognizable image. The darkest and lightest pixels define the start and end points of the image's tonal range. The widest possible tonal range would stretch from the black of the deepest shadows to the white in the brightest highlights, but this is rarely seen in practice. How a photograph is exposed determines its tonal range, but you can also influence it with careful lighting, as well as by applying in-camera or post-production techniques.

▲ Tones range from shadows to mid-tones and then highlights, all determined by reflectivity. Black reflects no light at all, mid-tones are around 18% reflective, and pure white is 100% reflective.

LOW-KEY EXPOSURE	HIGH-KEY EXPOSURE

▲ A photo with mainly dark tones is said to be low-key. You can underexpose an image to make it low-key, but it is better to use just one light source in combination with a snoot or grid (see p.27) to direct where the light falls.

▲ A high-key photo is dominated by light tones, with very few dark tones, or none at all. Overexposure will create a high-key image, but a true high-key exposure is one in which the brightness of the shadows has been increased by using additional lighting.

HIGH DYNAMIC RANGE (HDR)

When shooting in high-contrast situations, it is not always possible to make an exposure that records enough detail in both the shadows and the highlights. High Dynamic Range (HDR) imaging overcomes this limitation. To create an HDR image, you shoot three images or more, varying the exposure as you do so. At least one image should be exposed to capture the shadows, one to record the mid-tones, and one to record detail in the highlights. You then merge these images either in-camera or in post-production to make a picture with the widest possible tonal range. The result can be naturalistic or heavily processed, depending on the effect that you wish to create in the final photograph.

SHADOWS

MID-TONES

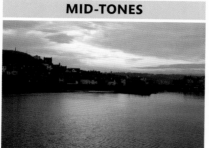

HIGHLIGHTS

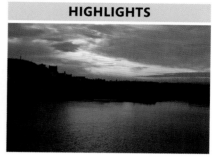

FINAL MERGED IMAGE

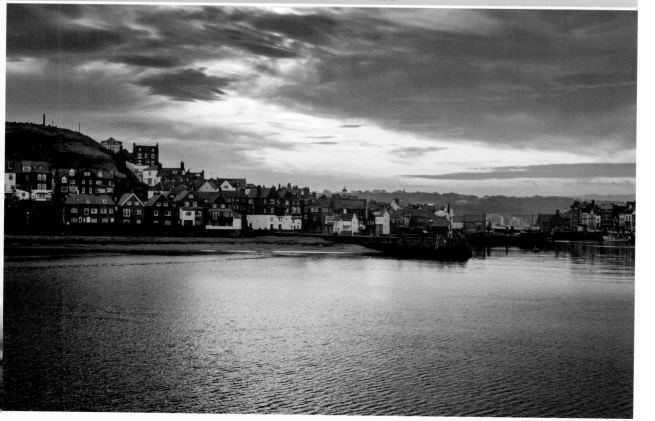

BLENDING MULTIPLE PHOTOS

A multiple exposure photo is created by combining two or more photos together in-camera. When you are shooting on film, this is achieved by not advancing the film after a shot, and then exposing for a second time on the same frame. On digital cameras, multiple exposures are created by blending photos electronically after you have shot them. A camera that can shoot multiple exposure images will have a number of options that let you vary how the final image is created, including the number of photos to be combined. Photos can also be merged together in post-production (see right).

1 CHOOSE YOUR SUBJECTS
Select subjects that are visually different. A high-contrast scene (such as trees) blended with a lower-contrast main subject (such as a person) works well.

2 SELECT MULTIPLE EXPOSURE
Not many cameras can blend photos. However, those that do should have a menu that gives you the option to shoot in a multiple exposure mode.

3 SELECT A BLEND MODE
Depending on the type of camera you have, the range of blend modes can vary. Here, we chose the Additive mode. This lays one photo over another.

4 SELECT THE NUMBER OF SHOTS
Choose the number of shots that you want to overlay and set the exposure for each shot. To do this, meter the scene and multiply the exposure by the number of shots – if the shutter speed is 1/100 and you select two shots, the shutter speed should be 1/200 for each shot. (This only applies when in Additive mode).

5 SHOOT AND REFRAME
Shoot the first photo and note where the shadows are in the scene. Compose the next shots making sure that the subjects fall within these darker areas, so that they will show through them more than the highlighted areas.

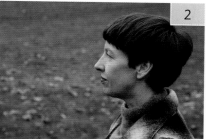

POST-PRODUCTION

You can also use editing software to blend photos if it supports the use of layers (see p.172). Open your photos, then copy the contents of one and paste it into a new layer in another. You can either adjust the opacity of this layer or change its blend mode. Blend modes alter how pixels in one layer affect the colour or brightness of the pixels in any layers below. Perfecting this technique requires careful practice.

6 ASSESS YOUR COMPOSITION
Check your final shots to ensure that they will blend together well. Re-shoot them if a vital part of your main subject (shot number 2 in this instance) is going to be obscured by details in the first image. If your camera has the option, experiment with other blend modes it may offer.

THE RESULT

The soft, feathery outlines of the trees in the first exposure appear to follow the woman's hairline and add texture to her face, creating an interesting and slightly surreal final image.

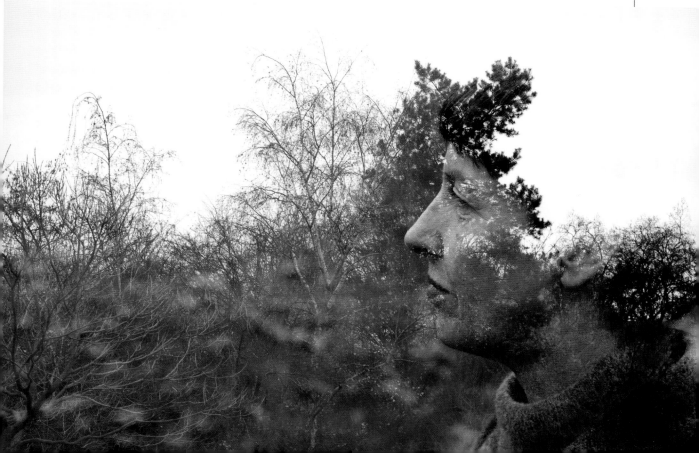

4

FOCUSING

FOCUSING

Despite the technical ingenuity of modern cameras and lenses, it is still frustratingly easy to shoot unsharp photos. Accurate focusing is the key to overcoming this problem, and it helps to understand both the strengths and weaknesses of a camera's autofocus (AF) system so that you know which options are best for any situation. It also helps you to decide when you would get more accurate and consistent results by switching to manual focus (MF).

AUTOFOCUS SYSTEMS

There are two different AF systems used in cameras. DSLRs use phase detection through the viewfinder, while compacts, bridges, and CSCs use contrast detection, which is also employed in dSLR Live View. The AF systems drive motors inside the lens (or via the camera body in the case of older AF lenses) that move the lens optics to the right position so that the image is in focus. Both systems have their advantages and disadvantages in terms of speed and accuracy.

PHASE DETECTION SYSTEM

The reflex mirror in a dSLR is partially translucent to allow light from the lens to be directed to a secondary mirror and, from there, down to a phase-detection AF module. Phase-detection AF is extremely fast and largely accurate, but every component in the system – the lens, mirrors, and the AF module – must be precisely aligned. Any manufacturing fault or misalignment due to damage will produce focusing errors, which some dSLRs can compensate for with lens calibration (see p.81).

KEY TO ANNOTATIONS

1. Viewfinder eyepiece
2. Focusing screen
3. Digital sensor and shutter
4. Reflex mirror
5. Secondary mirror
6. AF module
7. Subject
8. Light rays
9. Lens optics
10. Pentaprism

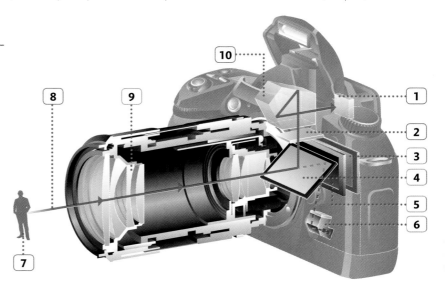

CONTRAST DETECTION SYSTEM

Contrast-detection AF is far simpler and more robust than phase-detection AF: there are no components other than the lens optics and digital sensor. It's the digital sensor that calculates focus distance, often along with the camera's image processor. Despite its simplicity, contrast detection is very accurate, but it's also relatively slow, although the technology is improving with each new generation of camera. Both accuracy and speed can also be compromised in low light.

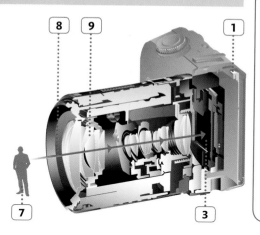

ON-SENSOR PHASE DETECTION

On-sensor phase detection helps to improve CSC AF speeds, using paired photodetectors on the camera's image sensor. One of each pair is masked so that it only receives light from the right half of the lens; the other, so it receives light from the left half. This mimics conventional phase detection and enables the camera to focus with a similar speed. Phase detection is usually only applied across a small area of the image.

LENS FOCUSING

There are two basic types of AF motor used in camera lenses. Most older or less expensive lenses use an arc-form drive motor, which can be slow and noisy and doesn't permit full-time manual focus; to focus the lens manually, you have to switch to MF. Ultrasonic motors, found in newer lenses, are far quieter and faster, which makes them more suitable for video work, too. You can also manually focus an ultrasonic-motor lens at any time without first switching it to MF.

PHASE DETECTION FOCUSING

Inside the phase-detection module are several paired AF sensors, each of which is linked to a specific AF point in the viewfinder. The images received by the paired AF sensors are compared to see if they match each other. If they don't match, it means the image is out of focus, so the AF module adjusts the lens optics until the images match or are in phase.

The lens optics rotate left or right to adjust the focus point

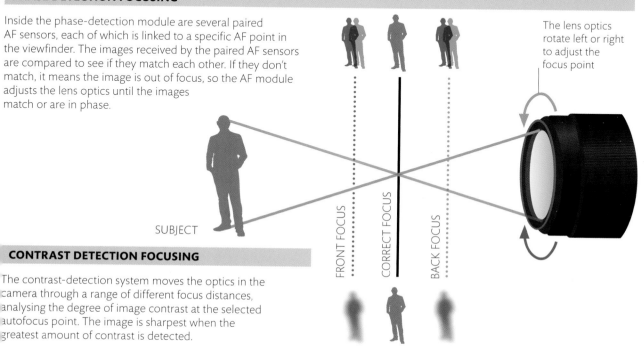

SUBJECT

FRONT FOCUS

CORRECT FOCUS

BACK FOCUS

CONTRAST DETECTION FOCUSING

The contrast-detection system moves the optics in the camera through a range of different focus distances, analysing the degree of image contrast at the selected autofocus point. The image is sharpest when the greatest amount of contrast is detected.

AUTOFOCUS MODES

Modern autofocus (AF) systems are a miraculous blend of sophistication and convenience. Unfortunately, this doesn't mean that you just point your camera and it will focus exactly where necessary. To get the optimal performance from the AF system, you need to choose the best focusing mode for your subject. If you select the wrong mode, you may still be lucky and achieve sharp images, but choosing the right mode will help you to improve your chances of success every time.

SINGLE-SHOT

Single-shot AF (also known as One-shot and AF-S) is the default mode on most cameras. Press halfway down on the shutter button, and the camera will focus, using one or more of the AF points. Once correct focus has been acquired, it will lock and remain locked at the same distance until you either press or release the shutter button. Single-shot is ideal for static subjects or subjects that remain a constant distance from the camera. It's also the mode to select if you want to focus and recompose, using the focus-lock technique (see right).

BEST FOR

- Still-life, food, and product photography in a studio
- Landscape and static macro photography
- Posed portraits of older children and adults

▲ Single-shot AF is perfect for subjects that are static by nature, such as still lifes, particularly when you are shooting in controlled studio conditions.

CONTINUOUS

You should use Continuous AF (also known as AI-Servo and AF-C) when shooting subjects moving towards or away from the camera. Position the selected AF point onto the subject, and half-press the shutter button to activate the AF system. The focus will continually adjust to keep the subject sharp but will not lock focus until the shutter button is fully pressed. If you combine this mode with Zone or Automatic AF Point selection (see p.83), it will enable the camera to automatically select the required AF point to keep a sideways-moving subject in focus.

BEST FOR

- Wildlife and moving macro subjects
- Sports and action photography
- Younger children, who are difficult to pose or keep still

▲ Continuous AF is ideal for subjects that move predictably, such as motor vehicles or runners, but pre-focusing (see pp.88–89) is often more reliable for fast or erratic subjects.

CALIBRATING AF

DSLR phase-detection AF is fast, but it can be imprecise – the lens sometimes focuses slightly behind the subject or slightly in front, known respectively as back and front focusing. Many dSLRs let you calibrate individual lenses to compensate for this shortcoming, and the details are saved to the camera so that they may be applied whenever that lens is fitted. You can calibrate accurately by using a commercial distance scale that enables you to take precise measurements and correct such errors.

AUTO

Auto (or AF-A) is a mix of Single-shot and Continuous AF. If the subject is static, the camera will lock focus when the shutter button is partially pressed down, as for Single-shot. But if the subject then moves, the system will start tracking the movement exactly as it does when using Continuous AF. Although this sounds ideal, there's often a very slight lag before AF begins to track the subject. This pause can be enough to miss the moment you wanted. If your subject is likely to move, Continuous AF is a better option.

BEST FOR

- Studio photography
- Wildlife and macro subjects that are still but may move
- Most portrait work

▲ Auto AF is not generally the best mode for shooting wildlife. The exceptions are animals that are relatively tame and are behaving in a predictable way.

FOCUS LOCK

With Single-shot AF selected, focus is locked as long as the shutter button is half-pressed. This lets you recompose and shoot without the focus distance changing. This technique is useful if want to shoot an off-centre subject that would otherwise be outside the AF area. Locking focus with Continuous AF is slightly more complicated. Professional cameras and lenses often have a dedicated focus lock button that pauses AF. Consumer cameras don't usually have such a button, but you can assign the task to a customizable function button if your camera allows this.

1 **FOCUS YOUR CAMERA**
Set Single-shot AF and Single point selection (see p.83) on your camera. Select the central AF point, then move your camera so that it covers the subject. Press the shutter button halfway to activate and lock the focus.

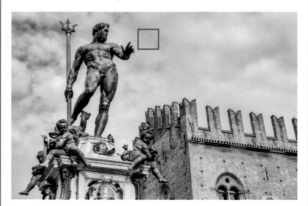

2 **RECOMPOSE THE SHOT**
Keep the shutter button held down and move the camera to compose the shot correctly. Press down fully on the shutter button to take the picture.

AUTOFOCUS POINTS

The various AF modes set how the camera focuses – whether it stops focusing once sharpness is acquired, or if focusing shifts until the moment of exposure. What these modes don't do is select where the camera focuses; this is done by picking the appropriate AF point-selection mode. There are essentially two options: either you let the camera automatically choose where to focus, or you make the decision yourself.

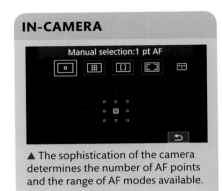

IN-CAMERA

▲ The sophistication of the camera determines the number of AF points and the range of AF modes available.

AF SENSORS

The AF points in a dSLR's viewfinder are linked to one of three types of phase-detection AF sensor with different specifications, so specific AF points will be better suited to certain conditions than others. The orientation of the sensor is one factor that affects AF efficiency, as does its light sensitivity. See your manual for details of your camera's AF system.

HORIZONTAL/VERTICAL

Horizontal and vertical sensors can detect and focus on lines or patterns in a scene that run in the opposite direction to the AF sensor's orientation: horizontal AF sensors detect vertical lines, and vice versa. The problem with this is that an AF point may not focus correctly if its associated sensor is in alignment with strongly horizontal or vertical details in the scene.

CROSS-TYPE

A cross-type AF sensor is preferable to horizontal and vertical sensors because it can detect and focus on both horizontal and vertical lines or patterns. However, cross-type sensors are typically less numerous, often found either at the centre only or across the AF area. An even more effective variation is the dual-cross AF point, which is sensitive to diagonal lines.

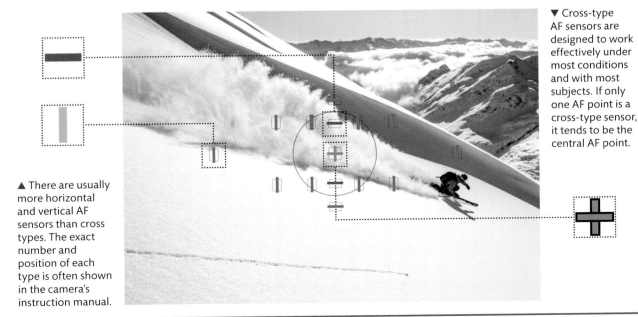

▲ There are usually more horizontal and vertical AF sensors than cross types. The exact number and position of each type is often shown in the camera's instruction manual.

▼ Cross-type AF sensors are designed to work effectively under most conditions and with most subjects. If only one AF point is a cross-type sensor, it tends to be the central AF point.

AF point selection

The AF point selection mode you choose will depend on your subject. Auto is excellent for social situations where there may be little or no time to manually select an appropriate AF point; choosing the right AF point in Single point selection is far slower by comparison. However, for slower-paced shooting – for example, still life, architecture, and landscape – the precision of Single point selection outweighs this disadvantage. Zone selection is a useful bridge between the two modes.

AUTO SELECTION

With Auto selection, your camera decides which AF points set the focus. You have no control, so it is not suitable if you need highly precise focusing. Auto usually focuses on the closest element in the scene, so the camera may not focus on your subject if it is partially obstructed by something.

SINGLE POINT SELECTION

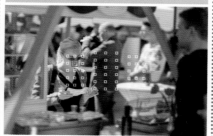

In this mode, you manually select one focus point from all those available. The main advantage of Single point selection is that you have precise control over where the camera focuses. This is useful if your subject is off-centre or partially hidden, or when you want to focus on a specific part of your subject.

ZONE SELECTION

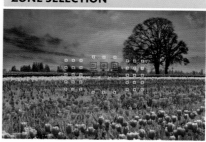

Zone selection groups neighbouring AF points together to effectively form one large AF point. You select the zone, and the camera focuses on the nearest point within it. There are far fewer zones than AF points, so this mode is useful when you need to be able to jump quickly between zones.

AF PROBLEMS

Despite their sophistication, modern AF systems still struggle to lock focus in certain conditions. When this happens the lens will "hunt", shifting focus indecisively, and you will have to decide whether to attempt to focus on another part of the scene, ideally at the same focus distance as your subject, or to switch to manual lens focusing.

LOW CONTRAST

Flat-toned subjects generally do not have the contrast that AF needs to work effectively. Conditions that lower the contrast, such as mist and fog, can also cause problems.

LOW LIGHT

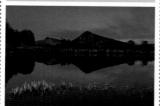

In low light, the AF system may not work efficiently. Try to work around this by adding a little light to the scene. Some flashes have an AF assist mode for such situations.

MOVEMENT

AF systems struggle with subjects that move quickly or erratically. In these situations, try to pre-focus and select a relatively small aperture to increase the depth of field.

TEXTURE

Fine-textured or busy surfaces can cause AF to fail. Solve the problem by focusing on a less busy part of the scene – as long as it is the same distance as what you want to capture.

BACK-BUTTON FOCUSING

Pressing the shutter button halfway down activates autofocus by default, but holding the shutter button also locks exposure, which you may not always want. It is also very easy to press down too hard and take a shot without meaning to. One way around this is to take autofocus activation away from the shutter button and assign it to a different button – either AF-ON or a customizable button on the back of the camera. Because of this, the technique is often referred to as back-button focusing. Using a separate button for focusing makes it easier for you to control when autofocus is activated for action shots.

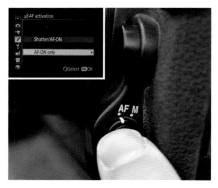

1 **SET BACK-BUTTON FOCUSING**
Using the custom control menu, set your camera to stop shutter button autofocus. You will also need to assign focusing to another button if AF-ON is not present.

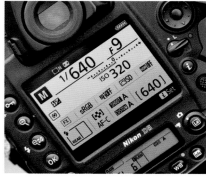

2 **CHOOSE CONTINUOUS AF**
Continuous AF constantly adjusts the focus when you hold down AF-ON. You will need to select an autofocus point selection mode. Choose Zone AF, the most useful mode for taking action shots.

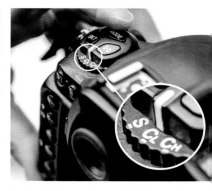

3 **SELECT CONTINUOUS DRIVE**
Continuous Drive is crucial when you are shooting fast-moving subjects. Shoot in brief bursts, to ensure that you capture the key moments of the action and to avoid filling the camera buffer.

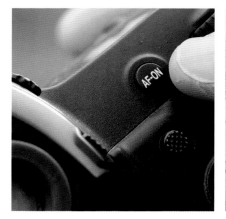

4 **HOLD DOWN AF-ON**
When your subject is in the autofocus zone you selected, press and hold down AF-ON. Trigger the shutter as normal, keeping your thumb on AF-ON.

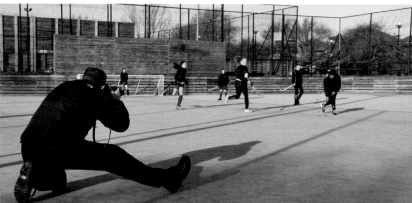

5 **RELEASE AF-ON TO STOP FOCUSING**
If your subject moves behind someone else, you can stop autofocus temporarily by releasing AF-ON. You can turn it on again once your subject is no longer hidden from sight.

WILDLIFE PHOTOGRAPHY

Animals are constantly on the move and their movements are unpredictable. Continuous autofocus is, therefore, a very useful technique because it helps to keep track of them. It is important for you to understand the habits of the animals that you intend to photograph so that you can anticipate how they might move. You can learn about them in books or online, talk to an animal expert, or even go out with a guide. It is vital to treat the animals with respect, and to put their needs first.

THE RESULT

Using the back-button focusing technique has ensured that the three figures in the foreground are pin-sharp. The eyes of the hockey players are all directed towards the ball, creating a focal point in the composition.

CAMERA **SETTINGS**

M · 1/2000 SEC · ISO 160 · AWB

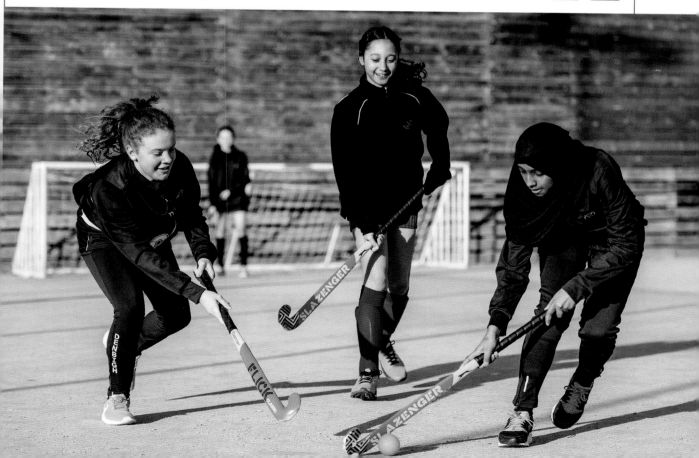

HOW TO **FOCUS MANUALLY**

Autofocus (AF) is an effective and convenient tool, but there are times when it is easier or necessary to focus manually. Manual focus (MF) allows you to focus on exactly what you want to in a scene, instead of what the camera decides, and it can also help when shooting in low light, when some AF systems can struggle to stay accurate. All lenses designed for dSLRs and CSCs have a focusing ring that can be switched to MF. Once set to MF, turn the focus ring on the lens to adjust focus, and check that the focal point is sharp.

Increased accuracy

Using your camera's MF option is far more than just a back-up to the AF system. Careful manual focusing, particularly when shooting macro, ensures greater accuracy than autofocus. It is also the key to success with techniques such as setting hyperfocal distance. Finally, focusing manually is often the only way that a lens can be focused when you are using adapted lenses on a CSC (see pp.108–09).

▼ Autofocus can struggle with fine detail or when the focal point of the image is small, such as the stamens of this flower. The AF points in a dSLR viewfinder are also relatively few in number and tend to be inconveniently spaced out.

FOCUS AIDS

Usually, viewfinders aren't perfect for judging whether a subject is in focus. Magnifying the area of focus will make a big difference to your precision when focusing manually; this is easy in Live View, but dSLR optical viewfinders don't have built-in magnification. Optional viewfinder magnifiers are available for some models, typically allowing up to 2x magnification.

LIVE VIEW MAGNIFICATION

The Live View image of a dSLR or CSC can be magnified (usually up to 10x) to show more detail. It's far easier to see whether the image is in focus when it is magnified, particularly if used alongside focus peaking (see below). Mount the camera on a tripod when using Live View magnification to prevent the subject-to-camera distance changing as you focus.

AF POINTS

The phase-detection AF points of a dSLR can help to confirm focus even when set to manual. The AF confirmation indicator in the viewfinder will light when the area under the selected AF point is in focus. Using the AF points this way helps confirm that your image is sharp, but it does restrict your focusing to the AF points, negating some of the benefits of MF.

FOCUS PEAKING

CSC cameras frequently offer a focus-peaking option, which activates when MF is selected. Focus peaking adds a coloured outline or highlights to sharp areas of an image. These highlights can often be set to either subtle or coarse; the latter is easier to see, but it can obscure the finer details of your subject, making composition more difficult. Focus peaking is a quick and useful way to check focus as you shoot.

▶ You can change the colour of the focus-peaking highlights to make them easier to see. Choose something that contrasts with, or is brighter than, the colour of your subject.

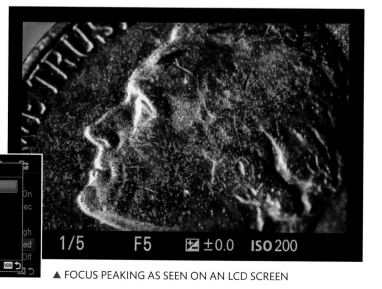

▲ FOCUS PEAKING AS SEEN ON AN LCD SCREEN

FOCUSING IN ADVANCE

Modern autofocus (AF) systems can be amazingly fast and precise but they are not perfect. AF can fail for a variety of reasons, such as a lack of contrast in your subject or low light levels. With a static subject this is easy to fix – you just try again, but when your subject is moving fast, you may not get a second chance. The answer is to prefocus. You anticipate a point that you think your subject will cross in front of the camera and manually focus the lens in advance. This technique works best with subjects that follow a set course or move in a predictable way, such as your dog bringing a ball back to you.

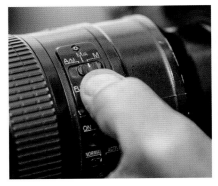

1 USE MANUAL FOCUS
Switching the lens to Manual focus (M) ensures that the focusing distance does not change once it has been set. Remember to switch back to AF once you have finished shooting.

2 SELECT APERTURE PRIORITY
Set a low-to-mid-range aperture to increase the chances that your subject will be sharp. This will make it possible to use a relatively fast shutter speed if you are using a mid-to-high ISO.

3 SET CONTINUOUS DRIVE
Turn the mode dial to CL. Firing several frames in quick succession using the Continuous Drive function will take a selection of photos from which you can select the most successful later.

4 PREFOCUS
Focus on an area in front of you that you predict your subject will pass through. Use elements in the scene, such as a path or a fence, to help you anticipate where your subject is likely to go.

5 WAIT AND SHOOT
Watch your subject as it moves towards you. Just before it reaches the area on which you have prefocused, press the shutter button and keep shooting until the subject has crossed it.

DRIVE MODES

A camera's drive mode specifies how many frames are shot when the shutter button is pressed down. Select Single and the camera will shoot just one photo and then stop. To take another photo, you have to release the shutter button and press it down again. Hold the shutter button down in Continuous Drive and the camera will shoot a series of photos until the shutter button is released, or until the buffer fills. Self-timer sets a timed delay on the shutter firing once the shutter button has been pressed.

THE RESULT

Prefocusing successfully takes a bit of practice, particularly if you are using a telephoto lens with a limited depth of field. Here, the dog's eyes are pin-sharp, which would have been difficult to achieve with AF.

CAMERA **SETTINGS**

A | ⊙ | f/2.8 | 1/400 SEC | ISO 400 | AWB

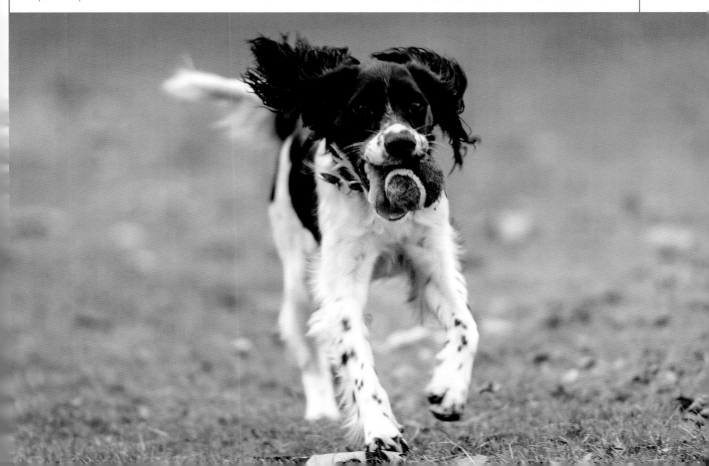

MAXIMIZING DEPTH OF FIELD

The distance between the areas of an image that are acceptably sharp behind and in front of the focus point is referred to as its depth of field. This extends twice as far behind the focus point as it does back towards the camera. One way to make sure that depth of field is used effectively is to focus on a point known as the hyperfocal distance. This is the point on which you focus to achieve maximum depth of field. The depth of field will then extend from one half of the focused distance to infinity. The hyperfocal distance varies depending on the aperture, the focal length, and the sensor size. Apps that use these variables to calculate the hyperfocal distance are widely available.

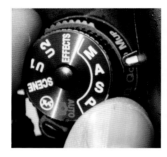

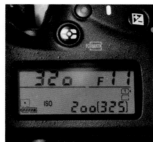

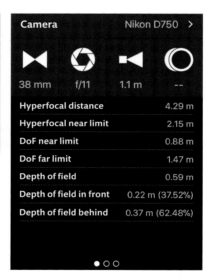

3 CALCULATE THE HYPER-FOCAL DISTANCE
Enter the camera and lens variables into a depth-of-field app to calculate the hyperfocal distance. Make a note of this value.

Camera	Nikon D750 >		
38 mm	f/11	1.1 m	--
Hyperfocal distance	4.29 m		
Hyperfocal near limit	2.15 m		
DoF near limit	0.88 m		
DoF far limit	1.47 m		
Depth of field	0.59 m		
Depth of field in front	0.22 m (37.52%)		
Depth of field behind	0.37 m (62.48%)		

1 SELECT APERTURE PRIORITY
To have control over the aperture (and thus the depth of field) that is needed for the hyperfocal distance technique, select Aperture Priority.

2 SET THE APERTURE
For landscape photos, select a mid-to-large range aperture setting, such as f/8 or f/11, especially if you are using a wide-angle lens.

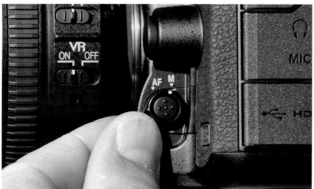

4 SELECT MANUAL FOCUS
Use either the AF/M switch on the camera body or lens, or the camera's focusing menu option screen to select manual focus.

5 FOCUS AT THE HYPERFOCAL DISTANCE
You need to focus the lens at the calculated hyperfocal distance. If your lens does not have a distance scale, you will have to estimate the distance visually and focus on a feature in the scene at this approximate distance.

6 SHOOT AND REVIEW
Check the sharpness of the shot by zooming into the image on the camera's LCD screen. Pay careful attention to the areas closest to the camera and check that the focusing was accurate. Try adjusting the aperture setting if you want more or less of the image to be sharp.

DIFFRACTION

The smallest lens apertures produce a visual effect called diffraction. It is caused by the reduction in optical resolution of a lens and results in a noticeable softening of images. The size of the camera sensor also determines how quickly diffraction becomes noticeable: smaller sensors are more prone to diffraction. For this reason, the minimum aperture range on compact cameras is often restricted to f/8 or f/11.

THE RESULT

Front-to-back sharpness is important for landscape subjects as it helps to convey a sense of depth and perspective. The hyperfocal distance was the rock just to the right of the image centre.

CAMERA SETTINGS

A | ● | f/10 | 1/800 SEC | ISO 200 | AWB

5

LENSES

LENSES

Digital cameras come and go, but a good lens is something you will treasure and keep. Ultimately, the lens determines the final quality of your photos. A great lens fitted to a consumer camera will produce better results than a poor lens fitted to a professional camera. Choosing a lens is a case of finding the right balance between what you can afford and its capabilities. Reviews that clearly describe a lens's strengths and weaknesses can be very helpful.

LENS FEATURES

The specifications of lenses vary according to their price and position within a manufacturer's range, but they all share certain features, such as a focus ring and filter thread. What distinguishes top-flight lenses from the rest are features such as distance scales. Although a lens is perfectly functional without these extra features, they do add to the experience and ease of shooting. Expensive lenses feature better quality optics and AF motors.

KEY TO ANNOTATIONS

1	Filter thread
2	Lens front element
3	Lens hood mount
4	Focus ring
5	Image stabilization switch
6	AF/MF switch
7	Focus distance scale
8	Focus distance indicator
9	Focal length indicator
10	Zoom ring
11	Lens mount indicator
12	Lens mount
13	Electronic contacts

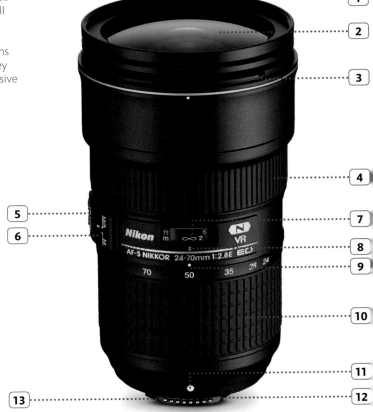

OPTICAL PROBLEMS

No lens is perfect, and all of them suffer from one or more optical problems. Flaws are usually seen when a lens is set to an aperture at either end of the range. You can usually reduce – or even eliminate – these optical problems by selecting one of the mid-range apertures. Fortunately, not all optical problems are serious, and they can often be cured either by selecting a lens-correction option in-camera or by applying a post-production fix. Be sure to zoom in on your images, because some problems, such as chromatic aberration, may only be visible at 100% magnification.

VIGNETTING

The corners of an image are generally darker than its centre when a lens is at the maximum aperture. This vignetting is usually cured by using a mid-range aperture. Vignetting can also be removed in-camera or in post-production. However, the higher the ISO used, the more difficult it is to remove vignetting without losing image quality.

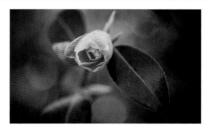

◀ Vignetting is most obvious when shooting large areas of light tone, such as soft-focus background greenery. It is not always a problem, though, because you can use it creatively to emphasize central subjects.

CHROMATIC ABERRATION

Coloured fringing around high-contrast edges in a photo is known as chromatic aberration, and there are two types: axial and transverse. Axial aberrations are seen across a photo taken with a lens at maximum aperture but disappear as you use a smaller aperture. Transverse aberrations are seen at the edges, regardless of aperture size.

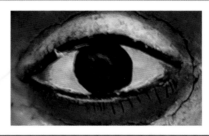

◀ When shooting JPEGs, transverse chromatic aberration can be cured in-camera, but axial cannot. If you shoot Raw, both transverse and axial aberrations have to be removed later. This photo has yet to be repaired.

DISTORTION

Some degree of distortion is often visible in lenses, and it takes one of two forms: barrel and pincushion. Barrel distortion makes straight lines bow out towards the edge of the frame, whereas pincushion makes them bow inwards. Zoom lenses often show barrel distortion at one end of the zoom range and pincushion at the other.

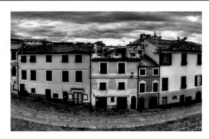

◀ Wide-angle lenses are particularly prone to distortion, usually towards the edge of the frame. It can be corrected in post-production, albeit with some loss of image resolution.

LENS TECHNOLOGY

Manufacturers are continually developing new techniques and materials to improve their lenses, often trying to minimize the problems described above. These technologies become more important as sensor resolutions increase. The table on the right explains some of the terms used.

TERM	DESCRIPTION
Low-dispersion glass	This type of glass is specially designed to minimize chromatic aberrations.
Aspherical lens	With its complex curved surface, this lens element focuses light more evenly and reduces aberrations.
Coatings	Applied to the surface of lens elements, coatings help to reduce the risk of flare.
Floating elements	These lens optics move independently of the main lens elements to improve close focusing.

FOCAL **LENGTH**

Measured in millimetres, focal length is the distance from the optical centre of a lens to a camera's focal plane (where light is focused) when the lens is focused on infinity (∞). Along with the size of the camera's sensor, focal length controls the angle of view and the magnification of subjects. The shorter it is, the wider the angle of view and the lower the magnification. Long-focal-length lenses have a narrower angle of view and greater magnification.

ANGLE OF VIEW	84°	63°	43°
FULL FRAME / APS-C	**24MM / 16MM**	**35MM / 23MM**	**50MM / 33MM**

The sensor in a full-frame camera is the same size as a 35mm film frame, whereas those in APS-C cameras are smaller.

When a lens is fitted to an APS-C camera, the angle of view is narrower than it would be on a full-frame camera. The difference can be calculated using the crop factor for the sensor (see p.98). APS-C cameras require a shorter-focal-length lens to match the angle of view of an equivalent lens fitted to a full-frame camera.

Manufacturers sometimes use the full-frame equivalent when describing the angle of view of a lens, rather than the actual focal length.

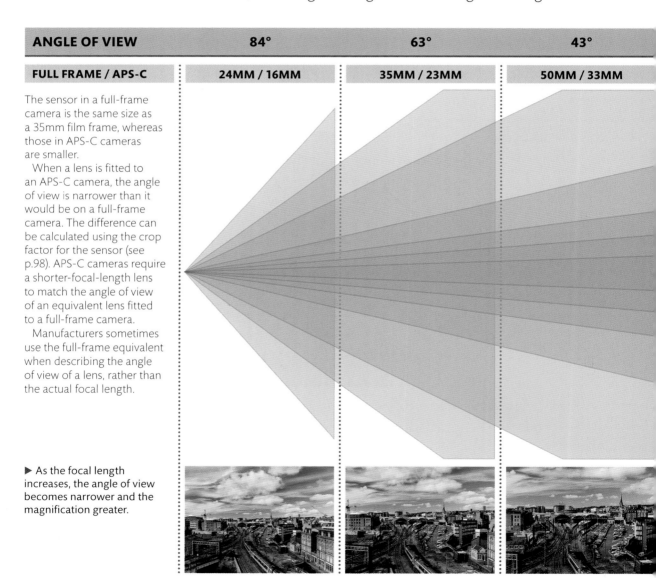

▶ As the focal length increases, the angle of view becomes narrower and the magnification greater.

LENS TYPES

Full-frame lenses can be used on APS-C cameras, but APS-C lenses cannot be used on full-frame cameras. Either the lens will not fit, or it will cause significant vignetting. Manufacturers use codes (see right) to differentiate full-frame lenses from APS-C lenses.

MANUFACTURER	FULL FRAME	APS-C
Canon	EF	EF-S
Nikon/Tokina	FX	DX
Sony E	FE	E
Pentax	FA	DA
Sigma	DG	DC
Tamron	Di	Di II

25°	18°	12°	6°
85MM / 57MM	135MM / 90MM	200MM / 133MM	400MM / 266MM

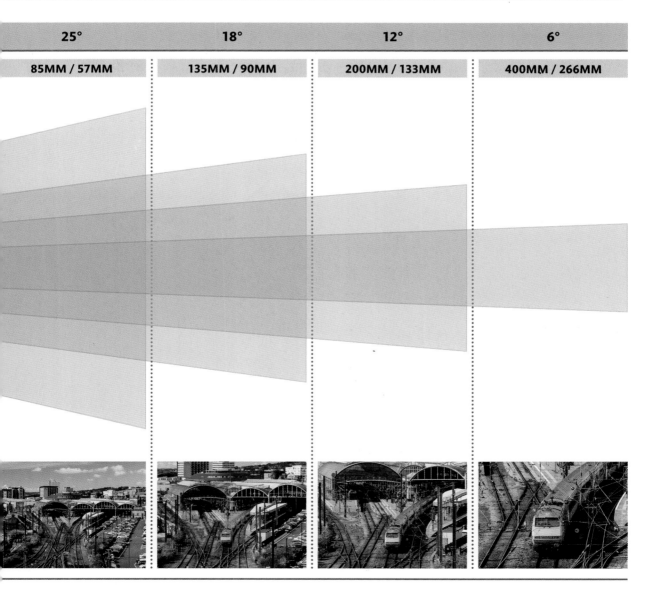

Sensor size and the crop factor

If you attach a lens to an APS-C camera, it will appear to have a longer focal length than it would when fitted to a full-frame camera. The apparent difference is due to the crop factor of the smaller sensor on the APS-C. The crop factor is the ratio of the size of a sensor compared to full-frame; APS-C sensors have a crop factor of 1.5 (or 1.6 on Canon cameras). To calculate the equivalent focal length when a lens is fitted to a camera smaller than full frame, multiply the focal length of the lens by the crop factor – for example, a 28mm lens fitted to an APS-C camera has the same angle of view as a 42mm lens on a full-frame camera. To work out the lens that matches the angle of view of a lens fitted to a full-frame camera, divide the focal length by the crop factor – so, to match a 15mm lens, you would need to fit a 10mm lens to an APS-C camera.

IMAGE CIRCLE

Cameras do not record the entire image "seen" by a lens; lenses project a circular image, in which the edges are usually outside the area captured by the sensor. Lenses for APS-C cameras project a small circle that, when used on a full-frame camera, shows noticeable vignetting. This is why full-frame cameras crop photos when they detect an APS-C lens.

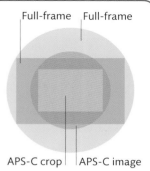

Full-frame Full-frame

APS-C crop | APS-C image

▲ The large full-frame image circle can be adapted for use on almost any current full-frame or APS-C CSC.

SENSOR SIZE KEY

Full-frame 36x24mm	APS-C Canon 22.2x14.8mm
APS-C Nikon 23.6x15.7mm	Four-Thirds system 17.3x13mm

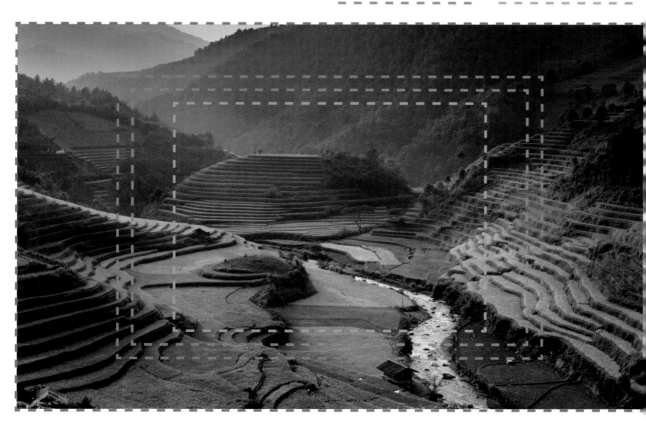

Perspective

The term "perspective" has several meanings in art. In photography, it's used to describe the spatial relationships – the relative size and distance – of the elements in an image. The focal length of a lens does not directly affect perspective; the camera's position relative to the subject or point of interest does. This is when the focal length you choose has an effect. If you are using a wide-angle lens, you normally have to get close to your subject, but when using a telephoto lens, the increased magnification and the narrowness of the angle of view mean that you need to move further back. This physical change in distance, rather than the change in the focal length of the lens, alters the perspective.

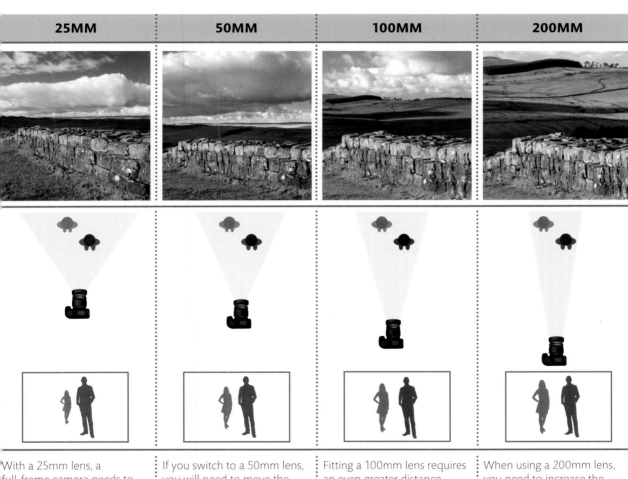

25MM	50MM	100MM	200MM

With a 25mm lens, a full-frame camera needs to be close to the subject for it to look the right size within the frame. Elements in the background are reduced in size and look further away from the subject than they are in real life.

If you switch to a 50mm lens, you will need to move the camera further away from the subject for it to stay the same size within the frame. The background elements now look larger in the frame and closer to the subject.

Fitting a 100mm lens requires an even greater distance between the camera and your subject. Space appears more compressed in the resulting photo, with the size of the background elements increased relative to the size of the subject.

When using a 200mm lens, you need to increase the camera-to-subject distance even more. However, the background seems closer to the subject. Space is highly compressed, and the background elements look much larger in the frame.

SHOOTING
INTERIOR SPACES

Wide-angle lenses are ideal for shooting interiors, and are particularly useful when working in small, indoor spaces. However, you have to think quite carefully about how to compose your shot. As this type of lens captures a wider area than a longer lens, you need to decide what to exclude from the composition, as well as what to include. The space between various elements in the scene is also important. These lenses emphasize elements in the foreground far more than those further away from the camera.

1 **CHOOSE A LENS**
Select a wide-angle lens that gives you the best perspective and that captures everything you want to include in the composition.

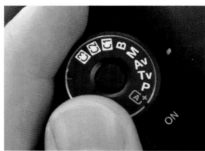

2 **SELECT APERTURE PRIORITY**
Interior shots usually require a relatively wide depth of field. To achieve this, select a small aperture setting using the Aperture Priority mode.

BARREL DISTORTION

Images taken with wide-angle lenses can suffer from barrel distortion, which makes straight vertical lines appear to bow out towards the edge of the frame. This can be rectified in post-production, unless it is particularly extreme. If your camera offers lens correction, try shooting in JPEG to avoid barrel distortion.

3 **USE A TRIPOD**
Using a small aperture to maximize depth of field can lead to long exposures. You should use a tripod to avoid the risk of camera shake.

4 **CREATE COMPOSITION**
Lines, whether physically present or implied by edges, can be used to help create an interesting composition and a sense of perspective.

5 **CHANGE THE FORMAT**
Switching format is a quick and easy way to change a composition. A landscape format helps to convey width, whereas a portrait emphasizes height, which is ideal for large, open interior spaces. The best format depends on the size and shape of the subject – and ultimately how wide your lens is. Here, a landscape format was chosen to emphasize the wide space.

THE RESULT

The strong diagonals of the architectural features give the final shot dynamism and visual interest. This has been emphasized by tilting the camera slightly upwards to eliminate any horizontal lines.

A | 1/20 SEC | ISO 320 | AWB

SHOOTING
STREET PHOTOGRAPHY

Urban locations, such as busy streets, parks, or shopping centres are good subjects for street photography. They provide plenty of opportunities to shoot people as they go about their lives, either individually or in groups. Creating a successful street photo involves luck, as often you have no control over the subject. With practice, however, you can learn to anticipate behaviour. Make sure that photography is allowed at that location, and use common sense when picking a subject. A standard lens is ideal for street photography as you want your photos to look natural, without an added effect.

1 CHOOSE A LOCATION
A busy location, with a constant flow of people, is a good option. People who are moving with purpose – for example, when walking to work – will be less likely to notice you or be bothered by you as you shoot.

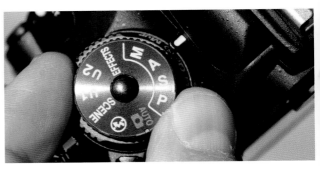

2 SELECT A MODE
Choose a semi-automatic mode, such as Aperture or Shutter Priority, to achieve a particular effect – a wide depth of field or a sense of movement – and leave the camera to deal with other aspects of exposure.

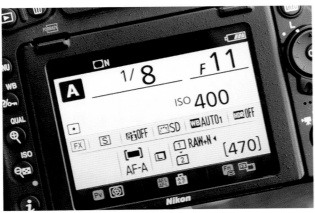

3 SET AUTO ISO
Select Auto ISO to ensure that camera shake is not an issue. Some cameras have an ISO menu option that lets you choose a shutter speed to maintain when Auto ISO is selected. Choose 1/50 or faster when shooting hand-held.

4 TRY DIFFERENT VIEWPOINTS
Add visual interest to your photos by varying your viewpoint. Try higher or lower viewpoints to alter the perspective, and shoot reflections of people as they pass by windows or metallic surfaces.

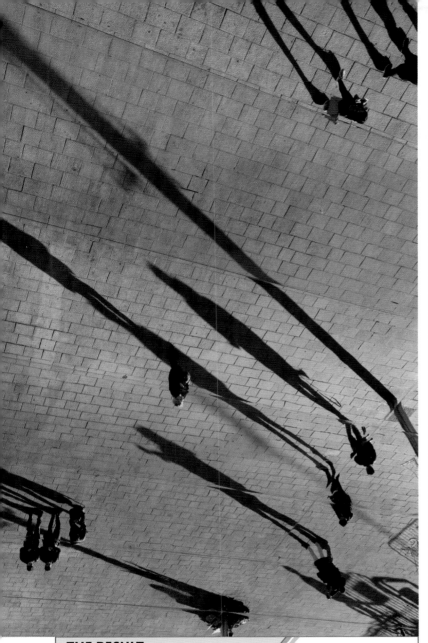

THE DECISIVE MOMENT

The French photographer Henri Cartier-Bresson invented the concept of the "decisive moment" – the exact point in time that the visual elements of a scene align to create a strong composition. The term influenced photographers throughout the 20th century. Cartier-Bresson used manual film cameras, so capturing the decisive moment was entirely down to his skill and reflexes. Today, using Continuous Drive (see p.89), it is possible to shoot multiple photos and pick the one that works best.

THE RESULT

The shot has depth, thanks to the unusual viewpoint and the long, raking shadows. Shooting the scene using an overhead reflective surface has also introduced a pleasing visual ambiguity.

CAMERA **SETTINGS**

 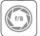

A | • | f/8 | 1/250 SEC | ISO 360 | AWB

THE **BRENIZER METHOD**

A shallow depth of field helps to make your subject stand out, but this can be difficult to achieve if you are shooting with a compact camera or CSC, particularly if you are using a lens with a relatively small maximum aperture. The Brenizer method, which is named after wedding photographer Ryan Brenizer who popularized its use, is a technique that produces images with a shallow depth of field but a wide angle of view, so that only a centrally-placed subject is sharp. To do this you have to shoot 30 to 60 photos in a rectangular grid pattern that you later stitch together in post-production (see pp.170–71).

1 CHOOSE YOUR LENS
Fit a telephoto lens to your camera; between 85mm and 105mm (full-frame equivalent) is ideal. The technique also works with compact cameras, but only zoom in using the optical zoom, to maintain image quality.

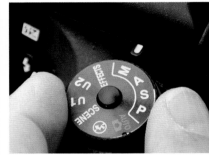

2 SELECT MANUAL
The exposure should remain constant as you shoot the sequence. Switch to Manual and select the maximum aperture available. Set the required shutter speed and increase the ISO if camera shake is likely to be an issue.

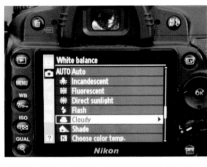

3 SET A FIXED WHITE BALANCE
The white balance should also be consistent. Set the right preset for the light source you are shooting under. This is particularly important if you are shooting JPEG; Raw files can be adjusted later in post-production, if necessary.

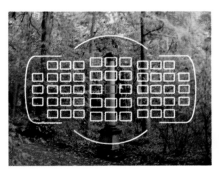

4 FOCUS ON YOUR SUBJECT
Carefully focus on your subject and then switch to manual focus or lock focus, so that the camera will not try to refocus as you shoot the sequence. Do not alter the distance between the camera and the subject as you shoot.

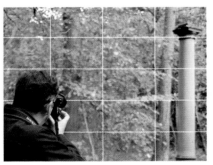

5 SHOOT THE SEQUENCE
Visualize how much of the scene you want to include with your subject. Shoot the top left corner of this scene, and then pan right and shoot a second photo so that it overlaps with the first shot – and then repeat.

6 CHECK YOUR PHOTOS
Continue shooting until you reach the top right corner, then lower the camera and work from right to left, as before, overlapping the images. Shoot the whole scene in this way, then check that you have covered everything.

BOKEH

Bokeh is a Japanese word for the aesthetic qualities of the out-of-focus areas of an image. A telephoto lens used at its maximum aperture produces pleasing bokeh. A lens creating poor bokeh will produce harsh, out-of-focus areas with obvious coloured fringing around any highlights. A lens producing good bokeh creates smooth out-of-focus areas that are not distracting. Factors such as lens elements, whether the lens being used is a prime or zoom lens, and the number of aperture blades all affect the quality of bokeh. Mirror and Petzval lenses produce a unique bokeh style (see p.107).

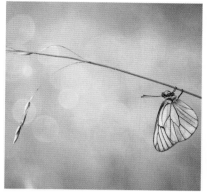

THE RESULT

This shallow depth of field would not normally be possible without stitching together in post-production (see p.170), particularly with a wide-angle lens. Your eye is led straight to the column at the centre of the image.

CAMERA **SETTINGS**

M | • | f/4.5 | 1/40 SEC | ISO 400 | ☁

SPECIALITY LENSES

Conventional lenses give you a wide range of shooting options, but it is interesting to try out more specialized ones occasionally. These are the sorts of lens that you wouldn't want to use every day, but when you do, they will give you the chance to experiment with your own style of photography. They are not necessary, but they will inspire you to try out new creative approaches. Some of the effects possible with speciality lenses can also be created in post-production, but you will achieve a better-quality image using the right lens in the first place, and, perhaps more importantly, it will also be more rewarding.

TILT-SHIFT

A tilt-shift lens lets you angle (tilt) the front lens element or move it up and down or left and right (shift), relative to the camera body. Tilting controls image sharpness by altering the angle of the plane of focus. Tilting up will increase blur, whereas tilting downwards will increase sharpness. Shift lets you keep your camera parallel to your subject, which minimizes converging verticals (when parallel lines appear to get closer together).

BEST FOR

- Architectural subjects
- Front-to-back sharpness when shooting landscapes
- Macro in combination with extension tubes

FISHEYE

A fisheye lens, also known as an ultra-wide or super-wide lens, is an extreme form of wide-angle lens. It captures a very wide image that is highly distorted and produces an exaggerated curvature of straight lines. The resulting image is circular, though many modern fisheyes can produce rectangular images with a diagonal 180° angle of view. (The angle of view will also depend on the camera's crop factor.) Use a fisheye lens sparingly to produce the greatest visual impact.

BEST FOR

- Architectural subjects, particularly interiors
- 360° virtual-reality images
- Action sports such as snowboarding and surfing

MANUAL-FOCUS LENSES

Buying lenses secondhand is a good way to keep costs down. It's also the only way to buy lenses that are no longer produced. Old manual-focus lenses are often as sharp as modern autofocus versions, and they are particularly suited to CSCs if you have a suitable adapter. Where older lenses lose out to newer designs is in the coatings used, so flare may be more of an issue; images shot at maximum aperture may be softer; and you will need to set the aperture ring manually.

LENS MOUNT	PRODUCED	FOCAL LENGTH
Canon FD	1971–92	7.5–800mm
Olympus OM	1972–2002	8–1,000mm
Nikon F	1959–present	6–2,000mm
Minolta MD	1977–85	7.5–800mm
M42	1949–present	8–1,000mm
Leica M	1954–present	10–135mm
Leica R	1964–present	15–800mm
Contax/Yashica	1975–2002	15–800mm

MIRROR

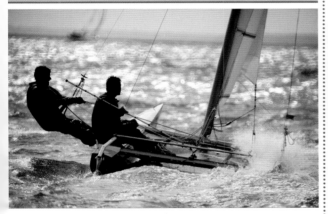

Also known as catadioptric lenses, mirror lenses use a combination of glass optics and a system of mirrors to produce an image. This creates long-focal-length lenses that

are both lighter and smaller than an equivalent glass lens. There are several drawbacks, though: they have a fixed aperture, they are slightly less sharp and have lower contrast than glass lenses, and any out-of-focus highlights have a distinctive ring shape. It is these characteristics, however, that can help you to create some interesting effects.

BEST FOR

■ Wildlife and sports subjects

■ Astronomical photography

■ Candid, long-distance street photography

PETZVAL

Modern lenses are of incredible quality, but in recent years, photographers looking for something different have turned to 19th-century designs. These retro lenses emulate the

effects created by less sophisticated lenses and give rise to a number of visual quirks. A good example is the Petzval lens, which was first produced in the 1840s and is now back in production. It creates a softer image than an equivalent modern lens, and when shot wide open, it produces a swirly, out-of-focus bokeh effect (see above).

BEST FOR

■ Romantic portraits

■ Backlit subjects

■ Flowers and nature

USING **ADAPTED LENSES**

By using a suitable adapter, you can fit virtually any lens designed for film or digital SLRs on to a compact system camera (CSC). This means that you can shoot with older lenses, which are a fraction of the price of a modern lens, particularly in the case of unusual types such as macro or tilt-and-shift. There are limitations to using older lenses, such as the lack of autofocus, but this does not matter much for shooting static subjects, such as portraits or landscapes. Focus peaking (see p.87) and being able to zoom-in to a Live View image are useful techniques when you are focusing manually.

1 FIT THE LENS
First fit the adapter to your camera, then attach the compatible lens. Make sure that both the adapter and lens are securely locked into place.

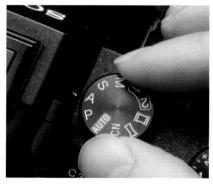

2 SELECT APERTURE PRIORITY
There is not usually an electronic connection between the camera and an adapted lens. Despite this, the camera will automatically meter correctly when it is set to Aperture Priority.

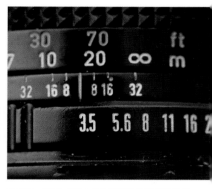

3 SET THE LARGEST APERTURE
A large aperture lets the greatest amount of light possible reach the sensor and reduces the problem of a grainy viewfinder or LCD. As this limits depth of field, it helps you to focus precisely.

4 FOCUS THE LENS
Manually turn the focus ring to focus your image. Depending on the type of lens you are using, you may find that the focus ring turns in the opposite direction to those on your regular lenses.

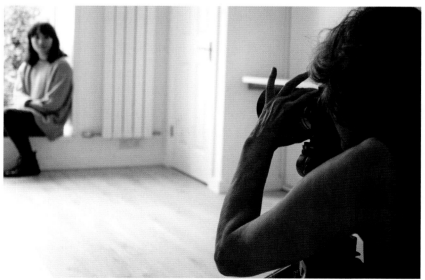

5 SET THE REQUIRED APERTURE
Older lenses do not perform as well at maximum aperture, so switch to a mid-range aperture to take the shot.

METADATA

Metadata is information embedded in a photo, which you can look at either on your camera or in image software on a computer. There are two types of metadata: EXIF and IPTC. EXIF metadata contains camera information, such as exposure and White Balance settings, and is automatically added to photos as you shoot. IPTC metadata is added later in post-production and includes information such as a photo caption and relevant keywords (see p.178). The aperture setting used is not recorded in EXIF if you are using an adapted lens. If you need that information later, you will need to note it down at the time of shooting.

FLANGE FOCAL DISTANCE

Lenses are designed to focus correctly for one specific camera system only. Every camera system needs the sensor and the lens to be a precise distance apart, a measurement known as the flange focal distance. If the lens is any closer than this, it will not be able to focus at infinity. The flange focal distance of an SLR is large compared with that of a compact system camera (CSC). A CSC lens adapter adds the correct spacing to mimic the flange focal distance for an SLR lens, which makes it possible to focus at infinity.

THE RESULT

This photo was shot using a 30-year old lens. Zooming into the Live Image to view the subject's face made it possible to focus on her eyes – the key to a successful portrait.

CAMERA **SETTINGS**

A | 1/250 SEC | ISO 400 | AWB

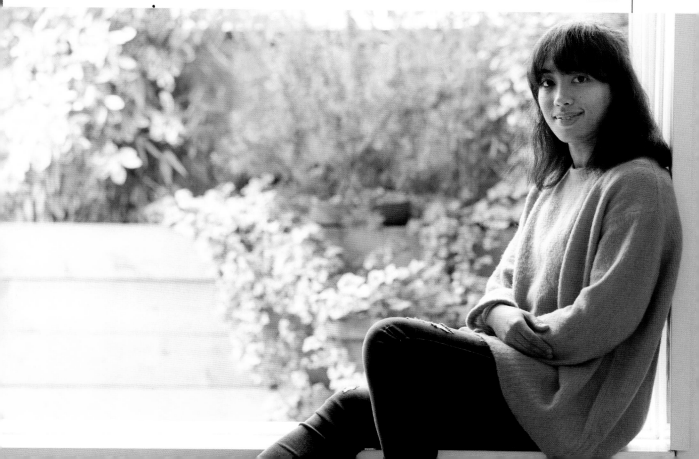

SHOOTING **TALL BUILDINGS**

Architectural photographers use tilt-shift lenses to prevent the sides of tall buildings from converging excessively. Tilt-shift lenses achieve this by allowing you to raise, lower, and tilt the lens in relation to the camera's sensor. Using a shift lens is not a quick process – it takes time to compose a shot as neither the shift nor the focusing are automated. With a suitably wide-angle shot, you can emulate the effects of a shift lens post-production and correct converging verticals using perspective correction tools (see pp.162–63) – but at a cost of losing some image resolution. Although shift lenses can be fiddly to use, they produce images at your camera's maximum resolution.

1 **SET UP YOUR CAMERA**
To use a shift lens correctly, you have to set your camera on a tripod. It is almost impossible to get the precision that you need if you hold your camera in your hand.

2 **POSITION THE CAMERA**
Check that your camera is parallel to your subject. Use the camera's built-in spirit level if it has one. Otherwise, fit a photographer's spirit level to the hot shoe. Adjust the tripod head if necessary.

3 **FOCUS PRECISELY**
All shift lenses have to be focused manually. Focus very carefully on your subject, or select a suitable aperture setting and then use hyperfocal distance focusing (see p.90)

USING TILTS

Tilts can be used to control sharpness. Initially, a lens's plane of focus is parallel to its front element. Tilting the lens also tilts the plane of focus. If you tilt the lens downward, the plane of focus makes both near and far objects sharper, so the depth of field appears to increase. This enables you to achieve sharpness from front to back with only moderate aperture settings. If you tilt the lens upwards, the depth of field appears to shrink. With careful focusing, this can help to isolate elements in the scene and make them stand out more.

4 **ADJUST LENS SHIFT**
Shift the lens so that all the parts of the building that you want to include are in the frame. Use a moderate amount of shift if possible, as image quality deteriorates as shift increases.

5 **SHOOT AND REVIEW**
Take the photo, then check it carefully. Zoom into the image and make sure that the shot is in focus right across the photo, and that there is no significant loss of quality around the edges.

CONVERGING VERTICALS

In photos, vertical lines on a building that should look parallel often appear to converge towards a distant point. This usually happens when a camera is pointed upwards to fit a building into the frame. Converging verticals can be used deliberately to create a really dramatic effect. What does not work, however, is when they look like a mistake. Boldness is the key to making the effect look deliberate.

THE RESULT

In the final photo taken using the shift lens, the vertical lines of the building are parallel to each other, making it seem as if you are looking at it head-on. In the photo taken without a shift lens, you are aware of looking upwards, as the verticals are converging.

▼ WITHOUT SHIFT LENS

CAMERA **SETTINGS**

M | 1/250 SEC | f/8 | ISO 400 | AWB

SHOOTING IN **MACRO**

Macro photography is the art and science of shooting extremely close-up subjects. Technically, a macro photograph is one in which the size of the image projected by the lens on to the sensor is life-size or larger. All lenses have a minimum focusing distance, and few of them have a particularly close focusing distance, which limits the size of the projected image. To shoot macro, you will need to use one or more of the accessories that shorten a lens's minimum focusing distance, or fit a macro lens to your camera.

MAGNIFICATION FACTOR

A lens's magnification factor describes the size of the image projected on to the sensor relative to the actual size of the subject. A magnification factor of 1x or higher indicates true macro capabilities, projecting an image that is life-size or larger. Macro properties may also be shown as a ratio: a 1:1 ratio is equivalent to 1x magnification, 2:1 is 2x, and so on.

SUBJECT	MAGNIFICATION	RESULT ON SENSOR
	HALF LIFE-SIZE At a magnification factor of 0.5x, the image of the subject is half life-size on the camera's sensor. The image of an 18mm-wide subject would be 9mm on the sensor, a quarter of the width of a full-frame sensor.	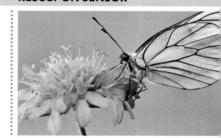
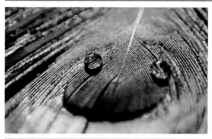	**LIFE-SIZE** Jump to 1x magnification, and the image of the subject is life-size on the camera's sensor. An 18mm-wide subject will now appear 18mm on the sensor, or half the width of a full-frame sensor.	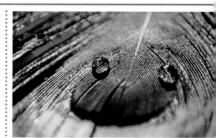
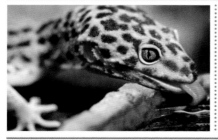	**TWICE LIFE-SIZE** Increase the magnification to 2x, and the image of the subject appears on the camera's sensor at twice its real-life size. The image of the 18mm subject is now 36mm and will fill the entire width of a full-frame sensor.	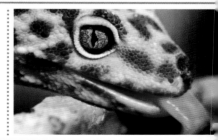

MACRO OPTIONS

There are several ways to shoot macro, not all of which use a true macro lens. By adding an accessory, any lens can be temporarily modified to focus more closely. This is an excellent way to experiment with macro photography without too much outlay. Ultimately, though, a true macro lens is far more convenient and optically superior.

CLOSE-UP LENSES

A close-up lens is a supplementary optic that screws onto a lens to reduce the minimum focusing distance. Close-up lenses are available in different strengths, measured in dioptres – the higher the value, the greater the magnification. You can stack lenses to increase magnification further, but quality will be compromised.

ADVANTAGES

- Add to any lens
- Much cheaper than a macro lens
- No effect on AF functions of a lens

DISADVANTAGES

- Image quality may be compromised
- You may need more than one lens
- True macro needs the strongest lenses

EXTENSION TUBES

Extension tubes fit between the camera and lens. There are no optics, so the image quality is not affected. The tubes work by shortening the focusing distance of the lens, thereby increasing magnification. Extension tubes are usually sold in sets of three and can be used singly or in combination with each other.

ADVANTAGES

- 1x magnification with shorter lenses
- Cheaper than a macro lens
- The lens image quality isn't affected

DISADVANTAGES

- AF is not possible with simple tubes
- Infinity focusing is lost
- Limited working distance

MACRO LENSES

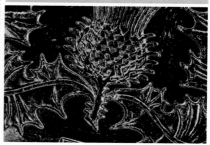

Macro lenses are available in many focal lengths for virtually every current camera system. The minimum specification of a macro lens is 1x magnification, though more specialized types offer up to 5x. Newer macro lenses often offer image stabilization, too, so you can use them for handheld work.

ADVANTAGES

- Excellent image quality
- Full focusing range, including ∞
- Can be used for non-macro work

DISADVANTAGES

- More expensive than other options
- Long macro lenses are heavy
- Specific to camera systems

WORKING DISTANCE

A lens's working distance is how far its front element is from the subject in order to focus upon it. The working distance of a 1:1 macro lens determines the photo's perspective, how easy it is to light your subject or use accessories such as filters and lens hoods, and how likely you are to disturb your subject. The longer the lens's focal length, the greater the working distance. Using extension tubes with wide-angle lenses will increase the magnification beyond 1x but will result in a very short working distance.

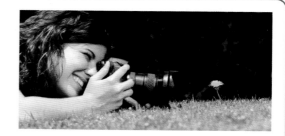

▲ UP CLOSE

FOCUSING **CLOSER**

Extension tubes let you temporarily modify any lens so that it can focus closer than usual. The simplest extension tubes do not maintain an electronic connection between the lens and camera, so you have to set both the focus and aperture manually, although the latter is only possible on lenses with

an aperture ring. Extension tubes with electronic contacts are far more convenient. These let you set the aperture via the camera, and allow autofocusing. Infinity focus (see p.66) is not possible with extension tubes; if you want to shoot a distant subject, you will need to remove them.

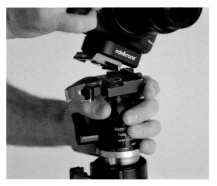

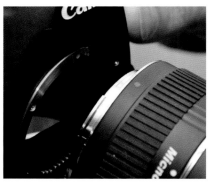

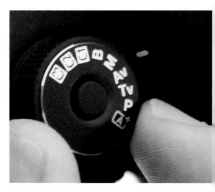

1 USE A TRIPOD
Shooting at high magnifications always results in light loss and longer shutter speed times. Use a tripod to reduce the risk of camera shake without the need for a high ISO.

2 PICK AN EXTENSION TUBE
Choose the level of magnification you want to shoot, and combine the appropriate lens and extension tube. For the highest magnification, use a wide-angle lens with the maximum extension.

3 SELECT APERTURE PRIORITY
The higher the magnification, the narrower the depth of field that will be produced. The Aperture Priority mode will give you the necessary control over aperture and depth of field.

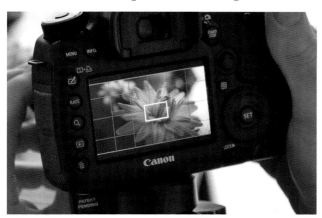

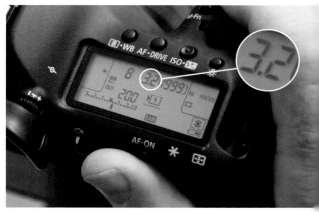

4 FOCUS THE LENS
Take extra care when focusing to make sure that the most important area of your subject is sharp. Use Live View on your camera's LCD screen and zoom in to the image to check the critical focus.

5 SET THE APERTURE
You often have to use very small apertures when shooting close-ups. If the image is underexposed, you may need to use flash. However, using larger apertures, as shown here, and a narrower depth of field can suit some subjects.

MAGNIFICATION

The level of magnification is determined by the focal length of the lens and the length of the extension tube or tubes. To shoot at 1x magnification, the length of the extension tubes should match the focal length of the lens as closely as possible. Magnification greater than 1x is only possible when the extension tubes are longer than the focal length of the lens. If you want to shoot at less than 1x magnification, use an extension tube that is shorter than the focal length of the lens.

THE RESULT

Here, a large aperture has been used to minimize depth of field and create a softer image. This works well with organic subjects such as flowers. The key is to focus precisely on the part of the subject you want to be sharpest.

CAMERA **SETTINGS**

Av | ⊙ | f/3.2 | 1/8 SEC | ISO 200 | ☀

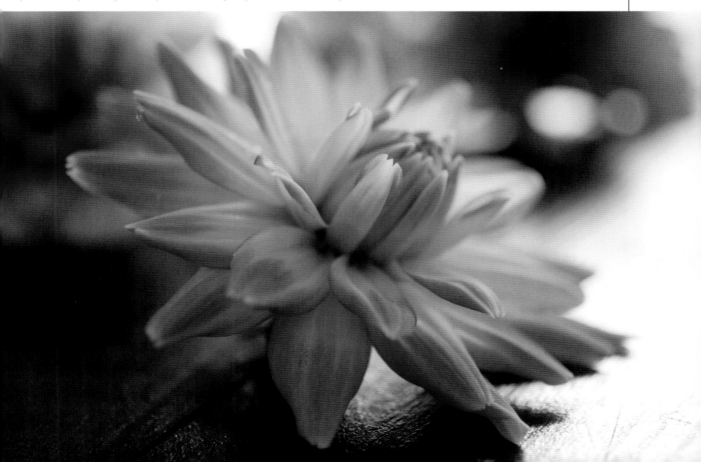

PERFECTING **FOCUS**

A common problem when shooting close-up and macro is a lack of depth of field. Even when using the smallest aperture, it is often impossible to achieve front-to-back sharpness. One solution is focus stacking, a technique that consists of two stages. First, you shoot a sequence of photos, altering the focusing distance between each shot starting at the front of the subject and ending at the back. Then you blend (stack) the sequence using editing software. During this process, the out-of-focus areas are discarded, so the final image should be sharp right from the foreground to the background.

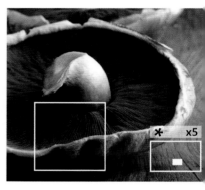

1 SET UP YOUR CAMERA
Your camera should not move as you shoot, so mount it on a heavy tripod and fit a remote release. Select Aperture Priority and set a mid-range aperture, a fixed ISO value, and a WB preset.

2 SELECT MANUAL FOCUS
It is essential that you have complete control over how your camera focuses. Switch to Live View so that you can zoom into the image to check focusing.

3 PLACE THE FOCUS POINT
Focus the lens so that the closest point of the subject you want to be sharp is in focus. The rest of the scene will be out-of-focus. When you're ready, take the first shot in the sequence.

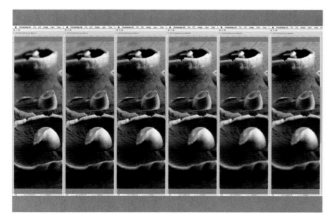

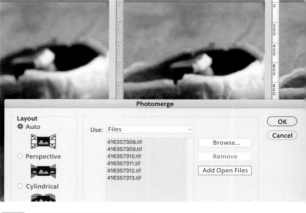

5 REVIEW THE SHOTS
Import all of the photos into a software of your choice. Here, Adobe Photoshop was used. Check that the exposure and WB are consistent, and alter them if necessary. Review the shots and check that the focal points are sharp across all the photos.

6 MERGE THE SHOTS
Click the File drop-down menu, select Automate, and then Photomerge, and add all the photos. Uncheck Blend Images Together. Select OK and the individual photos will be added to a new file, stacked as a series of layers.

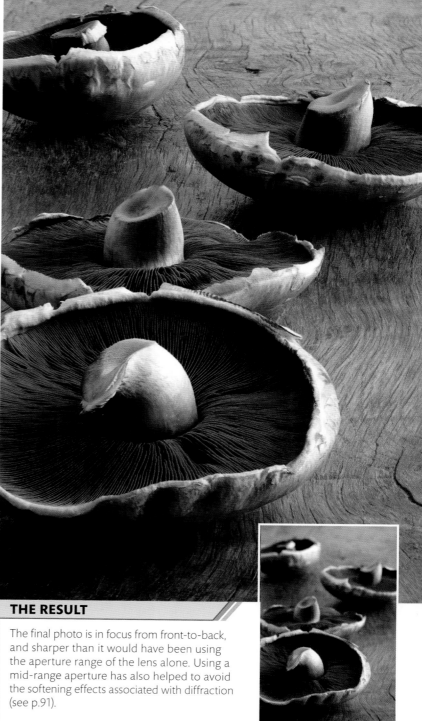

STACKING SOFTWARE

Not all photo editing software can be used to create a focus-stacked image. Adobe Photoshop (shown here) is one option. Helicon Focus by HeliconSoft, available for both PC and Mac, and Zerene Stacker, are alternatives. Focus stacking can be applied to any subjects that require an extensive depth of field, such as landscapes.

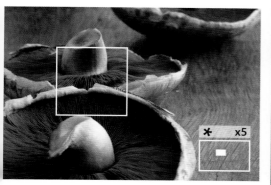

4 **MOVE THE FOCUS POINT**
Focus slightly further along the subject (away from the camera) and shoot. Continue until you reach the furthest distance you want to be sharp. How many shots this takes will depend on the size of the subject.

7 **STACK THE SHOTS**
Select all the layers. In the Edit drop-down menu, select Auto-Blend Layers. Click Stack Images, then OK. Once the layers have been processed, flatten the layers and save the final photo.

THE RESULT

The final photo is in focus from front-to-back, and sharper than it would have been using the aperture range of the lens alone. Using a mid-range aperture has also helped to avoid the softening effects associated with diffraction (see p.91).

CAMERA **SETTINGS**

A | f/20 | 1/125 SEC | ISO 100

▲ BEFORE USING FOCUS STACKING

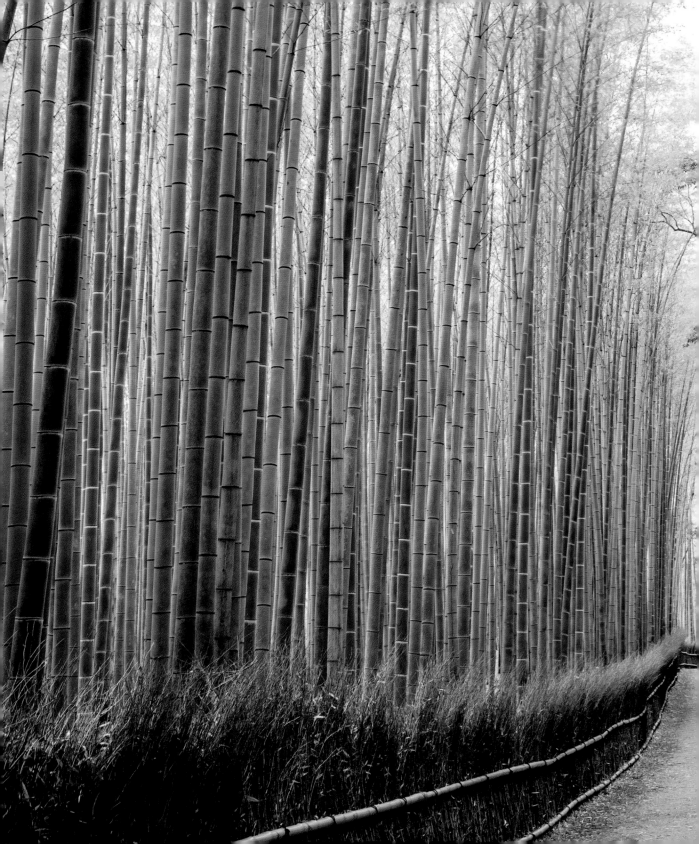

FILTERS

FILTERS

Made from glass, optical resin, or plastic, filters adjust the light that passes through them in ways specific to each type. Filters are not necessary for all types of photography, but they are invaluable for controlling contrast when shooting landscapes. They can also be used to create effects that would otherwise be impossible to achieve, such as extending shutter speeds to blur movement.

Filter systems

Filters are either circular and are screwed on to a lens filter thread, or are square/rectangular and slot into a filter holder. Screw-on filters are available in many sizes, determined by the filter thread size of the lens. There are several filter-holder systems.

The most popular size takes 100mm filters, though larger and smaller systems are also available. Filter holders are clipped to an adapter ring that is screwed to the lens. To use the filter holder on other lenses, you will need to buy more adapter rings.

SCREW-ON FILTERS	FILTER HOLDERS
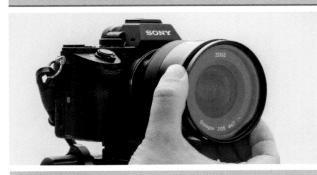	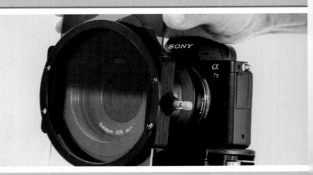

ADVANTAGES	**ADVANTAGES**
■ Cheap and commonly available	■ Can be used on a wide range of cameras and lenses using adapter rings
■ Wide choice of filter types	■ ND graduated filters can be positioned precisely
■ Can be used to protect the front element of the lens	

DISADVANTAGES	**DISADVANTAGES**
■ You may need more than one filter for multiple lenses	■ Initial expense of the filter holder and adapter rings
■ They cannot be stacked together easily	■ They restrict the use of lens hoods
■ ND graduated filters (see right) are fixed in place	■ May cause vignetting with wide-angle lenses

Types of filter

Filters can be categorized in three broad groups – exposure control, effects, and colour – each of which has a specific purpose and visual effect. Which group, or specific filter within that group, is best for you will depend entirely on the type of photography you intend to undertake – exposure-control filters tend not to be necessary for studio photography, for example. However, an effects filter such as a polarizing filter, which can reduce or entirely remove reflections, could prove indispensable.

FILTER THREADS

Filter thread sizes vary widely, from 30.5mm to 127mm. The size of a lens's filter thread is indicated on the barrel of the lens or inside the lens cap. Lenses that have a large maximum aperture usually need larger filters than lenses with a smaller maximum aperture.

USING FILTERS

You can mix and match filters to achieve different effects, but be aware that each one will degrade the image quality slightly. If you stack too many filters, the quality will drop unacceptably.

Stacking filters can also create vignetting problems, with the edge of the leading filter visible in the corners of a photo, especially if you are using wide-angle lenses.

ND FILTERS

ND (neutral-density) filters are semi-opaque and are available in strengths of 1 to 15 stops. They are usually used to increase the length of the shutter speed. The related ND graduated filter helps to balance the exposure of a bright sky with a darker foreground.

▲ 10-STOP ND FILTER

EFFECT FILTERS

Rather than just colouring or reducing the light that passes through them, effect filters distort it. Examples include the polarizing filter (above), soft-focus filters for portraits, and filters that were once fashionable but are now largely overlooked, such as the starburst filter.

▲ POLARIZING FILTER

COLOUR FILTERS

Colour filters are used in black-and-white photography to adjust tonal range, but post-production and in-camera options offer greater scope for adjustment. They are still useful if you shoot film, and you can also use them to alter the colour of flash light.

▲ RED FILTER

CONTROLLING EXPOSURE

Ambient light levels may constrain the range of exposure combinations that you can set on your camera, limiting your control over the final image. This is particularly true of shutter speed, as it is often impossible to select long shutter speeds in bright light, even when the camera's lowest ISO is used and the lens is set to its smallest aperture (largest f/stop). This means, for example, that it can be difficult to achieve the amount of blurring that you want when you are shooting a moving subject. The solution is to use exposure control filters, which reduce the amount of light that reaches a camera's sensor. Available in a range of strengths, these filters can be attached to your lens and mimic the effects of shooting in lower levels of light, giving you greater control over the level of exposure.

NEUTRAL DENSITY (ND) FILTER

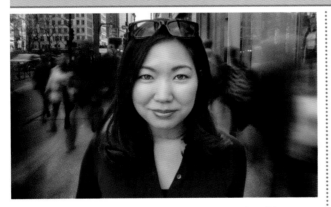

Neutral density (ND) filters are available in strengths of 1-stop to 5-stops. Theoretically, ND filters do not affect the colours in an image, although cheaper versions often add a slight magenta cast. A 1-stop ND filter halves the amount of light that reaches the sensor, allowing you to double the shutter speed (or open up the aperture by 1 stop). A 2-stop ND filter quarters the amount of light that reaches the sensor, with the same effect on the image, and so on.

BEST FOR

- Blurring movement to create a sense of speed and/or reduce detail
- Using maximum aperture in bright conditions

VARIABLE ND FILTER

Unlike a standard ND filter, which has a fixed strength, a variable ND filter allows you to adjust the amount of light it lets through by rotating a ring on the filter's frame. Being able to alter the filter's strength is particularly useful when shooting video, as you can vary the degree of filtration if the light levels change while you are recording. Variable ND filters can, however, make cross-shaped smears appear across the image when you use them at maximum strength.

BEST FOR

- Shooting video in changeable light conditions
- Very fine exposure control

FILTER STRENGTH

A filter's strength is shown as a filter factor value, which indicates how much light is blocked by the filter. A filter with a 1x filter factor allows 100% of the light to pass through and does not affect exposure. A filter with a 2x filter factor blocks 50% of the light that falls on it, requiring a 1-stop exposure adjustment. A filter's name usually incorporates a description of the filter's strength (such as ND 64). Manufacturers also use a decimal value to describe filter strength. This system starts at 0.1 for 1/3-stop filtration and usually increases by 0.1 for every further 1/3-stop increase in strength.

TYPE OF FILTER	FILTER FACTOR	F-STOP ADJUSTMENT
SKYLIGHT / UV	1X	NONE
ND 0.1	1.3X	1/3-STOP
ND 2 / ND 0.3	2X	1-STOP
POLARIZER	4X	2-STOPS
ND 4 / ND 0.6	4X	2-STOPS
ND 8 / ND 0.9	8X	3-STOPS
ND 64 / ND 1.8	64X	6-STOPS
ND 1024 / ND 3.0	1024X	10-STOPS

EXTREME ND FILTER

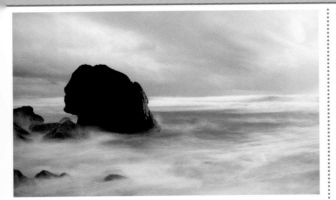

Extreme ND filters are available in strengths from 6- to 15-stops. As they severely restrict the amount of light entering the lens and make it possible to use shutter speeds of one second or longer, they produce extensive blurring of movement. The density of extreme ND filters means that you have to compose the photo and set the focus before you fit them onto the camera, as once they are in place you cannot see through the optical viewfinder. Using a tripod is a must.

BEST FOR

- Blurring movement to remove detail entirely
- Landscape photography, particularly seascapes
- Minimalist black and white photos

ND GRADUATED FILTER

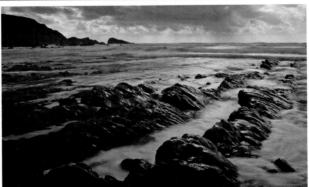

Graduated filters help to balance the exposure between two areas of a scene, in which there are differing amounts of light. One half of the filter is semi-opaque, like a standard ND filter, but the other half is transparent and the transition between the two halves may be soft or hard. It is best to use an ND graduated filter in a holder system, as you can then move it up and down or rotate it to find the right position to allow the appropriate amount of light through.

BEST FOR

- Balancing the exposure of bright skies with that of darker foregrounds
- Side-lit portraits or still life photography
- Adjusting the exposure of brightly sunlit snow or sand

CREATING **EXTREME BLUR**

In bright light conditions you can use a 10-stop neutral density (ND) filter to blur any movement in a scene – rivers, seascapes, and wind-blown foliage are subjects that work really well. When using an extreme ND filter, you will need to calculate the shutter speed, and you can do this with one of the many simple exposure calculator apps that are available for smartphones and tablets. If you are shooting in low light, fitting a 10-stop filter can result in an exposure longer than 30 seconds. This means that you will need to use the camera's Bulb mode (see pp.60-61), in which you manually time the exposure.

1 COMPOSE THE SHOT
Choose a scene that will have a lot of potential for movement during the exposure. Set up your tripod. If you are shooting with a wide-angle lens, get close to the subject.

2 SELECT APERTURE PRIORITY
Start with Aperture Priority, and set the aperture needed to obtain sufficient depth of field. Press on the shutter button to take a meter reading, and note the shutter speed suggested by the camera.

3 SWITCH TO MANUAL FOCUS
Use the camera's autofocus system to focus the scene, then switch the lens to manual focus. This will stop the camera from trying to re-focus once you have fitted the filter.

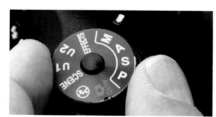

4 SELECT MANUAL
Switch the camera setting to Manual and set the aperture setting to the same value that you originally set in step 2.

5 CALCULATE EXPOSURE
Enter the shutter speed suggested at step 2 into an exposure calculator app to find out what shutter speed you need when the filter has been fitted. Set this new shutter speed on your camera.

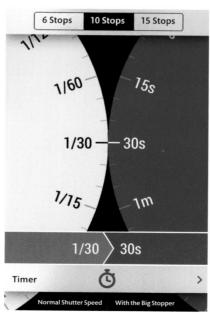

| 6 Stops | 10 Stops | 15 Stops |

1/12
1/60 — 15s
1/30 — 30s
1/15 — 1m

| 1/30 | 30s |

Timer

Normal Shutter Speed | With the Big Stopper

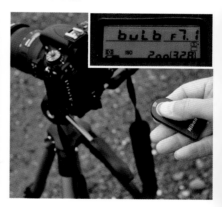

6 FIT THE REMOTE RELEASE
Fit a remote release to make sure that the camera does not move when the shutter is fired. For exposures longer than 30 seconds, when Bulb mode is required, a remote release is essential.

7 ATTACH THE FILTER
Fit the filter to the lens, being careful not to move the focus ring. Shoot the photo, review the image, and then adjust the exposure and re-shoot if necessary.

COLOUR CAST

Most 10-stop ND filters add a blue or sepia colour cast to the final photo. Auto White Balance (AWB) will reduce the cast but will not remove it entirely. It is better to create a Custom White Balance setting (see pp.46–47), with the filter fitted, before you shoot the final photo.

THE RESULT

The movement of the sea and the clouds is significantly blurred, creating an abstract, misty effect that is totally absent from the photo shot without the filter. The strong, dark shapes of the seaweed and the pier form a striking contrast to the swirling mist of the sea.

CAMERA **SETTINGS**

 30 SEC ISO 200

▼ SHOT WITHOUT A 10-STOP ND FILTER

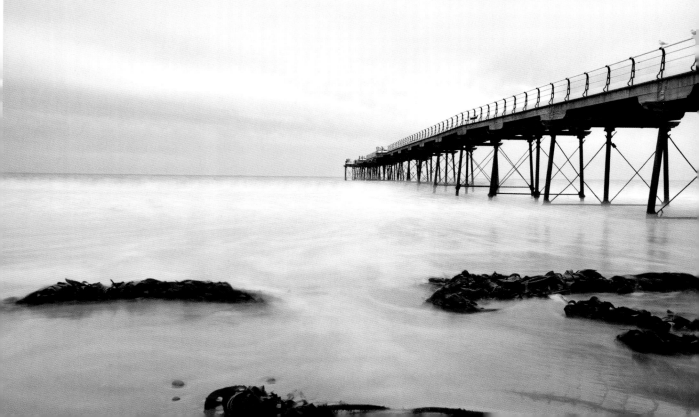

BALANCING **DIFFERENT AMOUNTS** **OF LIGHT** IN A LANDSCAPE

A common problem when shooting a landscape is getting the exposure right for both the foreground and the sky. When the sky is much brighter than the foreground it can be impossible to set an exposure that works for both of them. This usually happens when you are shooting towards the sun or when

there is no direct light on the foreground. In this situation, a neutral density (ND) graduate filter can help you to balance the exposure, but it is important to use a filter that is the right strength. If you add one that is too strong, the sky will look unnaturally dark, or the foreground may be overexposed.

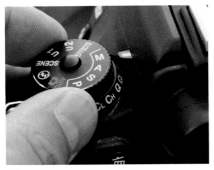

1 SELECT MANUAL
For shots like this, set the exposure for the foreground and use the filter to adjust the exposure for the sky. Manual gives you the precise control that you need for this process.

2 SELECT SPOT METERING
Switch the metering option to spot or partial metering. Neither multi-area nor centre-weighted metering are precise enough to be able to meter specific areas of a scene accurately.

3 METER THE FOREGROUND
Position the camera's spot meter area over a mid-tone in the foreground and take a reading. If there are no mid-tones in the foreground, use a grey card (see p.100) to assist you.

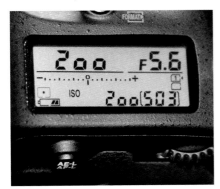

4 SET THE CORRECT EXPOSURE
Select the aperture that will create the required depth of field for the shot. Set the shutter speed so that the foreground will be correctly exposed.

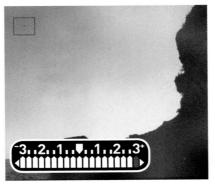

5 METER THE SKY
Position the meter over a mid-tone in the sky. The exposure index will show the variation in lighting between the foreground and the sky.

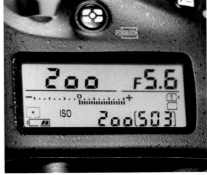

6 CALCULATE THE DIFFERENCE
Select an ND graduate filter that reduces the exposure difference to 1-stop. If the sky is 3-stops brighter than the foreground, use a 2-stop filter.

7 **ATTACH THE FILTER**
Slide the filter into the holder (see p.120), bringing the transition zone, where the filter blends from semi-opaque to clear, down to where the scene changes in brightness. Rotate the holder if this change occurs vertically rather than horizontally.

SOFT AND HARD ND GRADUATE FILTERS

The size of the transition zone varies in ND graduate filters. In soft ND graduate filters, the transition zone is subtly spread across a large area, whereas a hard ND graduate filter has a much smaller and more abrupt transition zone.

THE RESULT

The large contrast in brightness between the sky and the foreground initially meant that colour was lost in the sky. If the exposure had been set for the sky, the foreground would have been too dark. A 2-stop ND graduate filter helped to balance the two areas of the scene.

CAMERA **SETTINGS**

▼ SHOT WITHOUT A FILTER

USING **EFFECTS FILTERS**

Filters can do more than just control exposure; they can also be used to create visual effects that are not normally visible to the human eye. These effects can be subtle or dramatic. The handiest effects filter – one that you can use on a daily basis both in the studio and outdoors – is the polarizing filter. It can reduce or eliminate reflections on non-metallic surfaces, and deepen the blue of the sky. Other helpful effects filters are coloured, graduated filters, with which you can add colour to selected areas of a photo, and soft-focus filters that create a diffuse, romantic effect. Applying effects filters with careful thought can make the difference between a good photo and a great one. However, be aware that once a photo has been shot it is impossible to undo the filter's effect. You may also find that overuse of these filters can make your photos look formulaic.

SKYLIGHT AND UV FILTERS

These two filters absorb UV light, which helps to reduce the effect of atmospheric haze on your photos. They also reduce the blue cast caused by UV light at high altitudes. Skylight filters are a warm pink, and are available in two strengths: 1A and 1B. 1B adds more warmth to an image than 1A (but this warmth will be lost if Auto White Balance is selected). UV filters are completely transparent and they do not have any effect on exposure.

BEST FOR

- Reducing the effects of atmospheric haze
- Shooting in snow and ice

POLARIZING FILTER

Polarizing filters have two common uses: to deepen the blue of skies, and to reduce glare and the intensity of reflections from non-metallic surfaces. You adjust the strength of these effects by turning a ring on the front of the polarizing filter. Linear polarizers can affect the focusing and exposure accuracy of modern digital cameras and are more suited to film cameras, but circular polarizers can be used with any type of camera. A polarizing filter can also be used as a 2-stop neutral density filter.

BEST FOR

- Making water look more transparent
- Reducing glare on shiny, non-metallic surfaces
- Adding depth to sunny skies

POST-PRODUCTION EFFECTS

The effects of many – but not all – filters can be replicated in post-production. Fitting a filter compromises image quality slightly, so not using one at the shooting stage has its benefits. The simplest filters to mimic are coloured filters, which are used when shooting black and white. All good post-production software will also offer a range of black and white options that make more subtle conversion control possible than filters ever could. The effects of infrared can also be replicated in post-production by changing the relative mix of red, green, and blue in a photo. However, some filters, such as polarizing and star filters, physically affect the light that passes through the lens. As a result, their effects cannot easily be replicated by post-production software.

TAR FILTER

tar filters (also known as starburst and cross screen filters) re made of clear glass, and their surfaces are covered in a ne grid of etched grooves. These refract the light from dividual sources to produce a multi-coloured star effect. he spacing of the grid affects how many points the star has: sually four, six, or eight. A similar effect can be created by nooting with a lens set close to its minimum aperture. tar filters also add a slight soft focus to the image.

BEST FOR

- Night street scenes with multiple light sources
- Jewellery lit to produce small hard highlights
- Sunlight reflections on water

INFRARED FILTER

Infrared (IR) photography uses a part of the electromagnetic spectrum that is normally invisible to humans. The filter blocks visible light, letting only a specific range of IR through (a variety of IR filters can work with different IR wavelengths). As most sensors are designed to be insensitive to IR, you must either permanently modify your camera or fit an IR filter to your lens to take IR pictures. IR filters are very dense, and require long exposure times or high ISO settings.

BEST FOR

- Summer landscapes on sunny days
- Sunlit green foliage
- Architectural subjects such as ruins and industrial scenes

IMPROVING **VISIBILITY**

Polarizing filters are used to reduce the visibility of reflections on the surfaces of shiny subjects, such as glossy paint, water, or glass. As with polarized sunglasses, this helps to increase colour saturation, making colours look more vibrant. They also make the surface of water or glass look more transparent by removing the surface glare. A polarizing filter works best when it is at an angle of about 35 degrees to the subject's surface. You control the effects by turning the front ring of the filter. As it turns, the effect changes from minimum (no effect) to maximum (full polarization).

1 USE A TRIPOD
Since you will be taking a longer exposure than usual, mount your camera on a tripod to avoid the risk of camera shake. Look through the viewfinder and position your camera.

2 FIT THE FILTER
If you have a UV filter fitted to your lens, remove this first before you attach the polarizing filter. (Polarizing filters can be fiddly to take off when they are attached to a UV filter.)

3 ROTATE THE FILTER
Look through the viewfinder and slowly turn the filter's front ring. As it turns any glare from your subject should fade in and out. Stop rotating when the glare vanishes completely.

4 SHOOT AND REVIEW
Take some test shots where there is significant surface glare – one polarized and one unpolarized – and compare them, then increase or decrease the polarization as you see fit by rotating the filter ring.

▲ POLARIZED

▲ UNPOLARIZED

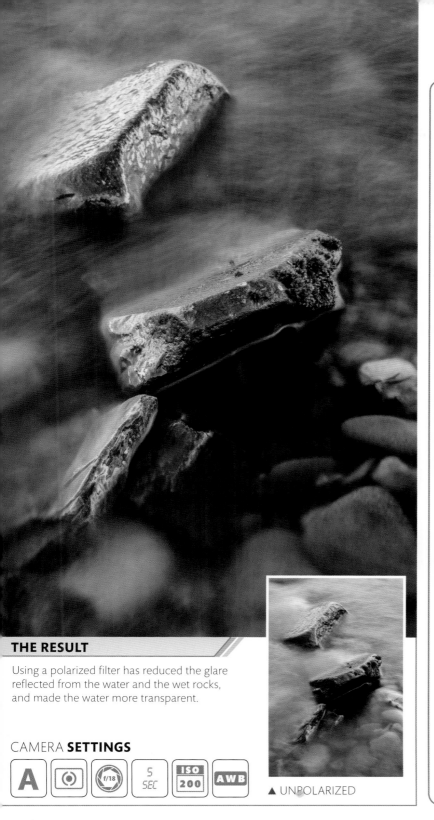

ALSO WORKS FOR...

Polarizing filters are also often used to deepen the colour of the sky, increasing the contrast with other colours in an image. The effect works best when you stand and shoot at an angle of roughly 90 degrees to the Sun.

▲ WITHOUT POLARIZING FILTER

THE RESULT

Using a polarized filter has reduced the glare reflected from the water and the wet rocks, and made the water more transparent.

CAMERA **SETTINGS**

| A | ◉ | f/18 | 5 SEC | ISO 200 | AWB |

▲ UNPOLARIZED

▲ WITH POLARIZING FILTER

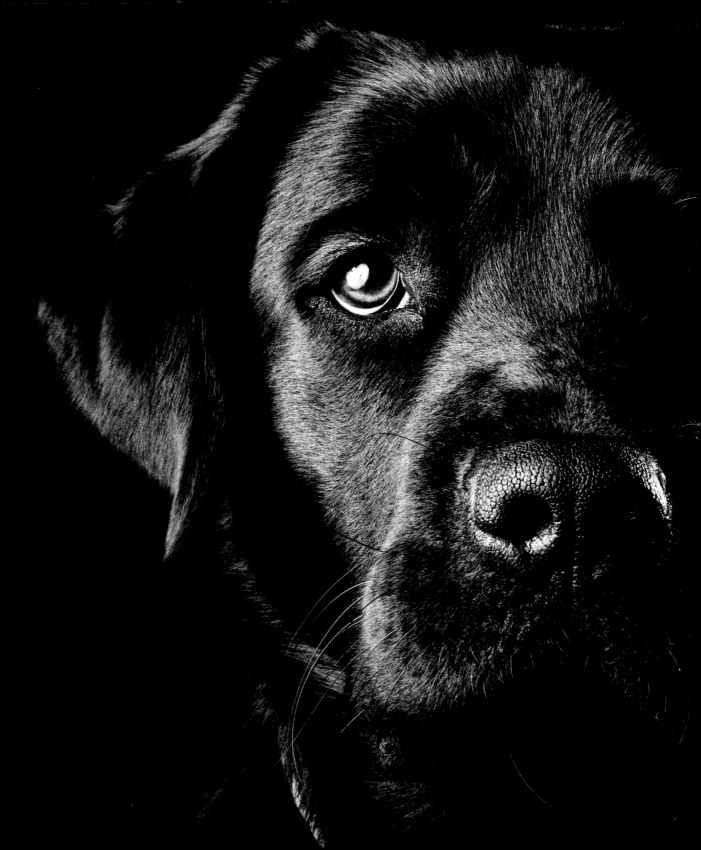

FLASH

FLASH

Flash is an effective way to add light to a scene, either as the single source of illumination or as a fill light to control the level of contrast. All flashes work in the same way. The flash head is a chamber filled with xenon gas. When the flash is triggered, an electrical pulse excites the gas so that it releases energy in the form of light. The power of a flash is determined by its Guide Number (GN): the higher the Guide Number, the greater the distance lit by the flash.

Flash exposure

There are three variables that control the effective range of a flash: its GN, the aperture setting, and the ISO. (Shutter speed only controls the exposure of those areas of a scene that are not lit by flash.) The smaller the aperture setting and the lower the ISO, the shorter the effective range. It is increased by using a large aperture or raising the ISO. The amount of light that the flash emits is controlled either by using the flash Manual exposure mode or the camera's Through The Lens (TTL) metering.

MANUAL EXPOSURE MODE	**TTL MODE**
In Manual exposure mode, you set the flash exposure by varying the power setting. At 1/1 the flash fires at full power. At 1/2 the power output is halved, reducing exposure by 1-stop. Power can usually be reduced down to 1/128.	In TTL mode, the camera calculates the flash exposure by firing a pre-flash. The camera sets the power of the flash, then the flash fires again to make the exposure.
■ Exposure is calculated by a hand-held meter and can also be determined by shooting test shots	■ Use when there is no time to set flash exposure manually
■ Lower power settings reduce the recycling time	■ Adjust flash power using Flash exposure compensation
	■ The exposure is not as consistent as Manual exposure flash

Flash power

The electrical energy to fire the flash is stored in a capacitor, which is recharged by batteries of the flash or camera after use. The time it takes to recharge is known as the flash recycling time, and this is affected by the flash power setting. The flash cannot be fired again until the capacitor is fully recharged.

SYNC SPEED

Flash can be used with any shutter speed up to the sync speed – usually between 1/150 and 1/250. If the sync speed is exceeded, the flash cannot illuminate the scene evenly, resulting in a dark band across the image. External flash often has a High speed sync (HSS) mode that makes it possible to use shutter speeds higher than the sync speed.

THE INVERSE SQUARE LAW

When a flash fires, the light spreads out in a cone shape, reducing in intensity as it travels. The amount that the light diminishes is described by the inverse square law. This means that an object that is 1m (3ft) away from the flash, for example, will receive four times more light than one that is 2m (6ft) away.

FLASH

Every time the distance doubles, the flash exposure has to be quadrupled. To do this, you increase it by 2-stops.

DISTANCE	1 metre	2 metres	3 metres
FLASH	1/1	1/4	1/9
BRIGHTNESS	100%	25%	11%

- The inverse square law applies for any flash exposure setting
- The flash-to-subject distance determines the flash exposure
- Alter the illumination by changing the flash-to-subject distance
- The background receives less light from the flash than the subject
- Light-absorbent accessories reduce the effective distance of the flash

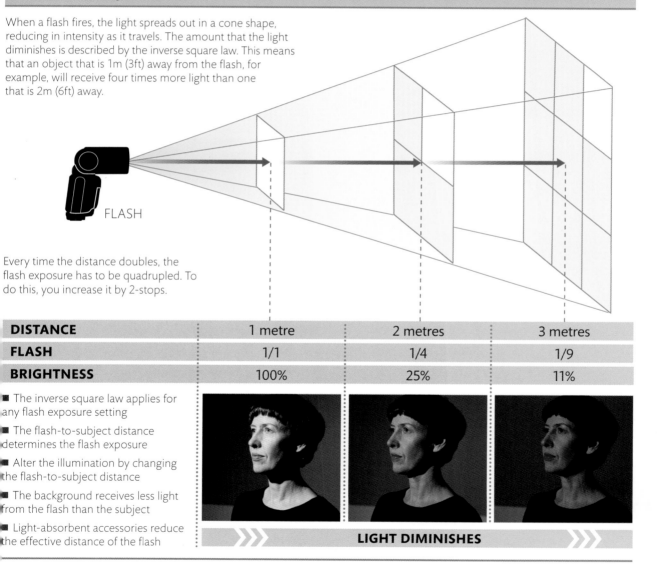

LIGHT DIMINISHES

WHAT IS **BUILT-IN FLASH?**

With a few exceptions, most compact and compact system cameras (CSCs) come with a built-in flash. These flashes are not particularly powerful, but they do have a number of uses, such as providing a fill-in light or triggering a compatible external flash wirelessly. In low light, the built-in flash can often serve as an auto-focus-assist light, to provide sufficient lighting for the camera to be able to focus. However, the built-in flash's lack of power means that there are limits to what it can do. You have to stay relatively close to your subject to avoid underexposure – usually within 3m (10ft), depending on the aperture and ISO settings that you have selected. The flash exposure generally defaults to TTL (automatic) when the built-in flash is used, and the exposure is modified with flash exposure compensation, but most dSLRs and CSCs also let you set the exposure of the built-in flash manually.

Using built-in flash

In automated exposure modes, the built-in flash fires automatically when light is low. Exceptions to this are modes such as No Flash, where the flash is turned off completely and cannot be used. You have greater control in modes such as Program, when the flash can either be set to fire automatically or is turned off until you either activate it or raise it manually. Built-in flash produces a frontal light, which is not always an ideal form of lighting. The small size of a built-in flash makes it hard – but not impossible – to modify. You can fit small diffusers over the flash to help to soften the light, or angle small pieces of white card in front of it to create a bounce flash effect, which also makes the light softer.

RED-EYE REDUCTION

If you use direct flash to light a human or animal that is looking straight at the camera, you run the risk of causing red-eye – the flash turns the pupils of the subject's eyes red, creating an unnatural effect. Red-eye is caused by light from the flash bouncing off blood vessels at the back of the subject's eyes. To combat this, a camera's red-eye reduction mode fires a burst of light from the flash just before exposure. This makes the subject's pupils contract, minimizing the likelihood of red-eye.

FILL-IN LIGHT

A fill-in light is used to light subjects in shadow or to reduce contrast. Built-in flash is ideal for this when you are shooting backlit subjects, as long as the camera is close to them. The one drawback to using the built-in flash as a fill-in is sync speed. When the ambient light levels are high, the required shutter speed may be higher than the camera's sync speed. Reducing the ISO to its minimum, using a smaller aperture, or using an ND filter to lower the shutter speed will all help.

BEST FOR

- Adding light to a backlit subject
- Illuminating subjects in shadow
- Adding sparkle to a subject's eyes

FRONTAL LIGHTING

The direction of light in relation to the camera is important. Frontal lighting comes from behind the camera – or from the camera itself if you are using built-in flash. Frontal lighting has the advantage of lighting a scene evenly so that contrast is low, making exposure metering more reliable, but it is not always aesthetically pleasing. Shadows are cast behind objects in the scene and this tends to flatten any texture, making your photo look two-dimensional. Side-lighting, when the source of light is set at 90 degrees to the camera, or backlighting, when the light source points towards the camera, are both better. Neither of these is possible with built-in flash.

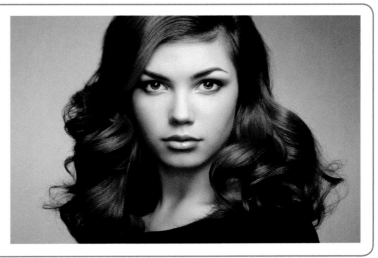

SLOW SYNC FLASH

The shutter speed that you select controls the exposure for the areas of a scene that are not lit by flash. Setting the correct shutter speed for the ambient exposure, so that the areas of the scene not lit by flash are correctly exposed, is known as slow sync flash. If, on the other hand, you want to keep these areas as dark as possible, so that your flash-lit subject is brighter, set the shutter speed as fast as possible (without exceeding the sync speed). Use a tripod in low light to avoid camera shake.

BEST FOR

- Creating a pleasing exposure across the entire scene
- Shooting at dusk when ambient light is low
- Adding blur to flash-lit moving subjects (see above)

OFF-CAMERA TRIGGER

The built-in flash in some camera models can be set to trigger a compatible external (slave) flash – the light from the built-in (master) flash is detected by a sensor on the external flash. This technique is known as optically-triggered wireless flash. As the system is light-based, the external flash has to be able to "see" the light from the built-in flash and maintain a "line-of-sight". Both TTL and Manual flash exposure are usually possible with optically-triggered wireless flash.

BEST FOR

- Using external flash for advanced lighting schemes
- Backlighting with an external flash behind the subject
- Adding multiple external flashes

USING **FLASH** IN **LOW LIGHT**

The slow sync flash technique combines using flash with a longer shutter speed. This creates a more balanced image by illuminating your subject or foreground, while allowing the background to be correctly exposed. The technique is often used at twilight, when there is still sufficient natural light.

Your subject will initially be frozen by the brief burst of light from the flash, and usually you will want your subject to remain as still as possible afterwards. However, unlike traditional flash photography, slow sync flash can also produce creative effects that combine frozen actions and motion blur.

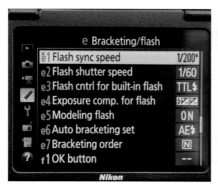

1 USE A TRIPOD
The shutter speeds used by the slow sync flash setting are usually long, making camera shake likely. Using a tripod will ensure that your camera is steady during the exposure. Although, you could choose to deliberately move the camera during the exposure to produce a creative effect (see pp.62-63).

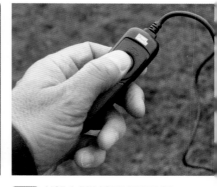

2 SELECT APERTURE PRIORITY
This mode enables you to set the correct aperture for the required depth of field. The camera will then set the shutter speed.

3 USE SLOW SYNC MODE
Different camera brands handle slow sync flash in different ways. You can use either the Flash sync speed (in Aperture Priority mode) or Slow sync on the camera's flash menu.

4 SET THE SHUTTER SYNC
If there is likely to be movement in the scene during the exposure, particularly across the image, set the shutter sync to 2nd (rear) curtain. Otherwise leave it set to the default.

5 USE A REMOTE RELEASE
It is very easy to move the camera accidentally during long exposures, so it is best to shoot the photo using a remote release, so that the risk of unwanted movement is reduced.

1ST/2ND CURTAIN SYNC

Flash can be set to fire either at the start of a slow sync flash exposure – 1st (front) curtain sync – or at the end – 2nd (rear) curtain sync. The difference is usually insignificant and generally it is safe to leave shutter sync set to either option. The exception is when your flash-lit subject moves across the scene during the exposure. If you select 1st curtain sync, the movement of the subject will create a blur in front of it. If you switch to 2nd curtain sync, the blur of the subject's movement will be recorded behind it.

▲ 1ST CURTAIN SYNC

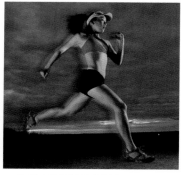

▲ 2ND CURTAIN SYNC

THE RESULT

The final shot has balanced the flash exposure and the natural light. To make the background lighter, a longer shutter speed could have been used by applying exposure compensation (see p.54).

CAMERA **SETTINGS**

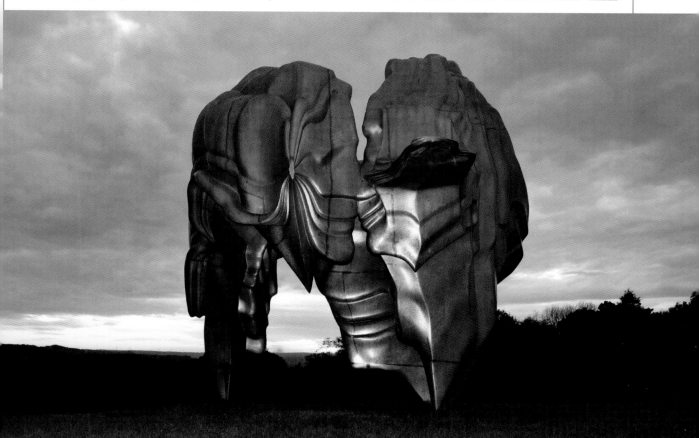

FLASH
EFFECTS

Adding an external flash – often referred to as a strobe or speedlite – to your set-up opens up a new world of creative possibilities. External flashes come in a variety of sizes and specifications, but even the smallest of them are more powerful than a camera's built-in flash. The key to buying an external flash is to strike a balance between size, weight, specification, and cost. Top-of-the-range flashes are large and heavy, and can make a CSC or small dSLR feel very unbalanced when fitted to the camera. Smaller flashes may be less powerful, but can be just as effective once you have mastered how to use them.

ADVANTAGES

- High position on the camera reduces the risk of red-eye
- Tilt head makes techniques such as bounce flash possible
- The flash can be fired off-camera for extra lighting options

DISADVANTAGES

- Bulky and adds weight to a camera bag
- Less convenient than a built-in flash
- Requires extra sets of batteries

LIGHT AND SHADE

Side lighting gives a photo a convincing sense of depth as one half of the scene is brightly lit while the other is in shadow. It is this contrast between light and shade that makes a photo look three-dimensional. Side lighting can, however, create too much contrast. This can be fixed by using a key light, or accessories such as reflectors.

FLASH TECHNIQUES

FREEZING MOVEMENT

The brief burst of light that is given off by flash makes it a good way to freeze movement. Adjusting the power changes the length of time that the flash is illuminated, altering the amount of light emitted. Use lower power settings to freeze the fastest movement, and increase the ISO or use a larger aperture to compensate.

BOUNCE FLASH

Angling a flash head to "bounce" the light off a nearby surface softens the light, creating a more pleasing effect. The surface should be neutral in colour to avoid a tint. Bouncing the flash increases the distance between the subject and the flash, so increase the flash exposure in manual exposure flash.

COLOUR CONTROL

Adding a gel to the flash alters the colour of the light. It is often done to make the colour temperature of the flash light the same as that of the ambient light. Gels are also used to add artificial colour and create particular lighting effects. Adding a gel reduces the flash exposure, so you will need to increase the power.

RANGE OF EFFECTS

DIRECT FLASH

Direct flash, with the flash head pointing straight at the subject, casts shadows behind the subject. Described as a point light source (a light that is smaller than the subject), it produces a harsh light that creates hard-edged, dark shadows and bright highlights.

DIRECT OFF-CAMERA FLASH

Moving the flash away from the camera to the left or the right creates side lighting, which is more interesting than direct flash. This is also a point light source, so the light is hard, casting deep shadows and increasing the levels of contrast.

OFF-CAMERA FLASH WITH A DIFFUSER

Adding a diffuser to the off-camera flash softens the light. Soft light is produced when the light source is larger than the subject it illuminates and a diffuser scatters light more than bare flash, effectively creating a larger light source. Shadows are now more diffuse and less dense, and contrast is lower.

BOUNCING THE FLASH

By creating a larger light source, a bounce flash softens light far more than when using just a diffuser. The shadows are soft and the highlights are less bright and distracting. The further the flash light is bounced, the softer the light effect will be.

BOUNCING THE FLASH AND DIFFUSER

Combining a diffuser with a bounce flash softens the light even more. This means, however, that there is less light reaching the subject. This technique is not suitable for smaller flashes, particularly if you are using small apertures and low ISO settings.

BOUNCING THE FLASH WITH A DIFFUSER AND CARD

Flashes often have a bounce card built into the head that can be used to bounce the light. The best way to use it is to pull the card out to its fullest extent, angle the flash head upwards, and shoot using the bounce technique. This softens the flash even more.

USING **HIGH SPEED SYNC FLASH**

Shutter speed controls the exposure of areas in the scene you are shooting that are not lit by flash. Selecting a high shutter speed is an effective way to make the background of your photo darker than the flash-lit subject, but when the ambient light levels are high, this is difficult to achieve without exceeding the sync speed. The High Speed Sync (HSS) flash mode enables you to use virtually any of a camera's shutter speeds, giving you precise control of the exposure of the background in bright light. One limitation of HSS is that it reduces the effective range of the flash, which decreases as the shutter speed increases.

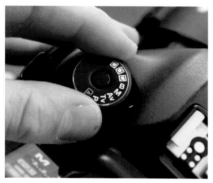 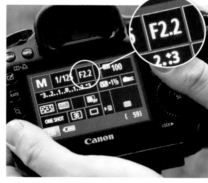 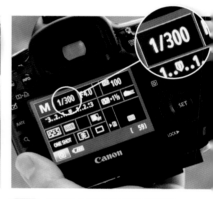

1 **SELECT MANUAL**
Switching to Manual allows you to set the shutter speed and the aperture independently of each other. Take a meter reading to find out what exposure you need for the aperture and shutter speed.

2 **SET THE APERTURE**
HSS works well when you are using a large to medium aperture, which increases the effective range of the flash. It also makes it possible to use a faster shutter speed to control the exposure of the background.

3 **SET THE SHUTTER SPEED**
The correct shutter speed for the set aperture will balance the exposure between the flash-lit subject and the background. Set a faster shutter speed to make the background darker in relation to the subject.

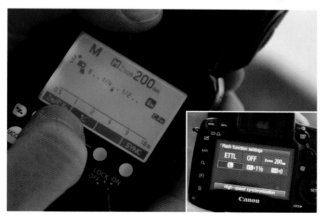 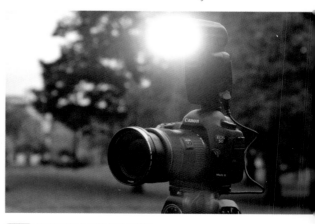

4 **SELECT HIGH SPEED SYNC**
Fit the flash to the hotshoe, then turn it on, and select the HSS mode, either on the flash itself or using your camera's flash menu options.

5 **SHOOT AND REVIEW**
Take a test shot and review the resulting photo. Make sure that the subject is correctly exposed and compare its brightness to that of the background.

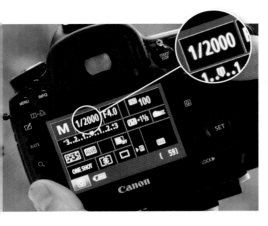

6 INCREASE THE SHUTTER SPEED

Select a faster shutter speed if you would like to make the background darker. This will not have any effect on the exposure of the flash-lit subject. People look at the brightest area of a photo first, so darkening the background is a simple way to focus attention on the subject.

TTL CORDS

To shoot HSS, you usually have to physically connect the flash to the camera via the hotshoe. To achieve a better result, however, you may want to move the flash away from the camera. You can do this by connecting the camera and flash using a TTL cord. These are camera-specific and are available in a variety of different lengths.

THE RESULT

Using high-speed sync flash has evenly lightened the subject so that it creates a clear focal point in the photo. Without HSS, the subject would be too dim in the ambient light.

▼ WITHOUT HIGH SPEED SYNC FLASH

CAMERA **SETTINGS**

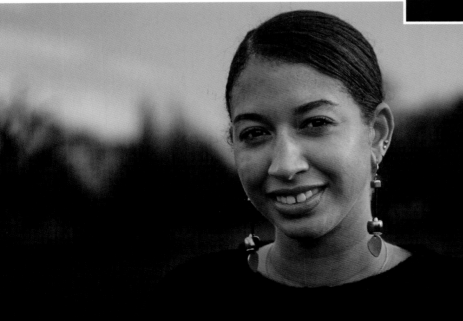

USING **MANUAL EXPOSURE FLASH**

Unlike with TTL settings, manual flash puts you in full control of flash exposure, with no automation to guide you. This means that it is not ideal for situations where the flash-to-subject distance is likely to change often, such as at social events. Once you understand the relationship between the effects of aperture, flash power, and ISO however, and have had some practice, manual flash becomes surprisingly intuitive to use.

When to use manual exposure flash

The TTL flash setting is convenient but, like the camera exposure meter, it can make mistakes with exposure when the reflectivity of a scene is lower or higher than average, and the results can be inconsistent. Manual flash will not vary in exposure once you have correctly set the aperture, flash power, and ISO. With manual flash you also have more control over the amount of light that is emitted by the flash throughout its duration than in TTL. This is necessary for techniques such as freezing movement using high speed flash.

FLASH DURATION

Set at full power, the burst of light emitted by a flash lasts for about 1/800 second. If you halve the power, this shortens to 1/1600 second. The lower the power used to achieve a correct exposure, the more the flash freezes movement, and the faster a subject moves, the less power you need to use. However, lower power shortens the range of the flash, so you may need to set a larger aperture, a higher ISO, or both.

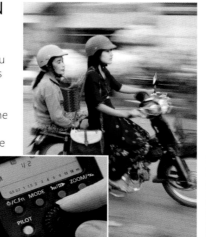

EXPOSURE

APERTURE

For every stop that you make the aperture smaller, the effective range of flash decreases by around a third. To maintain the same level of exposure, you will either need to raise the ISO by one stop or double the power output of the flash.

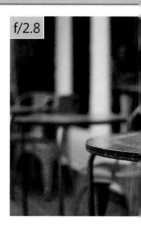

f/2.8

FLASH POWER

Every time that you halve the flash power, you reduce the effective range of the flash by about a third. But the advantages of doing this, if you open up the aperture or increase the ISO, are a shorter flash duration, a faster flash recycling time, and that the flash batteries last for longer.

Full

ISO

Raising the ISO setting increases the effective range of the flash. For every doubling of the ISO, the effective range increases 1.4x; to double the effective range, the ISO needs to be quadrupled. Increasing the ISO will also affect the exposure of areas not lit by flash, making them brighter.

100

MORE DEPTH OF FIELD

f/2.8 f/4 f/5.6 f/8 f/11 f/16

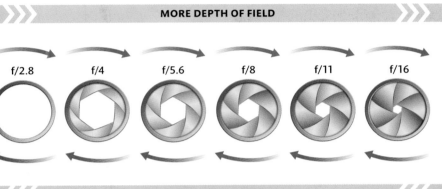

LESS DEPTH OF FIELD

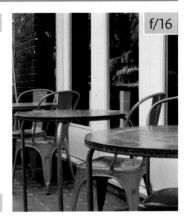

f/16

FASTER RECYCLING

FULL 1/2 1/4 1/8 1/16

SLOWER RECYCLING

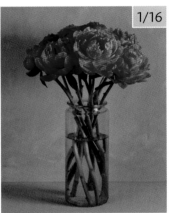

1/16

MORE NOISE

100 200 400 800 1600

LESS NOISE

1600

MANUALLY SETTING FLASH POWER

Automatic flash metering (TTL) is convenient but it can lead to inconsistent results, particularly if the scene's level of reflectivity changes between shots. Shooting with manual exposure flash, although initially more time-consuming, is more consistent providing your subject is not going to move; once the camera and flash are set correctly, you can shoot knowing that the exposure will not change. The most precise way to set flash exposure is to use a hand-held meter with a flash metering function. However, by shooting a series of test shots and adjusting exposure after viewing the results, it is possible to use manual exposure flash easily without one. You can also buy cheaper, non-proprietary flash heads for manual flashes.

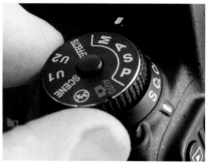

1 **SELECT MANUAL**
This mode lets you set the aperture and shutter speeds. Only flash exposure is affected by the aperture setting; the shutter speed controls the exposure of areas in the frame that are not lit by flash.

2 **SET THE CAMERA EXPOSURE**
Set the aperture for the required depth of field. Next, either set the shutter speed to the sync speed, which will darken the background, or to a slower speed to lighten the background.

3 **SET THE FLASH TO MANUAL**
Flash exposure is not automated in Manual mode; the amount of light produced by the flash is controlled by its power setting. At 1/1, the flash emits the maximum amount of light.

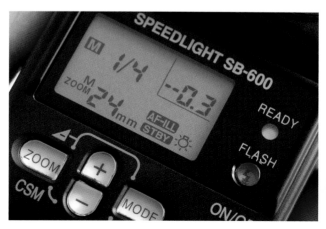

4 **SET THE FLASH POWER TO 1/4**
You can raise and lower the flash power. A good starting point is 1/4 (a quarter of its power). At this setting, the flash will recharge rapidly and won't drain the batteries as quickly as 1/1.

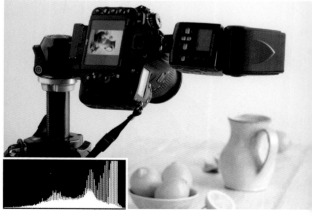

5 **SHOOT AND REVIEW**
Shoot a test shot and review the results on your camera's LCD screen. Look at the highlights in particular to see if they are correctly exposed. Use the histogram to check the exposure.

ISO AND FLASH

The ISO setting on your camera has an effect on the flash exposure. If you double the ISO, it increases the effective range of the flash by a factor of 1.4. If you are shooting close to your subject with flash, it is best to use a low ISO setting and a small aperture as these are less likely to cause overexposure. The higher the ISO, and the larger the aperture you set, the greater the reach of the flash. One drawback to using a high ISO is that it may make the shutter speed higher than the flash sync speed. In this case, you can either lower the ISO or switch to a high speed flash.

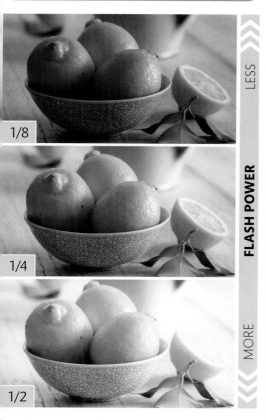

LESS

FLASH POWER

MORE

1/8

1/4

1/2

6 **VARY THE FLASH POWER**
If the exposure is incorrect adjust the flash power in increments of one stop, doubling or halving the power with each stop. Re-shoot and review the exposure until you are happy with the results.

THE RESULT

The final shot, taken with the flash power set to 1/4, has a good overall exposure, without burnt-out highlights. There is also a pleasing balance in exposure between the flash-lit foreground subject and the naturally lit background.

CAMERA **SETTINGS**

 1/125 SEC

ISO 100

USING **WIRELESS FLASH**

Taking flash off-camera immediately increases the number of ways in which you can light a scene. By fitting the flash on a light stand, you can position it where you like in relation to your subject, and can alter its height and angle. Using a stand for your light also makes it easier to modify it with accessories such as softboxes and beauty dishes, to create a softer light than is possible with bare flash alone. To fire flash off-camera, the camera has to communicate with the flash. This can be done using TTL cords that create a wired connection between the two. However, cords place a limit on how far apart the camera and flash can be, and it is easy to trip over them. Wireless flash is far more convenient. This connects the camera and a flash using either pulses of light or radio signals.

OPTICAL WIRELESS FLASH

This type of wireless flash uses the light from the master flash (see box right) to trigger the slave (secondary) flash. The built-in flash of modern dSLRs and CSCs often works wirelessly when paired with compatible off-camera flashes. The built-in flash acts as the master unit.

Built-in flash

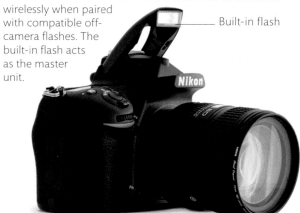

RADIO WIRELESS FLASH

There are currently no cameras available with a built-in radio flash trigger, so you need to add a radio trigger to your camera's hotshoe. This communicates with compatible flashes, so you can use it to alter the flash settings.

Radio trigger attached to hotsho

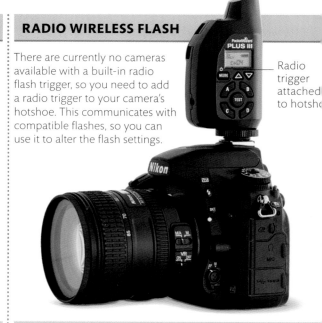

ADVANTAGES

- Only one compatible flash needed. You can add extra flashes
- Simple to set up using the camera's flash menu
- TTL exposure is usually supported

DISADVANTAGES

- Has a limited range, particularly outdoors
- You have to maintain line-of-sight between the flashes
- High speed sync is not usually available

ADVANTAGES

- Has a huge range and is not affected by location
- The flash can be placed anywhere, no line-of-sight needed
- There is no master flash to add unwanted extra light

DISADVANTAGES

- Has to be fitted to every flash without a built-in trigger
- Not all radio triggers support TTL flash exposure
- The radio trigger and external flash require batteries

MASTER AND SLAVE FLASHES

A master (or commander) unit is the trigger that controls how and when a slave flash fires. The master flash is usually either fitted onto the camera, or connected to it, whereas a slave flash is set up on its own, away from the camera.

A master flash that has neither an optical sensor nor the facility of built-in radio triggering can be temporarily modified using either an optical slave flash or a radio trigger accessory. Both of these fit onto the master flash's hotshoe and instruct the slave flash when to fire.

ZOOM FLASH

The zoom control of a flash enables you to vary the width of the light given off by the flash when it fires. The zoom usually adjusts automatically, to match the focal length of the lens and thereby ensure that there is an even spread of light in the photo. The zoom range is usually from 24-105mm (full-frame equivalent). Some flashes also have a wide-angle adapter screen in the head, which you can pull out to spread the light more widely when you are using lenses that are wider than 24mm. You can also adjust the zoom manually. Using the zoom at its longest setting produces a narrow beam of light that enables you to illuminate one specific part of a scene to a greater extent than its surroundings.

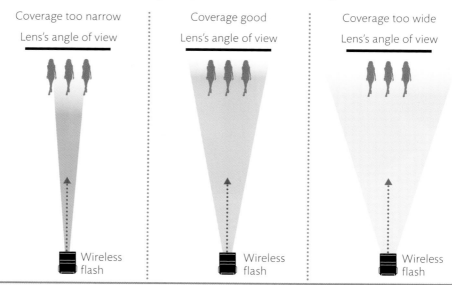

Coverage too narrow — Lens's angle of view — Wireless flash

Coverage good — Lens's angle of view — Wireless flash

Coverage too wide — Lens's angle of view — Wireless flash

CHANNELS

Both the trigger (regardless of whether it is optical or radio) and the flash need to be assigned to the same channel, typically one of four. This ensures that the trigger can connect to the flash without interference. If two or more people are using wireless flash in the same area, they should each use a different channel, to prevent one person's trigger from accidentally firing the other person's flash.

A group consists of two or more wireless flashes that share the same exposure setting. You can usually set up multiple groups, all of which are

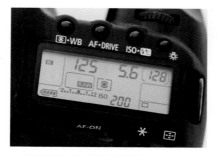

▲ CAMERA FLASH SETTINGS

fired by the master flash or radio trigger. The advantage of creating multiple groups is that it enables you to vary the light output of each group

▲ FLASH CHANNEL SETTINGS

for creative effect, using one group of flashes as the main light. All the groups that you set up, however, still have to share the same channel number.

USING **MULTIPLE FLASHES**

Adding a second off-camera flash to your set-up increases the ways in which you can light your subject. When you use two light sources, whether flash or studio lighting, one of them is the main or key light, and the other is the fill light, which is used to control the amount of contrast. This set-up is useful when you are shooting indoor portraits. The greater the difference in the brightness of the two light sources, the higher the resulting contrast in the image will be. The simplest way to vary the relative brightness of two flashes is to alter their power when they are both set to Manual mode.

1 POSITION THE FLASHES
Set up the two flashes on either side of your subject, an equal distance away and at head height. For a long vertical portrait, angle them so that the flash heads are vertical.

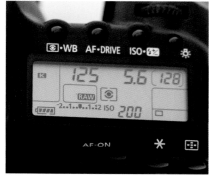

2 SET THE EXPOSURE
Set the camera to Manual, and select a shutter speed. To minimize the influence of ambient light, set the shutter speed at, or near, the sync speed. Set a mid-range aperture such as f/5.6 or f/8.

3 SET THE FLASHES TO MANUAL
Select Manual mode on both flashes. Decide which of the two flashes will be your key light and which will be the fill light.

4 SET THE LIGHTING RATIO
Start by setting your key light flash to 1/2 power and the fill light flash to 1/8, to provide a lighting ratio of 4:1.

5 TAKE A TEST SHOT
Review your shot and assess the exposure. If you need to adjust it, increase or decrease the flash power by an equal amount on both flashes.

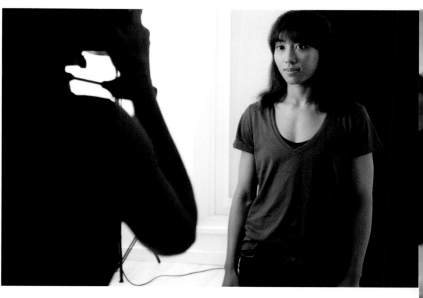

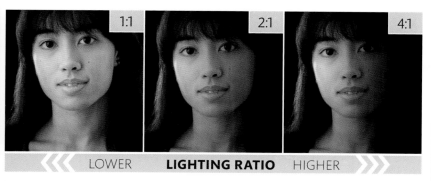

1:1 2:1 4:1

LOWER **LIGHTING RATIO** HIGHER

LIGHTING RATIOS

A lighting ratio is the difference in brightness between two light sources. When there is no difference and both light sources are the same brightness, the lighting ratio is 1:1. This produces even lighting across your subject's face. In relation to f-stops, a 1-stop difference produces a lighting ratio of 2:1. For portraits, a 2-stop difference or 4:1 lighting ratio is a good starting point.

6 VARY THE LIGHTING RATIOS

Take a number of shots, varying the difference in the power of the flashes each time to see what works best. To create more even lighting, increase the power of the fill light flash. To add contrast, reduce the power.

THE RESULT

A low lighting ratio (2:1), with the flashes set to a similar brightness, has cast soft, fairly even lighting across the subject's face. More contrast could have been achieved with a higher lighting ratio

CAMERA **SETTINGS**

 1/180 SEC ISO 200

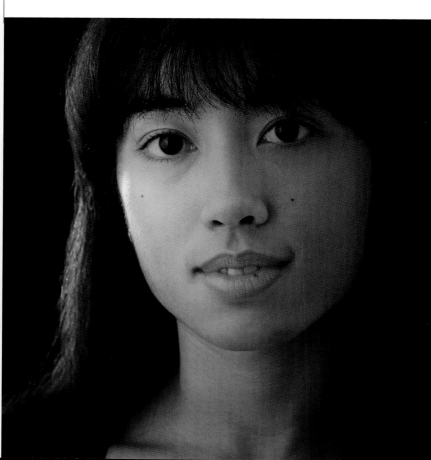

ALTERING FLASH COLOUR

Flash light has a neutral colour temperature, unlike most artificial lights such as incandescent bulbs, so if you mix flash with another light source, you cannot set the correct White Balance (WB) preset. Using the Flash preset will make areas of the scene that are not lit by flash look orange if there is artificial lighting, whereas using Tungsten will make light from the flash look blue. The solution is to fit a gel to the flash head, as this alters the colour of the flash to match the other light source. You can buy gels by the sheet, then cut them down and tape them to your flash, or add them to commercial gel holders that are fitted to the flash.

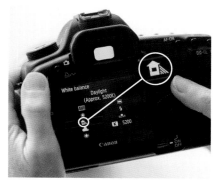

1 SET THE WHITE BALANCE
Select the WB preset for the ambient lighting or set its Kelvin value (see p.45). For internal lights, this is often provided with a light's packaging or can be found on the manufacturer's website.

2 FIT A FLASH GEL
Select and attach a gel to the flash head that will make the colour temperature of the flash match the WB of the ambient light. Here, a blue gel was used to match the ambient light.

3 SELECT APERTURE PRIORITY
Set the aperture to create the depth of field that you want. Fitting a gel reduces the range of the flash slightly, so increase the ISO by one or two stops, particularly if using a small aperture.

4 SHOOT AND REVIEW
Take a test shot and check it to make sure that the colour balance is neutral across the entire image. If it is not, add a second gel of a lower strength to the one you have already fitted, or change gels.

5 ADJUST THE FLASH EXPOSURE
Check the photo to make sure that the exposure is alright, as fitting a gel can cause slight underexposure. If this is the case, increase the flash exposure, use a larger aperture, or increase the ISO.

GELS FOR ARTIFICIAL LIGHTING

The most common use for gels is to match flash light to either tungsten or fluorescent lighting. To match tungsten lighting, which is warm, you should fit a Full CT Orange (204) gel to the flash. Fluorescent lighting has a slightly green tint, so add a Half Plus Green (245) gel to the flash head. You can buy gels in strengths of a quarter, a half, and full, which enables you to vary how much you alter the flash light. You can also mix and match different types of gels to suit more unusual types of lighting. Combining different gels of varying strengths can reduce the need for colour correction in post-production.

▲ WITHOUT ORANGE GEL ▲ WITH ORANGE GEL

THE RESULT

The colour balance of the image works well, as the WB of the flash-lit subject matches that of the background. Matching the WB of two different light sources makes fine-tuning in post-production simpler.

CAMERA **SETTINGS**

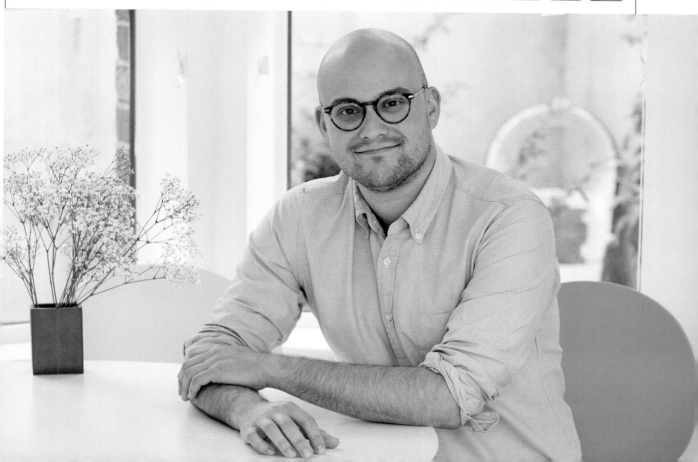

IMAGE
ENHANCEMENT

IMAGE ENHANCEMENT

Capturing a photo is just the beginning: if you use Raw, you can process your photos in countless ways. Having a clear idea of what you want to achieve when you start enhancing photos post-production will save time later, but you can go back to Raw files months or even years after shooting. Personal tastes change over time, so you may often find yourself working on old photos as well as current ones.

Post-production software

There are two types of post-production software available. Straight image-editing packages, such as Adobe Photoshop, essentially restrict you to working on one photo at a time. They offer few (if any) image-management tools, and once you have completed editing a photo, it is saved as a "finished" file (unless you make and work on a copy of the photo). Database-driven "workflow" packages, such as Adobe Lightroom, enable you to edit images, but also provide options for you to manage your photo collection, add keywords, and even to geo-tag your photos. A key advantage of this software is that all the edits that you make are non-destructive – they are stored in the database rather than being applied directly to the imported photo. The edits are only applied to the exported file. This also applies to JPEGs that have been imported.

TETHERED CAPTURE

Some post-production software lets you capture photos straight to your computer – a technique known as tethered capture. Being able to view your photos on the larger screen makes tasks that require composition or close attention much easier. Also, as soon as an image has been shot, it is transferred straight to your computer's hard drive, where you can process it immediately.

SUGGESTED WORKFLOW

IMPORT

To import photos, you connect your camera and computer via a USB cable, or by using a card reader. How long this takes depends on the read/write speed of the memory card and the USB specification of your computer.

BACK-UP

Always back-up your photos to an external hard drive to reduce the risk of losing data. Better still, keep a back-up hard drive and swap them regularly. Cloud storage is good for storing smaller files, such as JPEGs.

MANAGE AND ASSESS

Adding keywords and a description to photos can help you to track them down later. Most workflow editing software gives you options to add labels, which you can use to sort your photos into categories.

Adjustments

There are far more post-production adjustment options than can be covered in this book. However, most photos – as long as you made the right choices when shooting – should only need tweaking a little, using just a few adjustment tools. The most useful of these are shown below.

ADJUSTMENT	BEFORE	AFTER
ROTATE AND CROP There are two reasons to crop a photo: to remove unwanted details around the edges, or to change the aspect ratio so that you can improve the composition. You can rotate a photo dramatically to change its orientation, or apply it more subtly to straighten out key elements.		
EXPOSURE The Exposure adjustment enables you to correct any errors in exposure and to adjust the photo's brightness to your taste. You can also use it to create a high- or low-key photo (see p.72). Lightening a photo can, however, increase the visibility of noise, particularly in areas of shadow.		
WHITE BALANCE The colour temperature of a JPEG can only be adjusted crudely, to warm it or cool it down. With Raw, you can select any preset or specific Kelvin value without losing quality. You can also use the White Balance colour picker to take a White Balance "reading" from a neutral area of the photo.		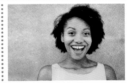
CONTRAST Lowering the contrast in a photo can make it appear flatter and greyer, as all the tones can be pushed closer to a mid-grey. Increasing the contrast pushes tones further apart, making the shadows darker and the highlights brighter, and colours appear more saturated.		
SHARPENING This option helps to emphasize details and reveal texture. How much you apply sharpening varies according to how the image is to be used. Input sharpening, applied after import, is normally moderate; output sharpening, when you are preparing a photo for printing, is usually more extensive.		

ADJUST

Make any alterations to your photos. If you have shot a sequence in the same conditions, adjust one photo to your liking and then apply the same settings to the others. This saves time, even if the photos need fine-tuning.

EXPORT

Export Raw photos to a more useful type of file, such as JPEG. At this stage, you can change settings such as resolution. Photos for screen use can be lower in resolution than those that you want to print.

PRINT

Creating prints is the ultimate way to view photos, as prints have a tactile quality that screen images lack. Printing involves making aesthetic choices and can be just as creative as shooting photos.

USING **EDITING SOFTWARE**

The software that you use to edit your photos is very much a personal choice. You can often download a 30-day trial version of commercial software, which is long enough to find out whether it suits the way that you work. Many cameras also come with free software on a disk, or available to download. Another option is open-source software, which is often inexpensive, sometimes free, and can even rival commercial software in terms of features.

Global and local corrections

There are two broad types of correction that you can make to a photo: global and local. A global correction is applied to the entire photo and affects each pixel in the image equally. A local correction is just made to a specific area of the photo. As a rule, you should make global image corrections, such as WB or exposure, first. Once you have done this, you can then start to fine-tune specific areas of the photo that need extra work, using tools such as the dodging and burning brushes.

SOFTWARE PLUG-INS

Some image adjustments involve several different steps and are time-consuming, but you can save time by using presets to automate tasks, especially complex adjustments that you make regularly. Adobe Photoshop and Adobe Lightroom also support plug-ins. These are third-party "mini-apps" that are added to the software to increase specific editing capabilities, such as making black and white conversions easier. Plug-ins often use a custom interface that differs from the standard interface of the host software. This means you have to learn another way of working, but the time you save makes this worthwhile.

GRADUATED FILTER

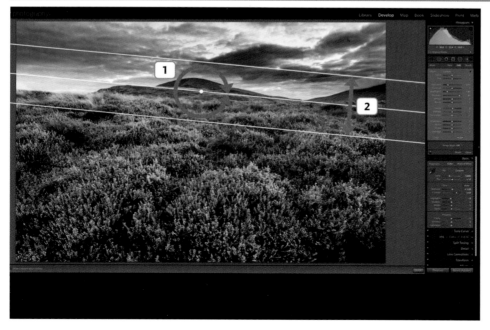

Lightroom's Graduated filter lets you locally adjust exposure, sharpness, and saturation. Select the Graduated filter tool, then click and drag the image to add a gradient. You can add multiple filters for different adjustments. To remove one, click on its pin and press delete.

1 You can rotate graduated filters, using the pin as the rotation point. Drag the pin to move the filter around.

2 The two outer lines of the Graduated filter define the gradient. Pulling the lines further apart softens the effect.

Sensor dust

Digital sensors have an electrical charge that attracts dust and other small particles, which stick to them. This is not a problem for cameras with a fixed lens, but dSLRs and CSCs both let dust into the camera body every time that you change the lens. Over time, dust can build up on the sensor, becoming visible in your photos as small, diffuse grey disks, particularly in light areas or on even tones, as in the sky. CSCs are more prone to problems with dust than dSLRs, as their sensors are not protected by a shutter. There are several solutions to sensor dust, some of which are applied when you shoot and others in post-production.

CLEANING A SENSOR

Sticky or wet particles such as pollen have to be removed from the sensor using sensor cleaning tools. The simplest way is to use a sensor swab with a few drops of sensor cleaning fluid on it. Gently wipe the swab across the sensor, once only on each side, to remove the particles. DSLRs usually have a mirror lock-up function specifically for cleaning the sensor.

APERTURE AND LENS TYPE

The visibility of dust is affected by the lens and aperture that you use. The greater the depth of field, the more visible dust will be. If you use large apertures and long-focal-length lenses, you may never see dust in your photos. Landscape photographers have to clean their sensors regularly, as they work in dusty environments and tend to maximize depth of field.

AUTOMATIC REMOVAL

Most modern dSLRs and CSCs have automatic dust removal systems that physically shake the sensor, making dust fall off. These systems can be set to activate when the camera is turned on or off, or as necessary after selecting the sensor cleaning option. The dust removal cycle is a far easier task than cloning out dust spots in post-production.

DIGITAL REMOVAL

Dust can be removed in post-production using a number of tools. The simplest is the Spot Healing Brush, with which you "paint" over the dust. The software then automatically replaces it with patches of colour and texture similar to the area around the brush. The Clone Stamp tool is more complex, but gives you better control over what you patch-in to replace the dust spots.

ADJUSTMENT BRUSH

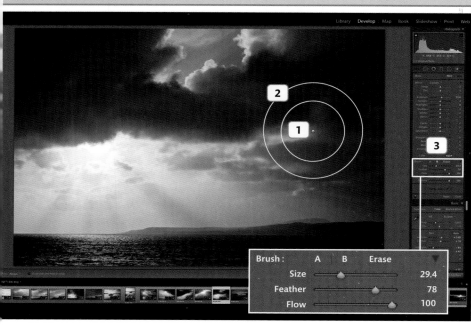

Lightroom's Adjustment Brush tool enables you to paint local adjustments onto your photo. You can create two brushes and alternate them to vary the Size, Feather, and Flow. The brushes can also be set to Erase to remove adjustments.

1 A brush is shown by a pin. Select it to move or delete an adjustment.

2 Size alters the brush's dimensions. Feather sets how soft the edge is.

3 The Flow slider sets how quickly the effect builds up. A low Flow value lets you increase it gradually.

LIGHTENING AND DARKENING

Dodging and burning are simple but useful ways to improve selected areas of an image. Dodging is lightening an area of a photo and burning means to darken an area. Both terms come from techniques used in the darkroom on analogue prints. As with any image enhancements, you must be careful not to go too far and aim to retain some detail in the area you are working on. Both tools let you vary the strength of the adjustment. It is a good idea to start with a low strength and apply the effect gradually. If you need to correct a photo's overall exposure, do that before dodging and burning.

1 ASSESS THE PHOTO
Open the photo in editing software (Adobe Photoshop was used here) and decide which areas of your photo you would like to adjust. Select either the Dodge or Burn tool.

2 CHOOSE THE BRUSH SIZE
A brush that is over 1,000 pixels in size is ideal for adjusting large areas of a photo, such as sky. However, for a more targeted adjustment, such as here, select a smaller brush size.

3 CHANGE THE HARDNESS
Use the Hardness slider to set how marked the adjustment will be. A high value creates a very crisp-edged effect. A low value results in a more subtle adjustment.

4 SET THE TONAL RANGE
Use the Range menu to select the part of the tonal range of your photo that you want to change with the tool. Here, Midtones has been selected.

5 SELECT THE EXPOSURE
Adjust Exposure to control the tool's strength. Start with a low value so that you can increase the effect slowly. You can always raise the exposure.

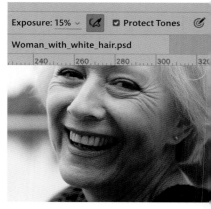

6 SELECT PROTECT TONES
Check Protect Tones, so that colour will only get lighter or darker as you brush. If it is left unchecked, colours can change.

SHADOWS/ HIGHLIGHTS

The darkest and lightest areas of a photo can be adjusted globally (across the entire photo) using the Shadows/Highlights tool. In Raw editing software, you can use Shadows/Highlights to recover image detail from highlights that are only slightly clipped (when detail in highlights or shadows is lost). Be careful though – heavy-handed use of this tool can lead to flat photos that are low in contrast.

7 **LIGHTEN THE IMAGE**
Move the tool gently back and forth over the area that you want to adjust. Stop every now and again to assess the effects. is better to adjust the image a little at a me and to go over it again rather than to y and apply the adjustment in one go.

8 **DARKEN THE IMAGE**
To darken an area, such as this highlight on the forehead, select the Burn tool and repeat the same steps as for using the Dodge tool, moving the brush gently backwards and forwards, a little at a time, until you are happy with the result.

THE RESULT

Here, the Dodge and Burn tools have been used to lighten areas of shadow and to modify (darken) a highlight on the subject's face. The results look natural and subtly enhance the photo without it looking processed.

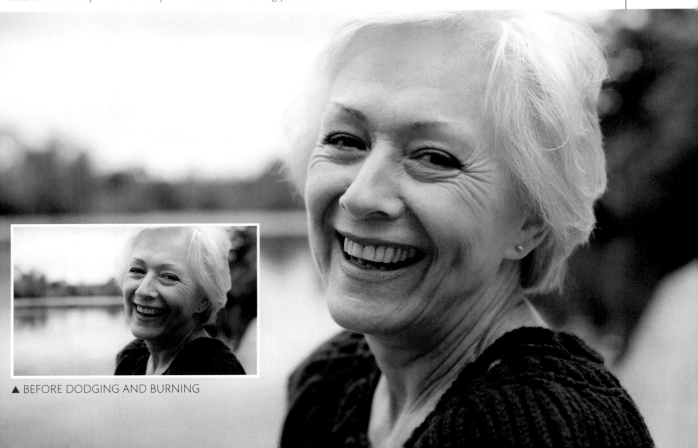

▲ BEFORE DODGING AND BURNING

CORRECTING **SUBTLE FLAWS**

No lens is perfect – even the most expensive lenses can produce photos with aberrations or distortions. Adobe Lightroom's Lens Correction panel offers a range of options for correcting these flaws. With a few notable exceptions, such as older manual-focus or adapted lenses, information about a lens is added to the metadata (see p.178) of every photo that is shot with it. Lightroom has a number of built-in profiles for specific lenses, which enable you to automatically correct lens flaws on multiple photos at the same time. For the best results, apply profiles to RAW files, as JPEG formats may produce inconsistent results.

1 **AUTOMATIC CORRECTION**
Chromatic aberrations and distortions are only visible if you examine the photo very closely. Check Enable Profile Corrections. If a lens profile is not automatically selected, use the Make/Model/ Profile menus to find out if the profile for your lens is available.

2 **MANUAL CORRECTION**
If a profile for your lens is not available, or if you want to make adjustments selectively, click on Manual. This allows you to make adjustments to distortions and vignetting, and to crop the photo yourself (see steps 3, 4, and 5).

3 **ADJUST DISTORTION**
Move the slider right (applying a positive value) to correct barrel distortion, or to the left (applying a negative value) to correct pincushion distortion (see p.95).

4 **CORRECT VIGNETTING**
Move the Amount slider to the right to lighten the corners, or to the left to darken them. A high Midpoint value pushes the effect further into the corners; a low value spreads it towards the centre.

5 CROP THE IMAGE
Check Constrain Crop to automatically crop the photo and remove any curved edges that were created when correcting distortion in step 3.

REMOVING CHROMATIC ABERRATIONS

The Remove Chromatic Aberration tool automatically counters the effects of red/green or blue/yellow chromatic aberration, but it does not remove the purple/green fringing often seen when using fast prime lenses at maximum aperture. This can be removed by selecting Defringe and then adjusting the Amount and the Purple and Green Hue sliders (see left).

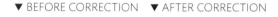

THE RESULT
If you are careful with your adjustments, you can straighten out subtly bowed lines in buildings (see p.100). Here, fringing (see above) and vignetting (see right) have also been removed.

▼ BEFORE CORRECTION ▼ AFTER CORRECTION

ADJUSTING **SHARPNESS**

Most camera sensors are designed to produce slightly soft images, to counteract the effects of moiré, an interference pattern seen when shooting detailed subjects such as fabric, so the images need to be sharpened. JPEGs are usually sharpened in-camera, but Raw files have to be slightly sharpened in post-production (input sharpening). You need a heavier degree of sharpening (output sharpening) if you plan to print a photo, as ink tends to spread, softening the print. In Adobe Lightroom (the editing software that has been used in this step-by-step guide) holding down Alt (Windows)/ Option (Mac) whilst moving the sliders helps to preview the effects of sharpening by briefly changing the photo to black and white.

1 **ASSESS YOUR IMAGE**
Open your photo at 100% magnification in the editing software of your choice (here, Adobe Lightroom was used) and check how sharp it is. Sensor softness is a slight blurring of fine detail. Open the Detail panel in Lightroom and locate the sliders that control sharpening. First, set the Amount; the higher the value you select, the sharper the image will become. Going too far, however, will make the image look odd.

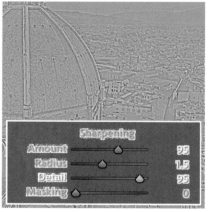

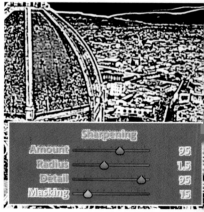

2 **SET THE RADIUS**
The Radius slider sets the size of the area being sharpened around edges in the photo. A high value increases sharpness but may create a halo effect (light band) around the edges.

3 **SET THE DETAIL**
Adjusting Detail changes the emphasis given to edges. The higher the value, the sharper the textural details. Hold Alt (Windows) / Option (Mac) while moving the slider to preview the result.

4 **SET THE MASKING**
Areas of even tone, such as sky, do not need sharpening. Set a high Masking value, as this will protect even tones from being sharpened. Again, hold Alt / Option to preview the result.

CREATIVE USE OF BLUR

Photos do not have to be pin sharp, even when they are printed. Deliberately shooting a subject out-of-focus can be very effective, particularly if it is a bold shape or brightly coloured. The lack of sharpness adds an element of ambiguity, making the viewer wonder how to interpret the image. You could also try using a shallow depth of field, as this helps to simplify a photo by placing the main emphasis on the subject, which should in sharp focus.

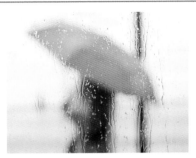

▲ OVERALL BLUR

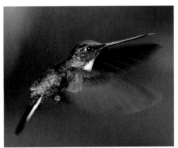

▲ SELECTIVE BLUR

THE RESULT

Subjects with a lot of fine detail, such as the cathedral and other buildings in this image, benefit from moderate sharpening. Here, it has accentuated the detail in the tiles of the cathedral, and the edges of the surrounding buildings. The degree of sharpening that you apply to an image will vary, depending on the subject.

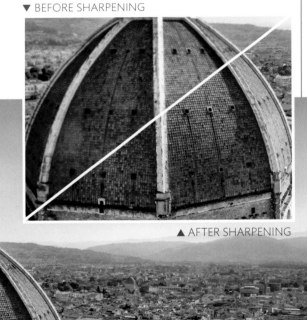

▼ BEFORE SHARPENING

▲ AFTER SHARPENING

BLACK AND WHITE PHOTOGRAPHY

Although colour photography was invented in the late 19th century, it did not replace black and white as the medium of choice until relatively late in the 20th century. Black and white photography is not obsolete however; it has a timeless quality that appeals to amateur and professional photographers alike.

A black and white photo is composed of a monochromatic range of tones. You can either take photos in black or white or make your photos monochrome in post-production. If you want to enhance your black and white photos even further, you can also apply tints and techniques such as split toning.

Choose your subjects carefully

Not all colour photos or subjects are good candidates for conversion to black and white. Any subject that relies on colour for impact, particularly when the various colours in the photo are similar, is generally not ideal. What does work is contrast, whether it is contrast in brightness or contrast in colour. If the various colours in a photo are distinct and can be separated tonally using filtration or in post-production, then it will be easier to convert a photo into black and white after you have shot it.

SUITABLE

- Good tonal and colour range
- Contrast quite high, bright clouds and dark shadows

- Red filtration darkens sky
- Strong highlights and shadows

UNSUITABLE

- Low contrast photo with limited range of colours
- Delicate pink of flower an important feature of subject

- Flat, little visual interest
- Lack of definition, flower merges into background

Coloured filters

Filters lighten colours that are similar to themselves and darken those on the other side of the colour wheel. Try using different filters to see what works best, depending on your subjects. There are options to mimic physical filters on the Monochrome colour setting in-camera.

LANDSCAPE	PORTRAIT
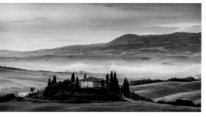	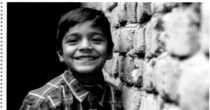

▲ No filter ▲ No filter

EFFECTS OF COLOURED FILTERS ON BLACK AND WHITE IMAGES

YELLOW

- Deepens blue tones slightly; adds contrast to the sky
- Lightens yellow/green foliage
- Lightens skin tones and any freckles

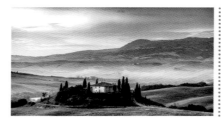 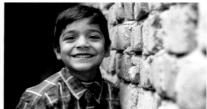

RED

- Red sky burns out
- Reduces the effects of haze and fog
- Skin tones over-lightened and look unnaturally pale

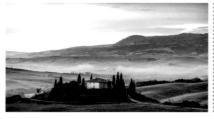 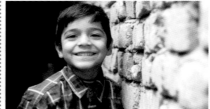

GREEN

- Lightens blue sky slightly
- Lightens green foliage and increases contrast with brightly-coloured flowers
- Darkens skin tones slightly

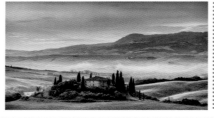 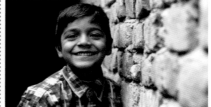

BLUE

- Over-lightens the sky
- Increases the effects of haze and fog
- Darkens skin tones unnaturally

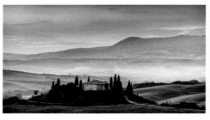 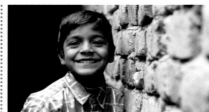

CHANGING TONES

Monochrome photos do not need to be made purely of shades of grey – photographers began to tone black and white photos soon after photography was invented. Simple toning adds one colour to a photo; split toning adds two – one to the highlighted areas of the photo, and the other to the shadows. It is up to you which colours you use. Complementary colours work well, with the warmer colour, such as yellow-orange, used for the highlights and the cooler one, such as blue, for the shadows. This mimics the way that shadows tend to be cooler in colour than brightly lit areas of a scene.

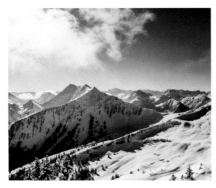

1 ASSESS YOUR PHOTO
Start with a colour image suitable for conversion to black and white. Split toning can also be used on colour photos, to add a warm tint to shadows.

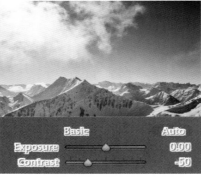

2 LOWER THE CONTRAST
Use the Contrast slider in Lightroom's Basic panel, Develop module, to slightly lower the contrast so there is enough detail in the highlights and shadow.

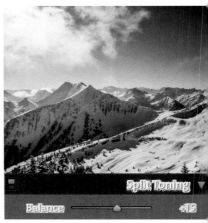

3 CONVERT THE IMAGE
Use the colour controls of the conversion tool to adjust the tonal range of the photo to black and white.

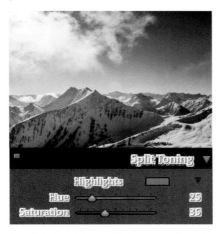

4 APPLY THE HIGHLIGHTS TONE
Starting with Highlights, use the Hue slider of the Split Toning tool to alter the colour tone, and the Saturation tool to vary the intensity of the colour.

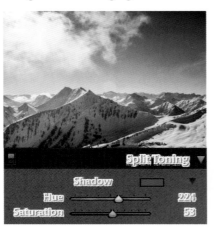

5 APPLY THE SHADOW TONE
Adjust the Shadows Hue and Saturation sliders, picking a colour that complements the one that you chose for the Highlights (see p.41).

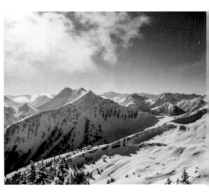

6 ADJUST THE BALANCE
Balance the strength of the colours in the highlights and shadows. Pull the slider to the right to favour the highlights and to the left to favour the shadows.

SEPIA

Sepia is a reddish-brown tint effect commonly produced in early photographic prints by processing chemicals that improved the archival properties of the photos. This effect can be used to "age" a digital photo. To add a single tone, set both the Highlights and Shadows to the same Hue and Saturation value.

THE RESULT

The cool, violet-blue tones of the shadows help to convey the chilly temperature of this wintery scene. The warm pink that has been added to the highlights gives the scene a late afternoon feel, replicating the colour effects of the setting sun.

▼ BEFORE SPLIT TONING

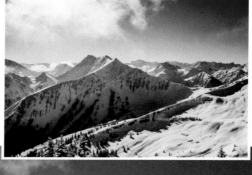

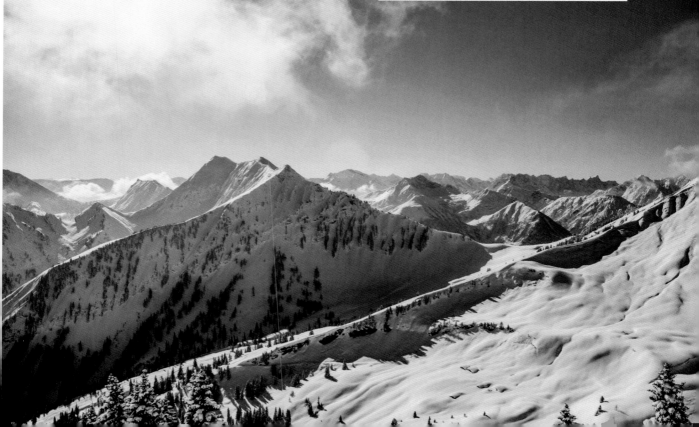

STITCHING TOGETHER BRENIZER AND PANORAMIC PHOTOS

Once you have shot a Brenizer (see pp.104–05) or panoramic (see pp.64–65) sequence of photos you will need to stitch them together digitally to create the final image. You can use either Adobe Photoshop or Lightroom to stitch photos together. Photoshop is perhaps the better of the two choices because it provides you with more options. However, both of them offer the same basic Layout or Projection

BRENIZER (STITCHED TOGETHER IN ADOBE PHOTOSHOP)

1 SELECT AUTO
Open all of the photos that you want to stitch together. Next, go to File, Automate, and then Photomerge. In the Layout column, select Auto. Check Blend Images Together. Finally, click Add Open Files.

2 PROCESSING TIME
Merging photos takes time, particularly with high resolution files. Merging quarter-sized copies of your photos will be quicker. Because you are merging lots of photos together, the final image will be very high in resolution.

3 FLATTEN THE LAYERS
A new file will be created with the photos stacked as layers. If you want to be able to edit these layers, save the file as a PSD or TIFF file. You can save a flattened image as a JPEG, but the photo will lose some resolution.

4 CROP THE PHOTO
The flattened photo will have ragged edges. Use the Crop tool to shape the image, holding down Shift as you drag your cursor to constrain the crop to a square. If you know the crop you'd like to set, input the aspect ratio in the Crop tool strip.

5 THE RESULT
Check the whole photo very carefully to see if there are any areas that have been misaligned. This may happen if part of the scene, such as leaves, moves while you are shooting. You can use the Clone Stamp tool to repair these areas.

choices: Perspective, Cylindrical, or Spherical. (Auto, which is an option with Photoshop alone, makes the Layout selection for you.) Perspective is a good choice if you want lines, such as in

architectural subjects, to be straight in the final photo; Spherical works best when you are creating panoramas that are very wide; Cylindrical is a good compromise between the first two options.

PANORAMIC (STITCHED TOGETHER IN ADOBE LIGHTROOM)

1 ADJUST YOUR PHOTOS
Select one of your photos and apply any adjustments that you want to make. Apply the same adjustments to the other photos in the sequence so that they are all completely consistent.

2 SELECT THE SEQUENCE
In the Library module (a mode in which you can organize photos), multi-select all the images in the sequence and then go to Photo, Photo Merge, and then Panorama.

3 CHOOSE A PROJECTION
Select the projection method that best suits the type of panorama you are creating. A high Boundary Warp value stretches the edges of the panorama to create a perfectly rectangular shape.

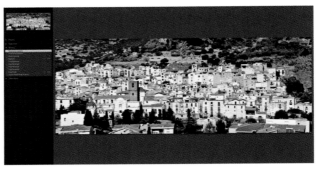

4 CROP THE PANORAMIC
Set the Boundary Warp value to 0 and select Auto Crop to crop the panorama to a rectangular shape without stretching the edges or leaving a ragged edge. Click on Merge to begin stitching the images together.

5 THE RESULT
If you use Raw images, Lightroom creates a separate Raw file for the final panorama. You can create more adjustments to this new file in the Develop module without compromising the quality of the image in any way.

WORKING WITH **LAYERS**

Layers can be added to photos in Adobe Photoshop and editing software such as Gimp. Adding a layer to a photo is like laying a sheet of glass over a print: you can draw on the glass without affecting the print underneath. Adding more layers is like adding further sheets of glass, and you can work on these without affecting anything below. There are different types of layer, but the most useful ones for editing a photo are the adjustment layers, which let you alter aspects of the photo such as exposure or contrast. Unlike making the alteration to the photo itself, you can either tweak the layer settings or discard the adjustment layer altogether if you do not like the final effect.

Layers

You can add numerous layers to a photo, each of which makes different adjustments or adds new content. By creating a layer mask, you can isolate the areas of an image to which you want to apply an effect. You could mask the background of an image and make an adjustment to the foreground, for example. Even with just a few layers, it is important to organize them logically. Start by renaming layers as you create them, using helpful titles. To rename a layer, double-click on its name in the layer panels. As you add layers, you create a stack. Moving layers into groups is a simple way to tidy up a layer stack.

LAYER MASKS

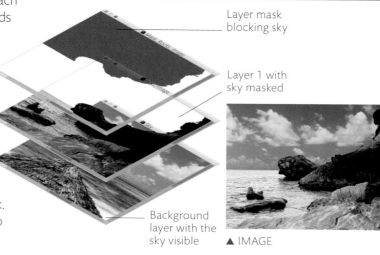

Layer mask blocking sky

Layer 1 with sky masked

Background layer with the sky visible

▲ IMAGE

PHOTOSHOP ADJUSTMENT LAYERS

 Brightness/Contrast Darkens or brightens a photo globally, and adjusts the overall contrast.

 Levels Uses an image's histogram and control tools to make tonal corrections.

 Curves Adds or removes contrast, and alters colour as you vary the shape of the curve.

 Exposure Alters the exposure of a photo in stops, similar to in-camera exposure compensation.

 Vibrance Adjusts the intensity of more muted colours.

 Hue/Saturation Changes the colour values of all or a selection of colours, and their intensity.

 Colour balance Adjusts the overall colour tint of an image; can be used to colour-correct photos.

 Black and white Converts colour photos to black and white, using sliders or a small range of presets.

 Photo filter Mimics the use of photographic colour correction filters to alter the White Balance.

 Invert Flips the tonal range of an image to produce a negative version of the original.

THE LAYERS PALETTE (OF ADOBE PHOTOSHOP)

Layer options can be found on both the Layer menu and the Layers panel (if it is not visible, go to the Windows menu and select Layers). The default layer is named Background and any layers that you add are stacked above it. The layer currently selected is highlighted grey. You can move layers up and down the stack by dragging the selected layer into position. You can also multi-select layers to move more than one.

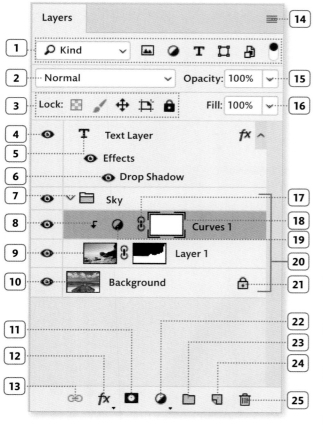

KEY

1 **Layer filter options** Hides or reveals the various types of layer.

2 **Blend mode** Alters how one layer visually affects any layer below.

3 **Lock options** Prevents a highlighted layer from being moved or edited.

4 **Layer visibility** Hides or reveals a layer.

5 **Text layer** Enables you to add text.

6 **Layer style type** Lists styles applied to a layer. Clicking on the icon turns it on or off.

7 **Layer group icon** Contains groups of layers.

8 **Layer clip** Connects two neighbouring layers together.

9 **Layer thumbnail** Shows the contents of a layer.

10 **Background layer** The default layer when a photo is opened.

11 **Layer mask options** Adds an editable mask to the selected layer.

12 **Layer style options** Shows the effects or styles that can be applied to a layer or groups of layers.

13 **Layer link options** Temporarily links selected layers so that they can be altered or moved simultaneously.

14 **Layer menu** Includes options such as deleting or flattening layers.

15 **Layer opacity** Changes a layer's transparency.

16 **Layer fill** Alters a layer's transparency, but does not alter the style effect (if one has been applied).

17 **Layer mask link** Unlinks a layer and layer mask, so that they can be moved independently.

18 **Layer mask** An image of the layer mask.

19 **Adjustment layer** Applies an adjustment to the layers below.

20 **Layer stack** Lists the layers and layer masks in a photo.

21 **Lock icon** Indicates that a layer has been locked, to prevent editing.

22 **Adjustment layer options** Applies a specific adjustment to the layers below.

23 **Layer group** Adds a new group folder inside the layer. Dragging a layer to the group icon adds the layer to a group.

24 **New layer** Adds a new layer to the layer stack. Dragging an existing layer to this icon duplicates the layer.

25 **Delete layer** Deletes the currently selected layer. Dragging a layer to the icon deletes it.

ADJUSTMENT LAYERS

There are 19 different adjustment layers. They let you vary effects by altering the layer options, make masks for local adjustments, and alter opacity. Adjustment layers affect all of the visible layers below, but you can lock the adjustment to just the layer directly below by applying the layer clip.

SELECTIVE **ADJUSTMENTS**

At first, the effect of a Photoshop adjustment layer is applied globally (to the entire image). Layer masks are a way to limit the adjustment to selected areas of the image, so use a layer mask if you want to adjust a selected part of your photo. You can add a layer mask to any type of layer. White areas on the mask reveal the layer to which the mask is attached. Black areas conceal that portion of the layer, allowing the layer underneath to show through. Remember this mnemonic: white reveals, black conceals. Grey areas reveal a blend of the layer to which the mask is attached and the layer beneath.

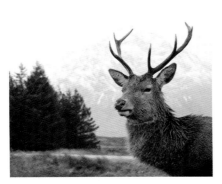

1 OPEN THE PHOTO
Start with a 16-bit TIFF exported from Raw editing software. Exporting as a 16-bit file instead of an 8-bit file helps to preserve image quality. Assess what you would like to change.

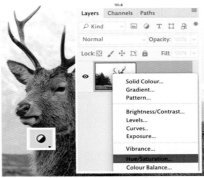

2 ADD THE ADJUSTMENT LAYER
Select the type of adjustment layer that you want to apply from the pop-up menu at the bottom of the Layer panel. Here, Hue/Saturation has been selected.

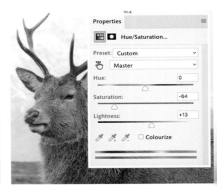

3 MAKE ADJUSTMENTS
Reduce the colour to silvery hues using the sliders in the Properties panel. If this is not visible, open it from the Window menu at the top of the screen.

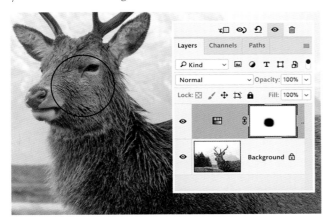

4 PAINT THE LAYER MASK
Select the Brush from the Tools panel and edit the layer mask (highlighted). Set the foreground colour to black and paint any part of the image where you want to remove the adjustment. The circle shows where the brush tool is.

5 ZOOM IN FOR DETAILS
Vary the size of the brush tool to suit the size of the area you are working on. Zooming into the photo and using a small brush will enable you to mask out intricate edges and details precisely.

QUICK MASKS

Photoshop's selection tools, such as the Rectangular Marquee and Lasso, can be turned into a temporary mask by clicking on the Quick Mask icon on the Tool bar. This lets you make alterations, such as painting new selected areas or softening the outline of an area with Photoshop's Blur filter. Clicking on Quick Mask once more will convert the mask back into a selection.

6 **CHECK THE LAYER MASK**
Click on the mask thumbnail on the Layer panel whilst holding down Option (Mac) / Alt (Win) to check that the layer mask is covering what you want.

7 **FLATTEN THE LAYERS**
Select Flatten Image in the layer panel menu to save the file. Save the master file as a TIFF or PSD to preserve all the layers. This will allow you to re-open the file later and make further adjustments.

THE RESULT

The Hue/Saturation adjustment layer was used to tone down the colours in the background and make the stag stand out proud in the foreground. The silvery hues have also given the photo an atmospheric, wintry feel.

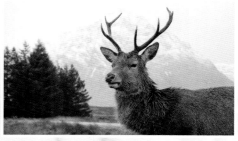

▲ BEFORE ADJUSTMENT

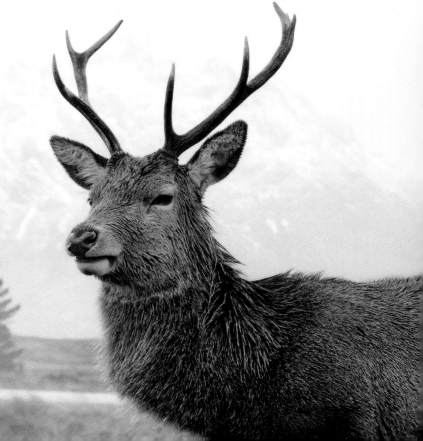

ADJUSTING **COLOUR**

Cross processing is a darkroom method in which one type of film, such as print, is developed in chemicals that are normally meant for a different type of film, such as transparency. Contrast is heightened in the resulting images and the colours are no longer true-to-life, most notably in the shadows and highlights. You can simulate the effects of cross processing digitally by adjusting the relative brightness of an image's individual colour channels: red, green, and blue.

SOLARIZATION

A photo is solarized when either its shadows or its highlights are tonally inverted. The effect works best with high-contrast photos. Using the Curves tool, add a control point halfway along the tone curve. To solarize shadows pull the point down to the bottom of the Curves box, then pull the shadow control point in the bottom left corner up to the top. To solarize highlights, pull the control point to the top of the box, then move the highlight control point, in the top right to the bottom.

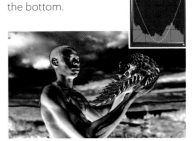

▲ SOLARIZED SHADOWS

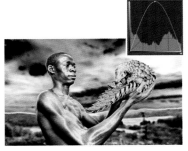

▲ SOLARIZED HIGHLIGHTS

1 **ASSESS YOUR IMAGE**
Select a photo that you think the technique might suit. Simple, colourful images with a single subject work well, especially if they have strong shadows and highlights.

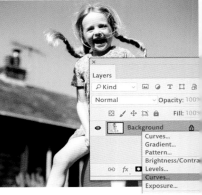

2 **SELECT CURVES**
Add a Curves adjustment layer to the photo. This will make it easier to change afterwards. You also have the option to change the layer's Opacity to vary the strength of the effect.

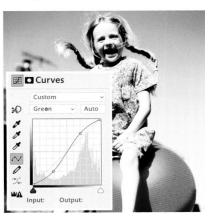

4 **ADJUST THE GREEN CHANNEL**
Select the Green channel and add two control points. Pull the left-hand point down and the right-hand point up, though not as far as for the Red channel.

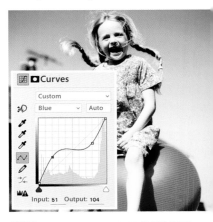

5 **ADJUST THE BLUE CHANNEL**
Select the Blue channel and add two control points. Pull the left-hand point up and the right-hand point down to produce an inverted S-shape.

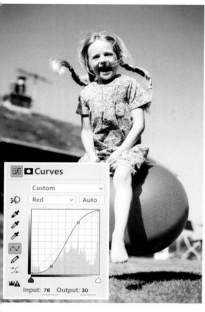

3 ADJUST THE RED CHANNEL

Select the Red channel from the RGB menu on the Curves panel. Add two control points spaced equally apart. Pull the left-hand point down, and the right-hand point up, to create an S-shape.

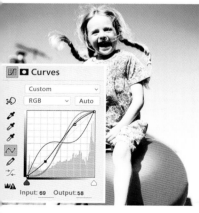

6 ADD CONTRAST

Select RGB and add contrast to the photo by creating an S-shape with two control points. There's no right or wrong adjustment. It's up to you.

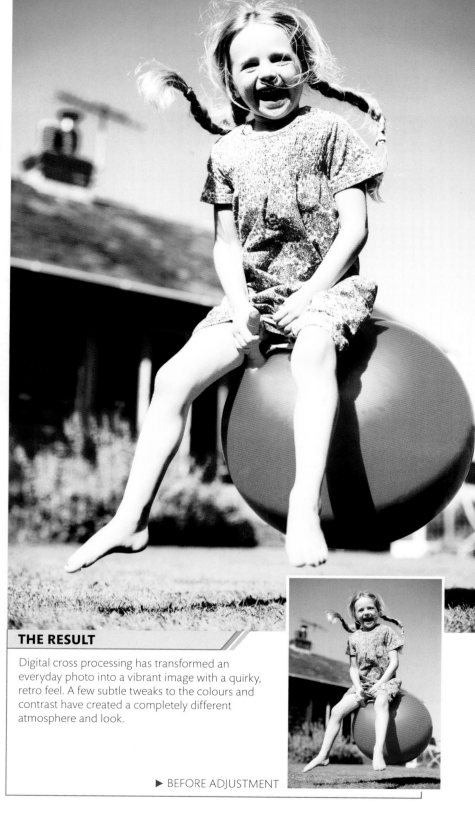

THE RESULT

Digital cross processing has transformed an everyday photo into a vibrant image with a quirky, retro feel. A few subtle tweaks to the colours and contrast have created a completely different atmosphere and look.

▶ BEFORE ADJUSTMENT

CATALOGUING
YOUR IMAGES

Post-production is only one aspect of working with your photos on a computer – cataloguing them efficiently is vital. When shooting on film was common, photographers used to store their negatives and transparencies in named folders kept in filing cabinets, with a paper list showing where to find each photo. Today, digital files are stored in folders on your computer or hard drive, and software databases make it possible to retrieve the photos that you want instantly.

Digital asset management (DAM)

Organizing digital files – such as photos – so that you can locate specific files quickly is referred to as digital asset management (DAM). It includes renaming files, creating folders with useful names, and moving relevant files into these folders. It also includes adding keywords and descriptions to your photos, as well as important procedures such as backing up files. You can do some of these things using a computer's operating system, but dedicated DAM software makes asset management far easier and more efficient. DAM capability is often built into image-editing software. Adobe Lightroom is one of many types of software that enables you to start sorting your images as soon as you have imported them.

METADATA

Information that is embedded in a photo is known as metadata. Data that is created by the camera, such as the exposure settings, is known as EXIF metadata. You can also add metadata to photos using DAM software. This is known as IPTC metadata, and includes information such as your personal details, image copyright status, and information related to specific images, such as a description and relevant keywords.

▲ EXIF METADATA

▲ IPTC METADATA

WORKFLOW

ASSIGN COPYRIGHT

Every photograph that you shoot belongs to you, unless you assign the copyright to another person or company. Add copyright information to a photo's metadata, including what rights restrict the use of the photo.

ASSIGN A CREATOR

Although you can assign the copyright to another party, you are the creator of your own photos. Both this field and Copyright can be used to determine if your photos have been used without your permission.

ADD A CAPTION

A caption is a short sentence that describes a photo (important information can also be added as keywords). Add a caption that gives anyone looking at the photo a useful summary of what it is about.

WATERMARK

A visible word or graphic that is applied to a photo in post-production is called a watermark. They are used to ensure that photos cannot be used by a third party without the creator's or copyright-owner's permission, either when it is printed or placed online. Watermarks should not be added to the original photo, but to a copy that is created specifically for the purpose of uploading.

ORGANIZATION

CREATING FOLDERS

Organizing your photos into named folders is a key part of image management. There is no right or wrong way to do this, as long as you have a system that works well, and you can expand it over time. One simple way to organize folders is to create a main folder for a particular topic, such as landscape, and then to create nested folders that become increasingly specific: USA > California > Yosemite > Half Dome and so on, for example. The advantages of this system are that you can build it up as time goes on and it is easy for other people to follow. Use your DAM software to create folders and to move photos around, rather than your computer's operating system, as this will make it possible for the software to keep track of any changes that you make.

NAMING FILES

Every photo that you shoot is assigned a numeric file name by your camera, starting at 0001. Unfortunately, this system loops round and begins to repeat after 9,999 photos, so you could end up having numerous photos with the same file name, making it harder to find a particular photo. Some cameras assign a date to photos, but this is not a foolproof way of naming your files. To avoid confusion, use a naming system that will never repeat, such as adding the location into the file name along with its numerical value (see right).

ADD KEYWORDS

Add a comprehensive set of keywords to a photo to make searching for a particular image easier. Keywords should include words that describe a photo's contents, such as the subject and location.

ADD A RATING

You can add a rating from 1 to 5 to a photo, either in-camera or in post-production. Use this to organize photos, either in terms of quality or into categories, if you are creating a larger catalogue of images.

FILE THE PHOTO

If you store all of your photos in one folder, you will soon find it difficult to find a particular photo, and the more photos you take, the worse the problem will become. Filing photos efficiently is therefore paramount.

PREPARING TO **PRINT**

There is nothing more satisfying than seeing a really good print of one of your favourite photos, but you have a few key decisions to make beforehand. First, you have to choose what print size to use, as today's high-resolution cameras mean that there is very little limitation on the potential size of a print. Then you need to decide what type of paper to use, as this will affect the visual qualities – the colour reproduction, for example – of the final print. You can preview the the effect that a particular type of paper will have on colour and contrast by using soft proofing, which simulates the likely result onscreen.

1 PLAN THE PRINT'S SIZE
Either set the print size in Print Settings or on a copy of your photo before printing. The second option is useful if you plan to reprint the image a lot. Here, Adobe Photoshop was used.

2 SHARPEN THE IMAGE
Go to Filter, Sharpen, and then Smart Sharpen to open this window above. Experiment with the amount of sharpening and note the settings you like best, depending on the paper.

3 SOFT PROOF
Go to View, Proof Setup, and select Custom. Pick the printer profile for your chosen paper. This is used to mimic the colours onscreen in the prints you make.

4 SELECT THE PAPER
Select Print on your editing software, followed by the printer profile for the paper. This should be the same as the profile you selected for soft proofing.

5 SET THE MEDIA TYPE
Match the Media Type to the paper you have chosen. This will affect the density of the ink used to print the photo, as well as the time it takes to print

PAPER

The type of paper that you use is a personal choice, but the subject of the photo will have some bearing on it. The most common type of paper used is gloss, which results in punchy, colourful prints, but it can be too bold, particularly when printing soft-toned subjects that require a more subtle approach. A gloss surface also reflects light, and this can make the image hard to see. Prints made on matt paper often look softer, as wet ink spreads further on it, and the colours are less dramatic. Matt paper works well for artistic images and black and white photos. Lustre paper is a good compromise between gloss and matt.

PAPER	ADVANTAGES	DISADVANTAGES
GLOSS	■ Vibrant colours ■ Sharp details ■ Durable print surface	■ Reflective surface ■ Can lack subtlety ■ Prints stick to plastic sleeves
LUSTRE	■ Less reflective than gloss ■ Wide colour range ■ Long print life	■ Expensive compared to gloss ■ Less impactful than gloss
MATT	■ No reflections when lit ■ Subtle artistic effect ■ Quick drying times	■ Print surface easily scratched ■ Muted colours ■ Soft details

THE RESULT

Paper designed to be printed on with inks – such as the paper in this book – is coated to prevent excessive ink spread. Try experimenting with different types of paper and see what works best for your photo.

GLOSSARY

aberration An image flaw or distortion that is caused by imperfect lens optics.

adjustment A change made to a photo in post-production, to the brightness or contrast, for example.

angle of view The angular extent of an image, measured in degrees, that is projected onto the sensor.

aperture A variable iris inside a lens, used to control the amount of light that passes through the lens.

Aperture Priority A semi-automatic exposure mode, in which the photographer selects the aperture.

APS-C (Advanced Photo System type-C) A digital sensor, around 23.6 x 15.8mm in size, that is used in most dSLRs and CSCs.

aspect ratio A description of the shape of an image, shown as the ratio between the horizontal and vertical dimensions.

autofocus (AF) A system that uses sensors to assess the subject and focus the camera lens automatically.

AWB (Automatic White Balance) A White Balance setting in which the camera assesses the colour bias of the lighting and automatically calculates the White Balance.

bokeh The aesthetic qualities of out-of-focus areas of a photo. Derived from a Japanese word for haze.

bracketing Shooting a sequence of two or more photos, varying a specific setting such as the exposure in each one, to determine the best setting for the shot.

buffer Memory that is built into a camera and is used as a temporary storage for photos until they can be written to the memory card.

Bulb An exposure mode in which the shutter can be held open for an indefinite period by holding down the shutter button.

burning A post-production digital adjustment that makes an image – or part of an image – look darker.

burnt-out A term for highlights that are pure white and lacking in detail due to overexposure.

camera shake Softness in a photo that is caused by moving the camera during an exposure.

centre-weighted metering A camera metering mode that biases exposure to a large central area of the image frame.

chromatic aberration Coloured fringing visible along high-contrast edges in a photo, caused by a lens being unable to focus the different wavelengths of light to one point.

colour temperature An indicator of how red- or blue-biased light is, measured in Kelvin.

Continuous AF An autofocus (AF) mode in which the focus distance is continuously adjusted by the lens until the moment of exposure.

Continuous Drive A drive mode that makes it possible to shoot a sequence of consecutive photos by holding down the shutter button.

contrast The difference in brightness between the darkest and lightest areas of a scene or photo. Contrast can also be used to describe differences in colour or texture.

critical focus The part of a photo that is the sharpest.

crop To reshape or reduce the size of a photo, by trimming along one or more of its edges.

crop factor A figure used to calculate the difference in angle of view when a lens is fitted to cameras with different sensor sizes.

CSC (Compact System Camera) An interchangeable-lens camera that streams live image data from the sensor to an LCD or EVF. It is also known as a mirrorless camera.

depth of field The area of acceptable sharpness in a photo. Depth of field extends from the focus point and is controlled by adjusting the size of the lens aperture.

distortion The warping of an image by the optics of a lens, particularly noticeable in geometrical subjects.

dodging A post-production digital adjustment that makes an image, or part of an image, look lighter.

drive mode A mode in which you set the number of photos that a camera will shoot when the shutter is pressed and held down, or when the self-timer is activated.

dynamic range A ratio of intensity between the darkest and brightest tones that can be captured by a digital sensor without significant noise.

EVF (Electronic Viewfinder) A viewfinder that uses a miniature LCD to display a live image streamed directly from the sensor or a previously shot photo in playback.

exposure The aperture, shutter speed, and ISO settings necessary to take a photo. It also refers to the physical act of taking a photo.

exposure compensation An adjustment of the base exposure initially set by the camera, usually in 1/3, 1/2, or 1 EV increments. Negative exposure compensation darkens an image, and positive lightens it.

f/stop (f/number) A term used to refer to the size of the aperture in a lens. It is expressed as a fraction of the focal length: f/4, f/11, f/22, etc. The higher the f-stop, the smaller the aperture.

filter (physical) A piece of glass, plastic, or optical resin that is fitted to a lens to filter the light that passes through it. The effect is duplicated in the resulting image.

filter (digital) An image-editing effect that emulates a physical filter and alters either the entire image or a selected part of it.

focal length The distance (in millimetres) from the optical centre of a lens to the focal plane when the lens is focused on infinity. Focal length, together with the size of the camera's digital sensor, determines a lens's angle of view.

focus To adjust lens optics to ensure that a sharp image is produced on the camera's sensor.

flash An electronic device that emits a brief but intense burst of light.

frame A single photographic image. Also, a surround of wood, plastic, or metal made to display a print.

frame rate The number of photos that a camera can shoot every second in Continuous Drive mode. It is also referred to as frames per second (fps).

front element The part of the lens exposed to the scene.

full-frame A sensor size that matches the traditional size of a 35mm film frame; approximately 36mm x 24mm.

Fully Automatic (Auto) A shooting mode in which most of the camera's functions are set automatically, giving the photographer limited control.

geo-tag Digital information in a photo about its location, which is inputted either when the photo is shot, or later in post-production.

global correction An adjustment that is made across an entire photo.

highlights The brightest parts of a scene or photograph.

histogram A graph showing the relative spread of tones in an image.

hotshoe A connection found on the top of most dSLRs and some CSCs, to which an external flash or remote trigger can be fitted.

ICC profile Data that specifies the range of colours that a digital device, such as a monitor or printer, can produce to ensure that the colour is consistent across different devices.

incident-light metering The measurement of the amount of light falling onto a subject, usually taken with a handheld light meter.

infinity The furthest point from the camera on which the lens can focus.

ISO A numerical value that specifies how sensitive a sensor is to light. Higher ISO values make it possible to use faster shutter speeds or smaller apertures at the expense of noise.

JPEG (Joint Photographic Expert Group) One of the most popular file formats for recording and saving digital photographs.

Kelvin (K) A scale used to measure the colour temperature of light.

keyword A descriptive word or phrase added to the metadata of a photo. Keywords can be searched for in DAM software.

kit lens An inexpensive lens, usually a zoom, that is commonly sold as a package with a dSLR or CSC.

landscape (format) An image format in which the longest sides of the rectangle are horizontal (as opposed to portrait format).

layer An element that can be placed on an image in post-production, to which adjustments or changes can be made.

layer mask A part of a layer used to limit the area of an adjustment.

LCD (Liquid Crystal Display) Display technology used in EVFs and rear camera screens.

lens An assembly of glass or plastic optical elements used to focus light onto the camera's sensor.

lens elements The shaped pieces of glass in a lens that focus light.

light meter A tool used to measure the brightness of light, making it possible to determine which camera settings to use. All cameras have a built-in light meter.

line-of-sight Unobstructed visibility between the photographer and camera and a subject, or between a master and a slave flash.

local correction An adjustment applied to a specific part of a photo.

low-dispersion glass A type of glass that is used in lenses, which is designed to minimize chromatic aberration (coloured fringing).

macro A photographic technique in which subjects are shot at a 1x magnification or higher.

Manual An exposure mode in which both the shutter speed and aperture are set by the photographer.

manual focus (MF) A focusing mode in which the photographer physically turns the focus ring on a lens to achieve sharp focus.

memory card A removable storage device used in digital cameras. The most common type is an SD card.

metadata Information embedded in a digital file, such as a photo, that describes a particular aspect of the file. Settings, such as aperture and shutter speed, are examples of metadata that are automatically added to a photo by a camera.

metering The measurement of ambient light levels, so that the right exposure settings can be selected on a camera.

mid-tone A tone exactly halfway between black and white, with an 18% reflectivity.

monochrome An alternative term for black and white, or for a photo with a restricted range of colours.

multi-area metering A camera's default exposure metering mode, this divides a scene into zones, each of which is metered independently. The camera determines the final exposure by analysing and evaluating the exposure reading of each zone.

ND (neutral-density) filter A semi-opaque filter that reduces the intensity of light passing through it, allowing either a longer shutter speed or a larger aperture than would otherwise be possible.

ND graduated filter A filter that is often used when shooting landscapes, to balance the exposure between two different areas of a scene. One half of it is semi-opaque and acts as a filter, while the other half is transparent.

noise A random grain pattern that reduces fine detail in a photo.

noise reduction A technique used to reduce or remove the appearance of noise in a photo. This can either be set in-camera before shooting or done later in post-production.

non-proprietary Camera equipment that is not licensed with a particular brand.

opacity A measure of how transparent a layer is. It can be adjusted in post-production.

optical viewfinder A type of viewfinder that shows the subject through an optical system, rather than via an LCD screen.

orientation The angle at which a camera is held when shooting.

overexposure The result of letting too much light reach the sensor during an exposure, producing an image with burnt-out highlights and shadows that are too light.

perspective The illusion of depth in a photo, suggested by how the various elements relate to each other. It depends on the photographer's position in relation to the scene and the focal length of the lens used.

pixel Short for picture element; the smallest unit of image information in a photo or on a monitor.

pixellated The effect created in a digital image when the individual pixels are clearly visible.

plane of focus An imaginary horizontal plane perpendicular to a lens in which everything is in focus.

playback The viewing of photos from the camera's memory card.

polarizing filter A filter that is mainly used to reduce reflections from non-metallic surfaces, or to deepen the blue of the sky.

portrait A photo in which the main subject is a single person or animal, or a small group of people or animals. It is also used to describe the format of a photo in which the longest sides of the rectangle are vertical (as opposed to landscape format).

post-production Refers to any task or adjustment carried out on a photo after shooting. Post-production can be done in-camera on some models, but is usually handled with image-editing software on a computer.

prime lens A fixed-focal-length lens. A range of lengths are available.

Program An automatic exposure mode in which the camera sets the aperture and shutter speed, but you can control the exposure.

Raw An image file format that retains all the data captured by the camera at the time of the exposure.

red-eye An effect created when light (usually from a direct flash) reflects off the blood vessels at the back of the subject's eyes, making their pupils look red in the photo.

reflective metering The measurement of how much light is reflected from a scene.

reflector A sheet of material (normally white, silver, or gold) that is used to redirect light into the darker areas of a subject to lower the contrast

remote release A cable or infrared accessory that fires a camera's shutter without you having to physically press the shutter button.

resolution (digital image) The number of pixels per inch (ppi) or, in the case of a print, the number of dots per inch (dpi).

resolution (lens) The amount of detail that a lens can record.

RGB (Red, Green, Blue) The three primary colours of digital cameras and monitors.

saturation The intensity of a colour.

shutter A light-proof curtain in front of a sensor that is opened and closed during an exposure.

shutter speed The length of time selected for the shutter to be open.

Shutter Priority A semi-automatic exposure mode in which the shutter speed is set by the photographer.

SLR (Single-Lens Reflex) A camera system that uses a reflex mirror to direct the image projected by the lens to an optical viewfinder.

spirit level A device inside a camera that can be used to ensure whether an image will be horizontal or vertical. Spirit levels can be added to a camera via a hotshoe, or to a tripod.

spot metering An exposure-metering mode in which only a small area of the scene is measured.

standard lens A 50mm lens (full-frame) or 35mm lens (APS-C). Also known as a normal lens, it produces naturalistic imagery that closely matches human vision.

stop A unit in which aperture sizes, shutter speeds, and ISO settings are measured.

sync speed The fastest shutter speed that can be used when a flash is fitted to a camera.

telephoto lens A lens with a long focal length.

tone The brightness of a pixel or area of a photo.

tonal range The full range of brightness levels found across a photo, from pure black to pure white.

TTL (through-the-lens) A term used to describe automated flash-metering systems in which the flash exposure is set by the camera rather than by the flash.

underexposure The result of letting too little light reach the sensor during an exposure, producing an image that is too dark and that lacks detail in areas of shadow.

USB (Universal Serial Bus) A standard data connection used to link digital devices.

ultraviolet (UV) filter A filter that reduces the effects of ultraviolet light. It has no effect on exposure and is commonly used to protect the front of a lens.

viewfinder An optical or electronic device that shows a photographer the image that will be captured by a camera during exposure.

vignetting A darkening of the corners of an image that is either accidental, such as when using a lens at maximum aperture, or is applied deliberately in post-production.

weather sealing Built-in protection that shields the camera from rain, dust, or humidity.

White Balance (WB) A camera function that neutralizes the colour bias of a light source in a scene.

wide-angle lens A lens with an angle of view greater than 65 degrees.

zoom lens A type of lens that has a variable focal length.

INDEX

ACKNOWLEDGMENTS

DK would like to thank:

Heather Hughes, Thomas Morse, Kate Taylor, and Samuel Kennedy for editorial assistance; Helen Peters for indexing; Dhirendra Singh for design assistance; Chauney Dunford for proofreading; and Tania Taylor for extra assistance. Many thanks also to our models: Arianna Cavalenci, Mark Cavanagh, Samuel Kennedy, Zoë Rutland, Kaiya Shang, Julie Steward, and Breda Streeter. For their kind permission to photograph, we are very grateful to: Yorkshire Sculpture Park, Denbigh School in Milton Keynes, and the Design Museum, London.

The publisher would like to thank the following for their kind permission to reproduce their photographs:

(Key: a-above; b-below/bottom; c-centre; f-far; l-left; r-right; t-top)

2 **David Taylor:** (cr). 3 **iStockphoto. com:** WildLivingArts (cl); **500px:** Alex North (cr). **4-5 500px:** Lisaelle. **6 500px:** 劼 肖 (tc); Hande Aydıngün (tl). **Matthew Kane, www.matthewjakekane.com/ photography:** on Unsplash (tr). **7 500px:** Yoshitada Kurozumi (tl); Sue Hsu (tc). **8 123RF.com:** Pius Lee (tl). **Alamy Stock Photo:** John Bentley (cl). **500px:** Mark Bridger (ca); Chen Chan (cb); Rafał Kwiatkowski (bl); Hero Images (cra). **11 500px:** Mark Bridger (cl); Fabio Davini (fcl); Alena Haurylik (fcla). **iStockphoto. com:** urbancow (crb/girl space hooper); WildLivingArts (fcra, cfla). **David Taylor:** (ca, c). **12-13 500px:** Sean Gladwell. **14 © Canon:** (crb). **Courtesy of Nikon:** (cb). **Samsung Electronics:** (clb). **15 Courtesy of Nikon:** (crb). **Panasonic:** (clb). **© Sony Corporation:** (cb). **David Taylor:** (tr). **16 Sigma Imaging (UK) Ltd.:** (br). **18 © Canon. 19 500px:** Varman Fotographie (tc). **Courtesy of Nikon:** (b). **20 www.fujifilm-x.com. 21 123RF.com:** Pongphan Ruengchai (tc). **Olympus UK:** (b). **22 © Canon:** (cl). **Courtesy of Nikon:** (c). **Sigma Imaging (UK) Ltd.:** (cr). **David Taylor:** (tr). **23 Courtesy of Nikon:** (cr). **Olympus UK:** (c). **© Sony Corporation:** (cl). **David Taylor:** (tc, tr). **24 Courtesy of Nikon:** (l, r). **25 123RF.com:** Serezniy (bl). **© Canon:** (br). **iStockphoto.com:** Migfoto (c). **26 123RF.com:** Elnur Amikishiyev (bl). **Getty Images:** PhotoPlus Magazine (tr). **500px:** Gable Denims (cr); Valerie Quinn (br). **27 123RF.com:** Elnur Amikishiyev (bc); Chiyacat (ca); Aleksandr Kurganov (tc); Lorenzo Gambaro (cb). **500px:** Hero Images (tr); Ben Robson (crb); Albert Vik (cra); Oleg Gekman (br). **28 123RF.com:** Péter Gudella (br). **Simon Murrell:** (bc). **29 Manfrotto www.manfrotto.com:** (tr, cr). **Simon Murrell:** (bc, br). **30 500px:** Andreas Altenburger (br). **David Taylor:** (tr, bl). **31 500px:** Hero Images (t); Gable Denims (cb); Mike Clegg (ca). **David Taylor:** (c, b). **34 500px:** Roberto Melotti (bl); Aman Chotani (br); Moisés Rodríguez (bc). **35 Alamy Stock Photo:** AA World Travel Library (br); Mode / Tim Ridley (cl); Grant Rooney (bl); Vibrant Pictures (cb);

Neil Setchfield (bc); Stelios Michael (crb). **500px:** Mohammed Al Sulaili (ca); Aleš Krivec (cra). **36 Alamy Stock Photo:** Antony Ratcliffe (br). **500px:** Lauri Lohi (c). **iStockphoto.com:** Bluejayphoto (cr); Woottigon (crb). **37 500px:** Mark Umbrella (c); Kittiwut Chuamrassamee (br); Sven Kluegl (cb); Ronald Diel (crb); Peter Moorey (cr). **iStockphoto.com:** Dgedj (bl); Icarmen13 (cr); Kapook2981 (cb); wnjay_woottisak (bc). **38 500px:** Cvetelina Yurukova (tr); Pazargic Liviu (cra); Chen Chan (cr); Ryan Belote (crb); Alex North (br). **39 500px:** Daniel Cole (tl); Mike Clegg (cr); Gable Denims (tr); Maxime Riendeau (cla); Jozef Polc (cra); Alfon No (c); Benjeev Rendhava (clb); Aleksandr Naumenko (br). **iStockphoto.com:** Instants (tc); SunnySashka (ca); Kavalenkava Volha (cl); Petesaloutos (cb); Powerofforever (bc). **David Taylor:** (crb, bl). **40 500px:** Daria Garnik (bl); Dmytro Koro (fbl); Alex Altruist (bc); Roy Cheung (br). **41 500px:** sub_photography (tr); Rafał Kwiatkowski (cra); Chris Greenwood (crb); Martin Molcan (br). **42 O. Murrell:** (cla, ca, cra, cl). **Simon Murrell:** (br). **43 500px:** Hande Aydıngün (tc); Sue Hsu (tr). **Simon Murrell:** (b). **44 500px:** Sutipond Somnam (br). **David Taylor:** (tr, cra, cr, crb). **45 David Taylor:** (all). **46 O. Murrell:** (cla, ca, cra, bl, bc). **47 Simon Murrell:** (all). **48-49 500px:** Yoshitada Kurozumi. **50 David Taylor:** (all). **51 500px:** Kseniya Rimskaya (tc); Pedro Damásio (fbl); Maciej Figiel (bc). **iStockphoto.com:** Xijian (tr). **David Taylor:** (bl, br). **53 123RF.com:** Jakhut (tr). **500px:** 劼 肖 (cl); Iolanda Enrione (c); Dina Belenko (bc); Gable Denims (clb); Lukas Jonaitis (bl); Eric Esterle (cb); Teemu Tretjakov (cla); Mike Greenham (fbl); Karin Ziegler (fbr); Guerilla Images (ca). **58 Alamy Stock Photo:** Nazman Mizan (br). **500px:** Daria Garnik (bc). **O. Murrell:** (cla, ca, cra). **59 Simon Murrell:** (tl). **O. Murrell:** (r, cl, bl). **61 123RF.com:** Pius Lee (tc); Martin Novak (tr). **63 123RF.com:** Marek Uliasz (tc). **David Taylor:** (tr). **65 David Taylor:** (cra). **67 Getty Images:** Nimit Nigam (b). **iStockphoto.com:** 4zoom4 (tr). **69 500px:** Thomas Herzog (tr); Thai Thu (cl); Fabrizio Crippa (br). **70 Alamy Stock Photo:** John Bentley (b). **71 Alamy Stock Photo:** John Bentley (br). **72 500px:** Bruno Piovan (bl); matg1985 (br). **73 David Taylor:** (tr). **80 500px:** Alena Haurylik (bl); Fabio Davini (br). **81 500px:** Mark Bridger (bl); **iStockphoto.**

com: ermess (cr, br). **82 500px:** Christoph Oberschneider (b). **David Taylor:** (tr). **83 500px:** Matej Kastelic (ca); Jit Lim (cra); Gunnar Helliesen (bc); Peter Gowdy (br). **David Taylor:** (cla, fbl, bl). **85 Getty Images:** Barcroft Images / Ingo Gerlach (tr). **Matthew Kane. wwwmatthewjakekane.com/ photography:** on Unsplash (tc). **86 500px:** Akihiko Endo (b). **87 David Taylor:** (all). **89 iStockphoto.com:** iphotojr (tr). **92-93 iStockphoto.com:** aLittleSilhouetto. **94 Courtesy of Nikon. 95 500px:** Alberevi (b). **David Taylor:** (ca, c). **96-97 David Taylor:** (all). **98 500px:** Sarawut Intarob (b). **99 David Taylor:** (all). **100 500px:** Alberevi (bl). **105 500px:** Steyaert Didier (tc). **iStockphoto.com:** Zolnierek (tr). **106 © Canon:** (clb). **500px:** Sebastian Warneke (cl); Gable Denims (cr). **Sigma Imaging (UK) Ltd.:** (crb). **107 Alamy Stock Photo:** Patrick Eden (tr). **500px:** Lisaelle (b). **Iomography.com:** (cb). **Tokina:** (bl). **108 David Taylor:** (cla, ca). **111 iStockphoto.com:** fazon1 (b). **112 500px:** Ilyés Zoltán (cr, cl); Klaus Vartzbed (clb, crb); Attila Gimesi (bl, br). **113 Alamy Stock Photo:** Antonio Guillem Fernández (tr). **David Taylor:** (cla, ca, cra). **115 iStockphoto.com:** WildLivingArts (tc, tr). **118-119 iStockphoto.com:** Tommaso Tagliaferri. **120-121 David Taylor:** (all). **122 iStockphoto.com:** nycshooter (cl). **David Taylor:** (crb). **123 Alamy Stock Photo:** Cultura Creative (RF) (clb). **David Taylor:** (crb). **128 iStockphoto.com:** dominikmichalek (cl). **David Taylor:** (cr). **129 iStockphoto.com:** Andreas Reh (cr); Spondylolithesis (cl). **David Taylor:** (tr). **131 Alamy Stock Photo:** Arletta Cwalina (cr, br). **132-133 500px:** Oszkár Dániel Gáti. **134 500px:** Hiro Aoki (bl); Ian Reid (br). **136 500px:** Pablo Reinsch (cr). **137 500px:** Oleg Gekman (tr); Nova fly (crb); Muslim Kapasi (clb). **138 © DACS 2018:** Sculpture: "Caldera", by Tony Cragg 2008. Photographed by Nigel Wright at Yorkshire Sculpture Park. **139 © DACS 2018:** Sculpture: "Caldera", by Tony Cragg 2008. Photographed by Nigel Wright at Yorkshire Sculpture Park. (b). **500px:** RooM_the_Agency (tc); Gable Denims (tr). **140 Getty Images:** JazzIRT (tr). **500px:** First name Last name (cr); Ibrahim Alsamnan (br). **144 Alamy Stock Photo:** Lee Frost (bc). **iStockphoto.com:** Malkovstock (cr). **145 iStockphoto.com:**

Malkovstock (cr). **154-155 Getty Images:** Michael Honor. **156 Dean Digital Imaging / Floyd Dean. 157 iStockphoto.com:** alexabelov (crb, fcrb); Merlas (cr, fcr); RichVintage (tr, ftr); Jrleyland (br, fbr); Serg Veluseceac (cra, fcra). **158 David Taylor. 159 David Taylor.** 160-161 **iStockphoto.com:** Paul Bradbury. **162-163 David Taylor:** (all). **164-165 iStockphoto.com:** NickolayV (cathedral). **165 iStockphoto. com:** Prasit Chansarekorn (tr); Xesai (tc). **166 iStockphoto.com:** JacobH (b). **167 iStockphoto.com:** gehringj (c); pixelfusion3d (r). **168 Alamy Stock Photo:** Cultura RM (all). **169 123RF.com:** Denis Tabler (tc, tc). **Alamy Stock Photo:** Cultura RM (b, ca). **174-175 David Taylor:** (all). **176-177 iStockphoto.com:** urbancow (girl). **176 Getty Images:** Barcroft Media (clb, bl). **178-179 David Taylor:** (all). **180-181 David Taylor:** (all)

All other images © Dorling Kindersley For further information see: www.dkimages.com